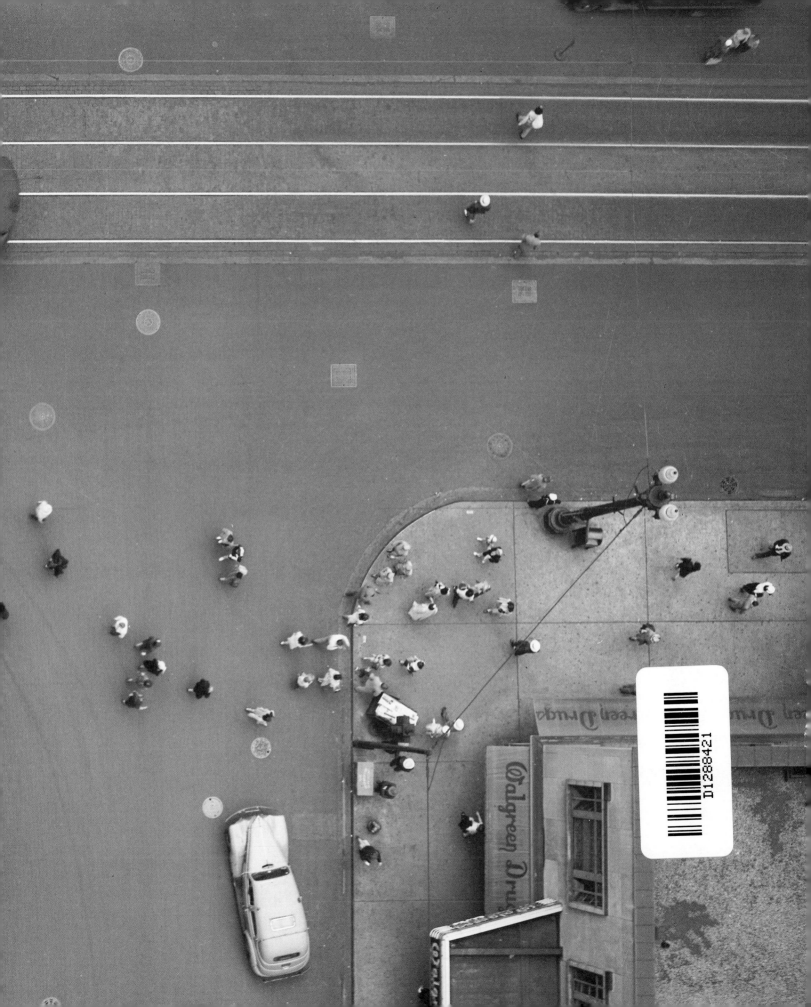

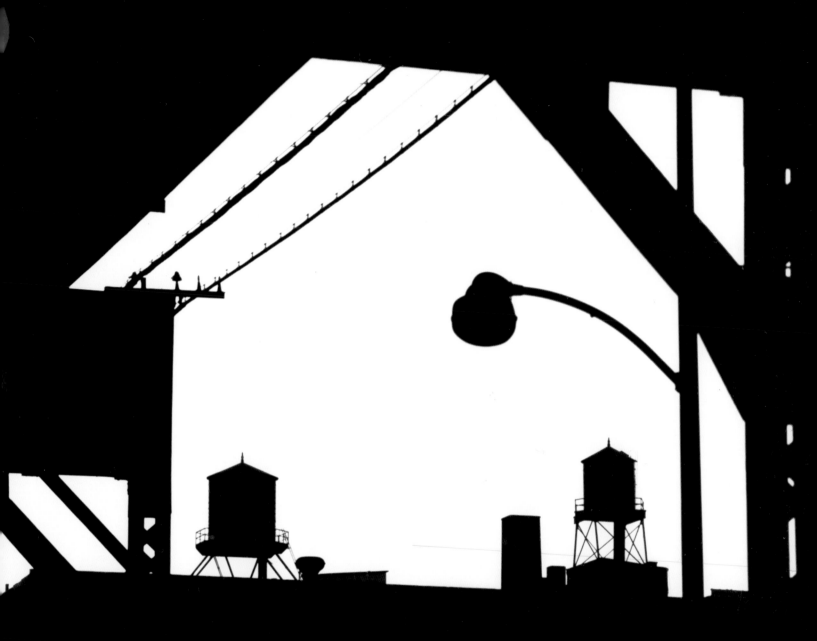

Tell it, Fanny. About the crowds, streets, buildings, lights, about the whirligig of loneliness, about the humpty-dumpty clutter of longings.

—Ben Hecht,
A Thousand and One Afternoons in Chicago

CHICAGO

CLASSIC PHOTOGRAPHS

**EDITED BY RICHARD CAHAN
AND MICHAEL WILLIAMS**

FEATURING

Michael Abrahamson • Harold Allen • Ralph Arvidson • Leonard Bass • Bob Black • James P. Blair •
Don Bronstein • Esther Bubley • Harry Callahan • Henri Cartier-Bresson • Gordon Coster •
Barbara Crane • Lloyd DeGrane • Jack Delano • Stephen Deutch • Yvette Marie Dostatni •
Jonas Dovydenas • Elliott Erwitt • Walker Evans • Ed Evenson • Michele Fitzsimmons • Raeburn Flerlage
Robert C. Florian • Ralph Frost • Eric Futran • Jun Fujita • Louis Giampa • Ron Gordon • Russell Hamm •
Tom Harney • Willming Hugh • Marc Hauser • Ken Hedrich • Yasuhiro Ishimoto • James Iska •
Joseph D. Jachna • Dave Jordano • Kenneth Josephson • Algimantas Kezys • Jay King • Bill Knefel •
Joe Kordick • Fred Korth • Lewis Kostiner • Bob Kotalik • Stanley Kubrick • George Kufrin •
Steve Lasker • Dorothea Lange • Clarence John Laughlin • Russell Lee • Nathan Lerner • Virginia Lockrow •
Marco Lorenzetti • Jon Lowenstein • Danny Lyon • Howard Lyon • Dave Mann • Stephen Marc •
Angie McMonigal • Mildred Mead • Ray Metzker • Sandro Miller • Wayne Miller • Al Mosse • Robert Murphy •
Robert Natkin • Marvin E. Newman • Richard Nickel • Larry Nocerino • Carlos Javier Ortiz •
Antonio Perez • Mark PoKempner • Allen Porter • Jon Randolph • Kathy Richland • Mickey Rito •
Diane Joy Schmidt • Ron Seymour • Art Shay • Vaughn Shoemaker • Howard D. Simmons •
Henry Simon • Art Sinsabaugh • Aaron Siskind • Frank Sokolik • Bill Sosin • Scott Strazzante •
Bill Sturm • Charles Swedlund • Charles H. Traub • Raymond Trowbridge •
John Tweedle • John Vachon • Ralph Walters • John H. White

© 2017 CITYFILES PRESS

All rights reserved. No part of this publication may be reproduced or transmitted in any form or by any means, electronic or mechanical, including photocopy, recording, or any information or storage retrieval system, without permission of the publisher.

Published by CityFiles Press, Chicago, Illinois

Produced and designed by Michael Williams

Copy edited by Caleb Burroughs, Cate Cahan, Mark Jacob, Amy Schroeder

Thanks to Paul Berlanga, Karen Burke, Agathe Cancellieri, Jacob Cartwright, Shashi Caudill, Joan and Peter Coster, Stephen Daiter, Robin Daughridge, Rick DeChantal, Keith de Lellis, Natasha Egan, Bernard Friedman, Dalton Hartye, Susan Hillman, Heidi and Virginia Jachna, Gary Johnson, Jim Kirk, Jim Kirkpatrick, Joan Kufrin, Graham Lee, Kiyoko Lerner, Maureen McLaughlin, Joan Miller, Laurence Miller, Bruce Moffat, Emiko Mogi, Paul Natkin, Nathaniel Parks, David R. Phillips, John Powell, Victor Powell, Cliff Radix, Michal Raz-Russo, Toby Roberts, Bob Roth, John Russick, Tim Samuelson, John Scott, Michael Shulman, Liz Siegel, Norbert Simon, Elisabeth Sinsabaugh, Lisa Stone, Kristin Taylor, Diane Tweedle, Midge Wilson, Paul Young, Lucas Zenk, and Marilyn Zimmerwoman

Snapshot Nation NFP is the fiscal sponsor of this book.

ISBN: 978-0991541874

First Edition

Printed in China

Pages 1-9: From "Chicago in Silhouette." Howard Lyon (1915–1994), who worked for the *Chicago Sun-Times* for thirty-two years, wrote, "I like to take pictures. I like to have the pictures I have taken published."

R0448446799

CONTENTS

INTRODUCTION

Richard Cahan and Michael Williams

THE PHOTOGRAPHS IN THE 1959 series "Chicago in Silhouette" by Howard Lyon, who tramped the city from the North Side to the Indiana border to capture smokestacks and church spires, railroad signals and expressway superstructures, open this book because they embody what we mean by classic: Beautiful. Lasting. Rooted in time and place.

Chicagoans have long treasured images of their beloved city, and *Chicago: Classic Photographs* is a testament to that. The photographs collected here bring back a lost city and link it to today. This book is not a portfolio of the most iconic photographs ever taken. Rather, it's an album of dazzling pictures that tells the city's story over the past century. Timeless photographs of a changing city.

Photography arrived in Chicago in the 1840s during the decade after the French inventor Louis Daguerre demonstrated his photographic process. The city's first photographers—Alexander Hesler, Charles D. Mosher, Samuel M. Fassett, and John Carbutt—were part scientist and part showman. They used primitive chemicals to make "sun-pictures." But most of their early work was destroyed in the Great Chicago Fire of 1871.

One piece that did survive was the panoramic cityscape by William Shaw displayed at the Chicago Daily Tribune Building in 1873. Shaw had set up his camera and tripod in the topmost tower of the city's courthouse before the Civil War. Before the assassination of President Lincoln. Before the fire.

His giant panorama—four feet high and twelve feet long—was considered a sacred relic by the people who lined up to study it. They brought with them a sense of melancholy as they looked back at the Chicago that once was. There was the Sherman House Hotel. There was Wood's Museum and the Great Wigwam, where the convention that nominated Abraham Lincoln had been held. There was the new post office and old First Presbyterian and First Baptist Churches. And there, on the ground, were the scars from where a circus ring had been built.

"Don't tell us here of the great rebuilding or of restoration," wrote a *Chicago Tribune* reporter. "We are writing of the city that is lost."

OUR SEARCH FOR CLASSIC Chicago photographs began in 1987, when Mike walked into the offices of the *Chicago Sun-Times* with pictures he had taken of the North Side's last movie palace, the Granada Theatre. Rich, the paper's picture editor, purchased a few of them—and took him on a quick excursion to the photo archives. Here was the modern visual history of Chicago, arranged in folders on movable shelves. The tour, as we realize now, linked us professionally for life.

Rich left the paper in 1999, but we were back together in its archives four years later as we scoured the shelves to compile *Real Chicago* and *Real Chicago Sports,* our first books exploring the city's history through photographs from the *Sun-Times.* By then, we were no longer bound by daily deadlines. We spent two years in the attic of the old Sun-Times Building, combing through hundreds of thousands of negatives that had been filed

long ago and forgotten.

Next was the archives of the Chicago Transit Authority, where we were given access to more than 200,000 negatives and 20,000 prints by photographers from the CTA and its predecessors. From those, we compiled the book *Chicago: City on the Move.* Then came a drive downstate to search through 220,000 glass-plate negatives taken for the Sanitary District of Chicago to document the effects of the reversal of the Chicago River on the region. Unearthed in a giant metal shed in the cornfields outside Springfield, these photographs were used for our book *Lost Panoramas.*

We've also pored over the exceptional work of the Chicago photographers Richard Nickel, Vivian Maier, and Michael Abramson to create five other books over the past decade. Through all those projects, we have found many photographs we haven't had a chance to show and some we want to show again.

This book started with a discussion of a single photograph of an ironworker near the top of the John Hancock Center. That photograph, by Jonas Dovydenas (on page 161), is one of the best known ever taken of Chicago. It is monumental both in scope and in what it says about the city. Compare it with famous photographs of cocky New York construction workers, and Dovydenas's midwestern laborer seems modest as he towers above the sprawling city, itself unpretentious. We visited Dovydenas to get the story behind that photo—and we decided to hunt down those of other classic pictures that reveal Chicago.

This project has given us a chance to work with people we have long admired. And it has allowed us to take a deeper look at the city's photographic history. Sometimes we've selected essential images from photographers, such as Art Shay's "Backyard Olympics." Other times we've chosen atypical photographs, such as the silhouettes by Art Sinsabaugh, known for his panoramic cityscapes.

In the process, we have tracked down dozens of men and women who have devoted decades to roaming the streets of Chicago with a camera. Their efforts constitute a remarkable legacy, but many of Chicago's most serious photographers worked in obscurity.

Paul Natkin, the son of Robert Natkin, carefully keeps his father's photographic archives intact because he understands their historical importance, but few people ever ring his doorbell. When assignments faded away in the 1950s, Gordon Coster folded his photography business and went to work as a hardware salesman and later as a menswear salesman for the department store chain Wieboldt's. His son Peter Coster was startled when we asked to pay him a visit. His father's photographs are framed on the walls of his house, and he kindly let us scan them for this book.

What separates *Chicago: Classic Photographs* from other photo books is that it combines all kinds of photography—fine art, student, editorial, commercial. Most of the photos were taken in black and white, but not all. We used everything from master prints to iPhone images. Some of these photos have appeared on museum walls; some have never been seen before. We've

set aside chronology to create a new kind of visual history of Chicago.

The photos come mainly from three sources: newspaper photographers, students and teachers from the Institute of Design, and independent photographers.

Chicago has long been a robust newspaper town. The *Chicago Tribune* began publishing photographs in 1897, and the *Chicago Daily News* soon followed. For much of the twentieth century, three or more daily newspapers competed for readers. Photos were an obvious draw. Though seldom considered artists, newspaper photographers produce reams of art in the course of their careers. From the *Tribune* and *Sun-Times* (and their predecessor and sister papers), we used work by Ralph Arvidson, Leonard Bass, Bob Black, Ralph Frost, Jun Fujita, Louis Giampa, Russell Hamm, Bob Kotalik, Bill Knefel, Joe Kordick, Steve Lasker, Howard Lyon, Dave Mann, Al Mosse, Larry Nocerino, Mickey Rito, Vaughn Shoemaker, Howard D. Simmons, Scott Strazzante, Bill Sturm, John Tweedle, Ralph Walters, and John H. White. From the *Chicago Reader,* the city's alternative weekly, we used photos by Eric Futran, Marc PoKempner, Jon Randolph, and Kathy Richland.

The Institute of Design, which was established in Chicago during the late 1930s as the New Bauhaus, was the largest single source of work in this book. Its Hungarian-born founder, László Moholy-Nagy, brought a modern aesthetic to Chicago. He believed that photography could offer a new way of seeing the world.

By rigorously teaching craft and imparting purpose, his school created a deep reservoir of talent and skill in the city. Moholy-Nagy invited Harry Callahan to join the faculty, and Callahan would become the linchpin of Chicago's progressive photographic community. He was intuitive, following his camera to all parts of the city, and had a ferocious desire to make imagery unlike any that had been seen before. Callahan and fellow teacher Aaron Siskind changed the photographic look of Chicago in the late 1940s and '50s. Siskind was a thinker well-versed in art and photography, and he tested the boundaries of each. He and Callahan mentored generations of photographers. Their influence is still evident today.

Institute of Design students whose work is included in this book are Michael Abramson, James P. Blair, Barbara Crane, Robert C. Florian, Yasuhiro Ishimoto, James Iska, Joseph D. Jachna, Kenneth Josephson, Lewis Kostiner, Nathan Lerner, Virginia Lockrow, Ray Metzker, Marvin E. Newman, Richard Nickel, Allen Porter, Art Sinsabaugh, Charles Swedlund, and Charles H. Traub. They are joined by Institute of Design teachers Gordon Coster, Wayne Miller, and Frank Sokolik.

Independent photographers have also taken it upon themselves to document the city. The editorial photographers included here are Don Bronstein, Lloyd DeGrane, Stephen Deutch, Yvette Marie Dostatni, Jonas Dovydenas, Ed Evenson, Michele Fitzsimmons, Raeburn Flerlage, Tom Harney, Willming Hugh, Jon Lowenstein, Danny Lyon, Mildred Mead, Robert Natkin, Carlos Javier Ortiz, Antonio Perez, Diane Schmidt, and Art Shay. Architectural photographers

are Harold Allen, Ron Gordon, Ken Hedrich, Marco Lorenzetti, Robert Murphy, and Raymond Trowbridge. Commercial photographers are Marc Hauser, Dave Jordano, George Kufrin, and Sandro Miller. And fine art photographers are Algimantas Kezys, Jay King, Fred Korth, Stephen Marc, Angie McMonigal, Mildred Mead, Ron Seymour, Henry Simon, and Bill Sosin.

In addition, the book includes photographs by outsiders, people who spent only a short time in Chicago but created images of lasting resonance. We used work by prominent photographers who traveled here on assignment: Esther Bubley, Henri Cartier-Bresson, Elliott Erwitt, Walker Evans, Stanley Kubrick, and Clarence John Laughlin. From the famed archives of the Farm Security Administration and the Office of War Information, we used work by Jack Delano, Dorothea Lange, Russell Lee, and John Vachon.

We were born and raised in Chicago. We've grown to see this city as a muse for photographers, artists, and writers. This book gave us a chance to better know the city's most accomplished photographers. We asked them to take a careful look at their work and search for classic Chicago imagery. They sometimes surprised themselves and us.

In addition, we've been able to haunt our favorite places—the Chicago History Museum, the Library of Congress, the Museum of Contemporary Photography, the Newberry, and the Ryerson and Burnham Libraries at the Art Institute of Chicago—in search of classic photographs. And we've been helped by photography dealers and curators Paul Berlanga, Shashi Caudill, Stephen

Daiter, Richard and Ellen Sandor, Liz Siegel, and David Travis. They care about this work as much as we do.

WE HOPE THIS PROJECT will spur Chicagoans to figure out a way to save their city's classic photography. Many photographers have no idea what will become of their work, and there needs to be a place to save it. We intend this book to be a call to action.

In 1921, the journalist Ben Hecht started a column called *A Thousand and One Afternoons in Chicago.* It was his endeavor to find ordinary people and situations that defined the city. We treasure the work, so we have followed his lead by naming each of our chapters with chapter titles from the 1922 book based on the column. "Romance. Adventure. Mystery," Hecht wrote in his first column. "The city is a magic dice box, shaking them out in everlasting new combinations." This book is an attempt to find images in that spirit.

Like Hecht's words, some of these photos are bold and brash; some are simple and nuanced. What they have in common is Chicago. Bridges, beaches, and backyards. As classics, these photos go beyond mere souvenirs. Each looks like Chicago, feels like Chicago, and moves like Chicago—the Chicago we know and the Chicago we once knew.

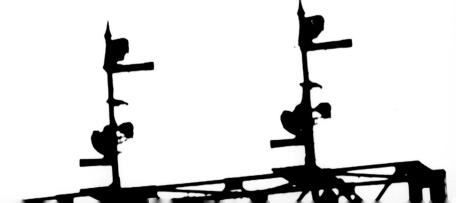

1

THE INDESTRUCTIBLE MASTERPIECE

The intersection of State and Madison Streets in the Loop is where Chicago's North, South, and West Sides meet. And at the center of the capital of the Midwest is where you find America. Where women wore white gloves and hats and men made every effort to look correct. Photographers come for the drama but stay for the light, watching it move through the grid of "L" tracks and around the mountains of skyscrapers. This is prime hunting ground. Here are the throngs.

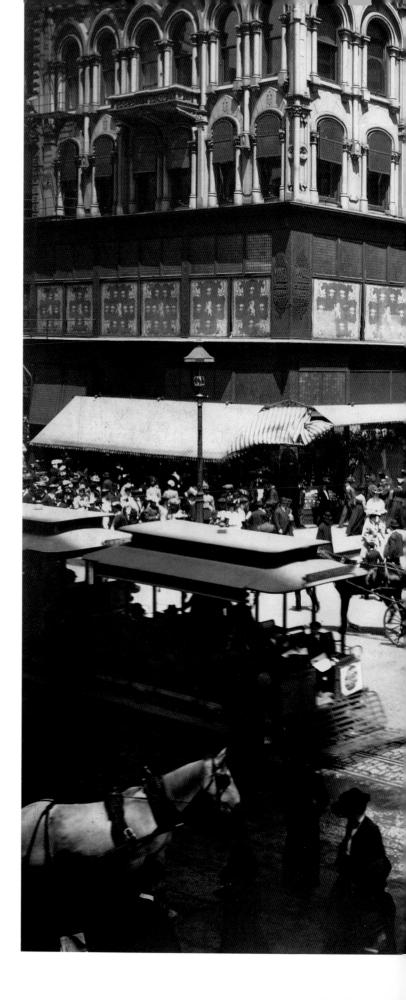

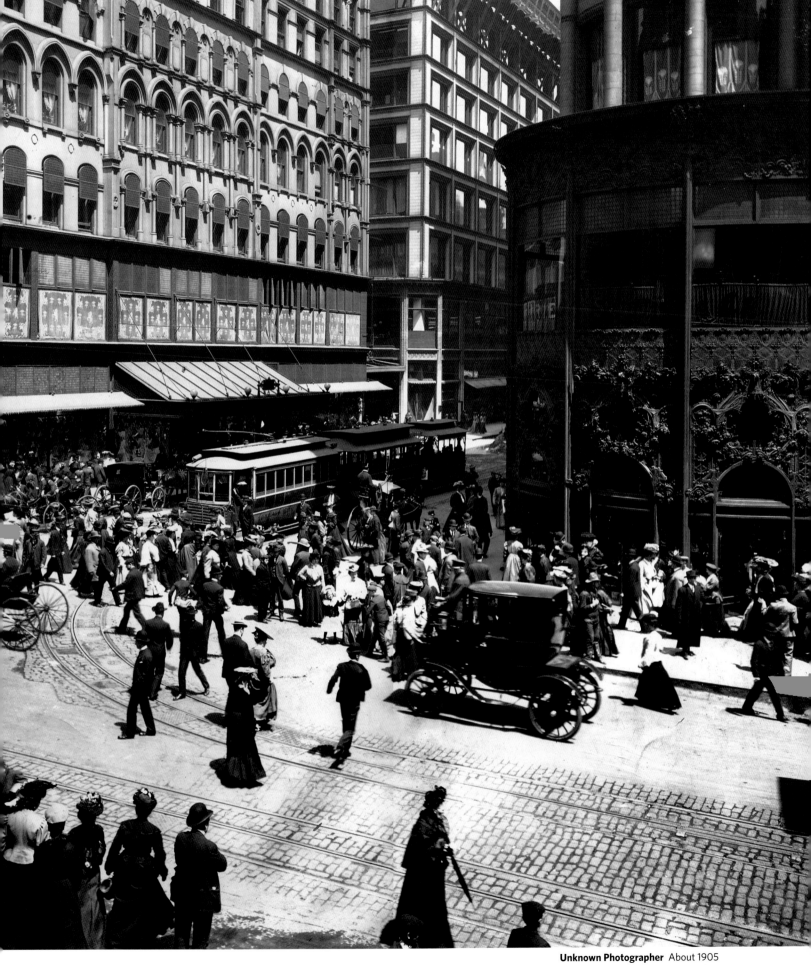

Unknown Photographer About 1905

James P. Blair 1951

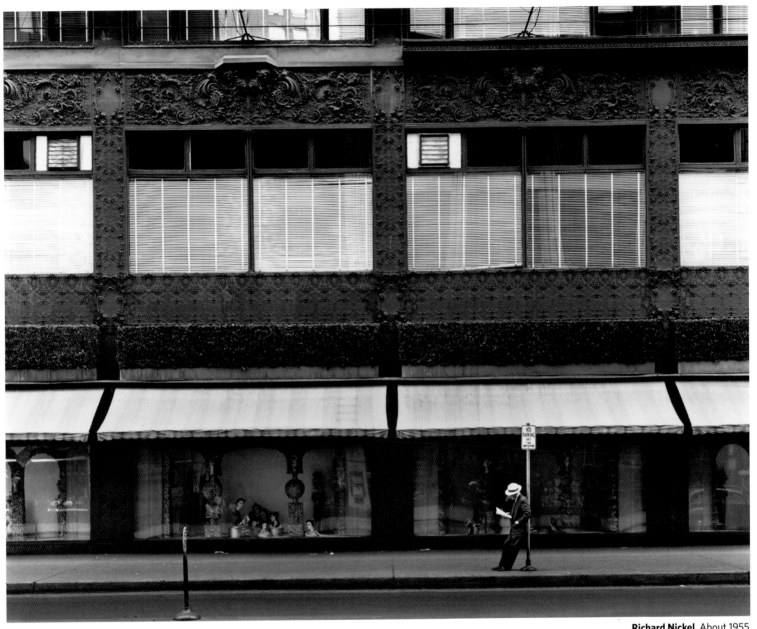

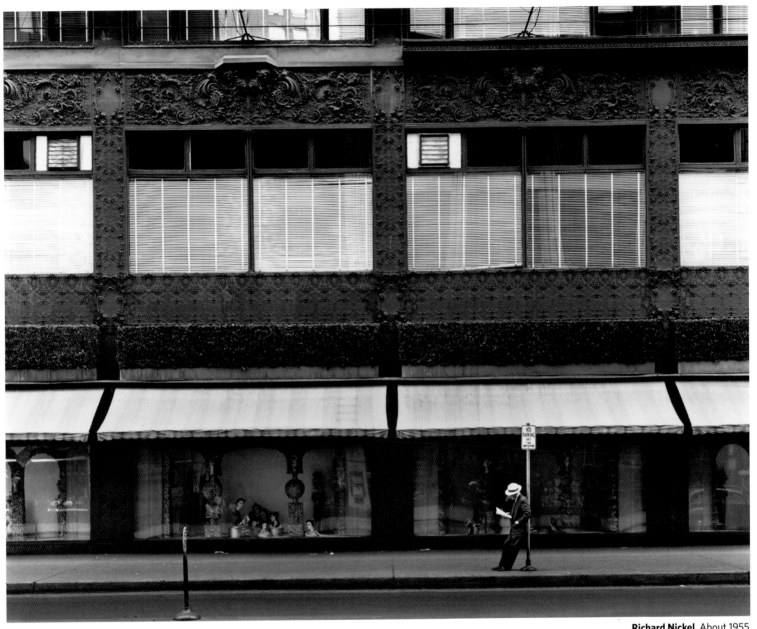**Richard Nickel** About 1955

Downtown life was a focus for students of the Institute of Design. **Above:** Richard Nickel (1928–1972) photographed the Carson's department store on State Street as part of a school documentary project to preserve the work of the architectural firm Adler & Sullivan. "If the Carson Pirie Scott store was erected today, just as [Louis] Sullivan did it in 1902, we would all be amazed," he wrote. **Opposite:** James P. Blair (born 1931) introduced himself to the cabbie and shot one frame. "I remember being very pleased with it, because it was real," he recalled. Blair left Chicago in 1954 after graduating from the institute. He spent more than three decades traveling the world as a *National Geographic* staff photographer. Nickel stayed in Chicago, continuing his architectural photography. He was killed trying to salvage items from Adler & Sullivan's Chicago Stock Exchange Building in 1972.

People wait for a southbound streetcar at the corner of Clark and Van Buren Streets. This was one of thousands of Chicago images taken by photographers with the Farm Security Administration during the 1930s and '40s. John Vachon (1914–1975) was hired as a messenger by the federal agency in 1936 but soon borrowed a camera and hit the streets. He was taught by Ben Shahn, Walker Evans, and Arthur Rothstein, FSA staffers who were among the foremost photographers of the twentieth century. Vachon photographed Chicago during the summers of 1940 and 1941. He went on to a long career as a photographer for *Look* and *Life* magazines.

Next spread: Commuters bathed in sunlight walk past the LaSalle Street Station near LaSalle and Van Buren Streets.

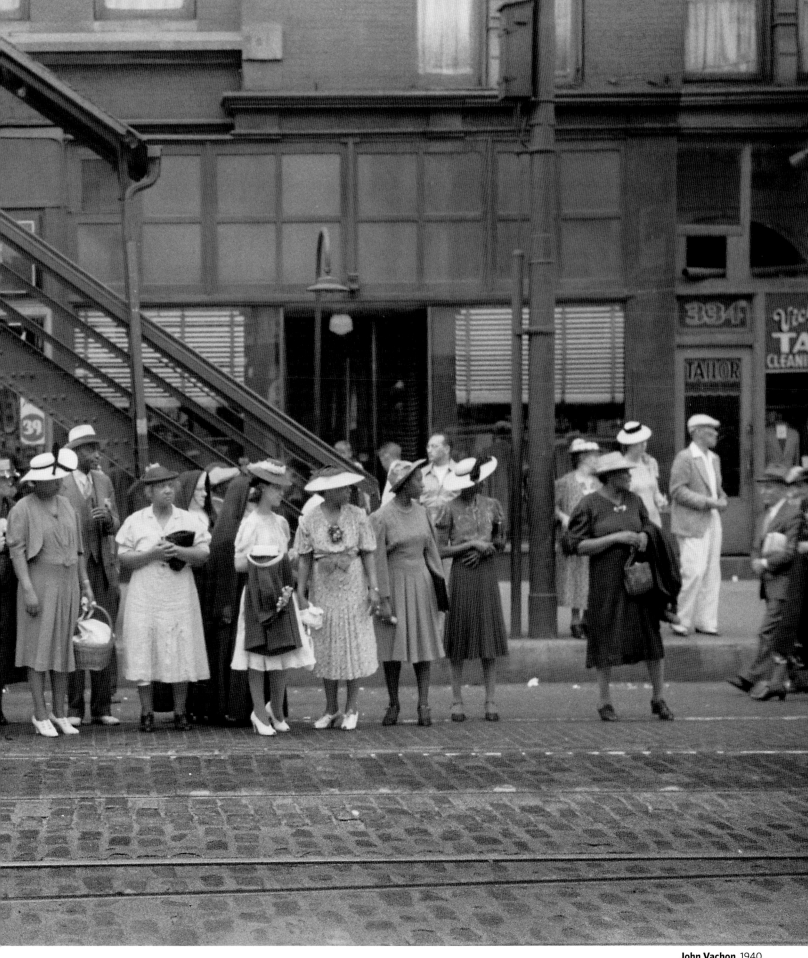

John Vachon 1940

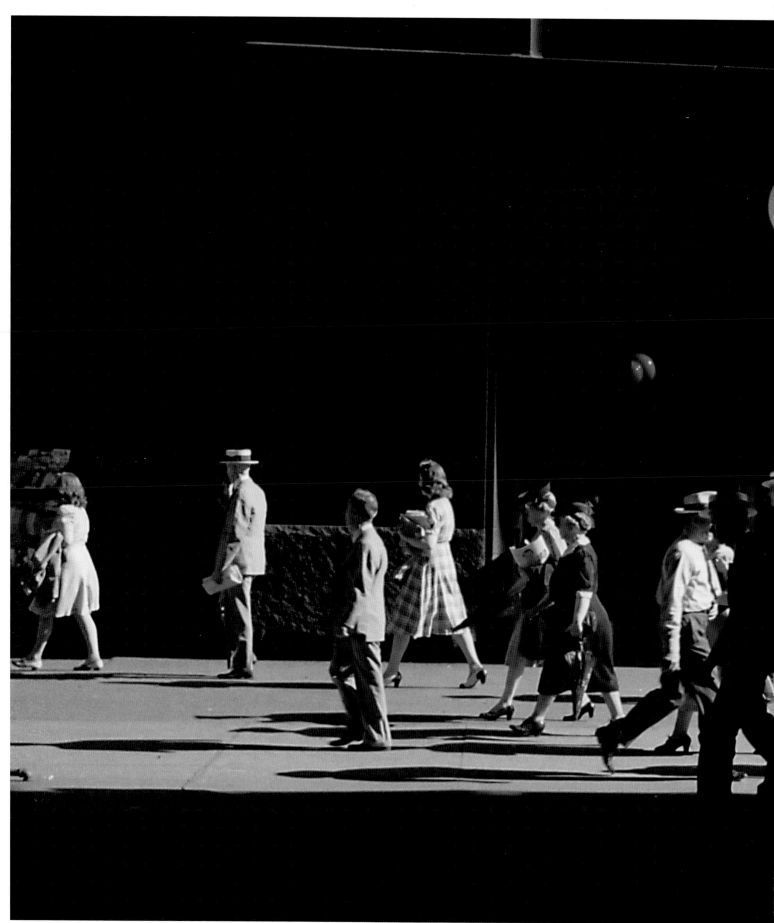

John Vachon 1941

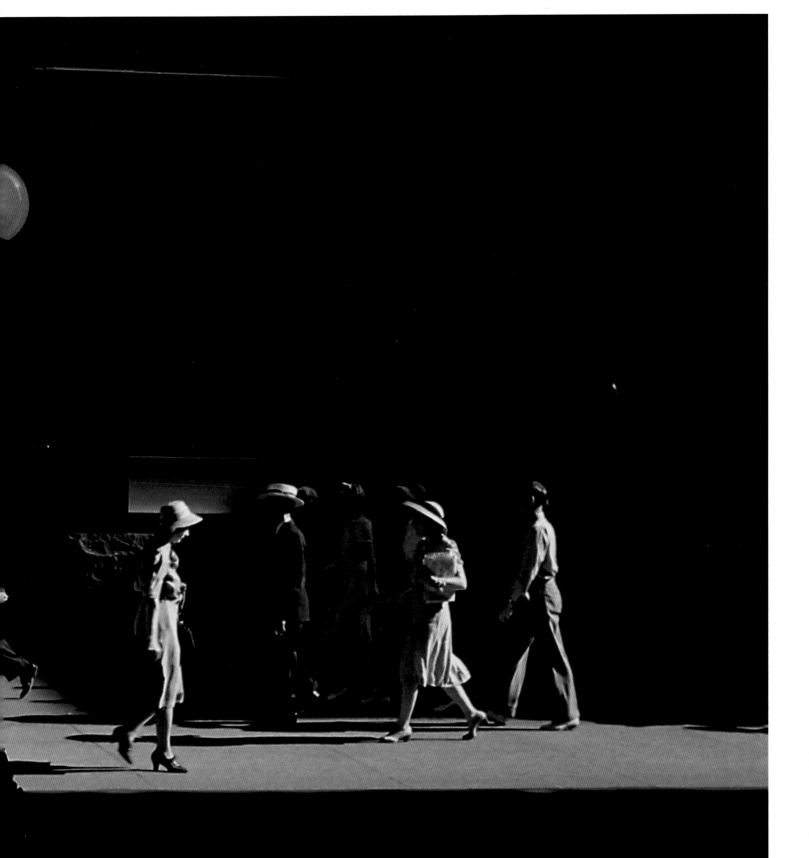

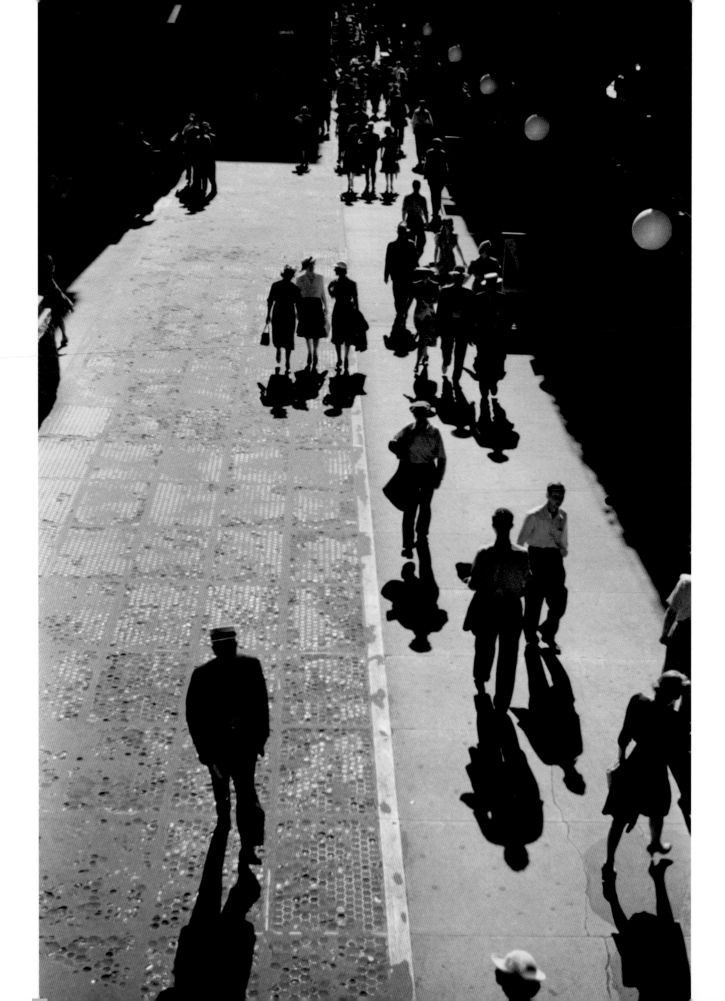

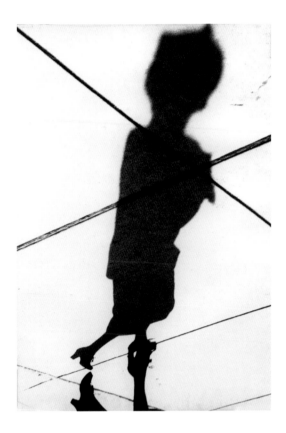

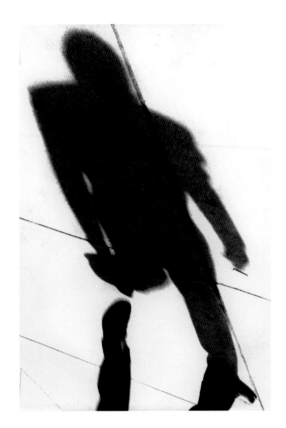

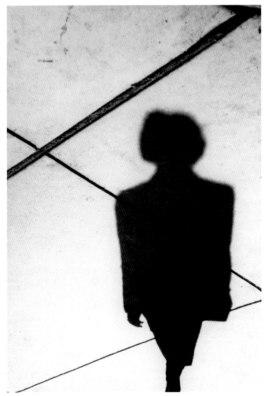

Marvin E. Newman 1951

Shadows. **Above:** As an Institute of Design student, Marvin E. Newman (born 1927) undertook a photo series of Michigan Avenue walkers. "It had to be done in the winter," he recalled. "The sun had to be low to cast that long shadow." The photographs were shot to work together. "When you make a series, the individual photos become more meaningful," he wrote. "I wanted to do things in photography that hadn't been done before." Born and raised in New York City, Newman lived in Chicago for four years. He returned to New York in 1954 to work for *Sports Illustrated* for the next sixteen years. **Opposite:** John Vachon's shadows near the LaSalle Street Station.

◁ **John Vachon** 1941

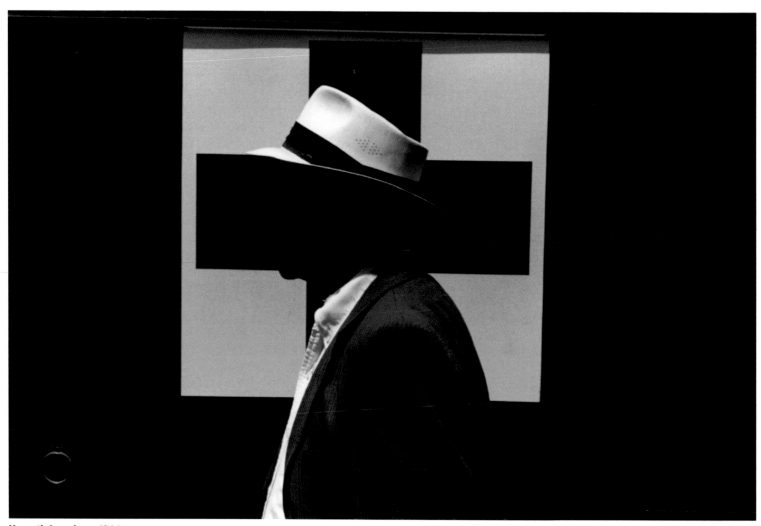

Kenneth Josephson 1964

The big parade. **Above:** Kenneth Josephson (born 1932) captured a man walking in front of a Red Cross truck at a parade. Josephson said he was attracted to the cross ("such a strong symbol") and waited to see relationships: "I had no idea when I printed it that the brim of his hat fit so perfectly. That was a real gift." **Opposite:** Scott Strazzante (born 1964) often photographed during the lunch hour in the plaza of the Richard J. Daley Center. "Until then, I seldom shot on the street because it seemed strange, creepy, and odd—almost voyeuristic, like I was doing something wrong," said Strazzante, a photojournalist who in 2001 was named National Newspaper Photographer of the Year. In 2011, he started using his camera phone, attracted by the serendipity. "I was searching for the pure photograph."

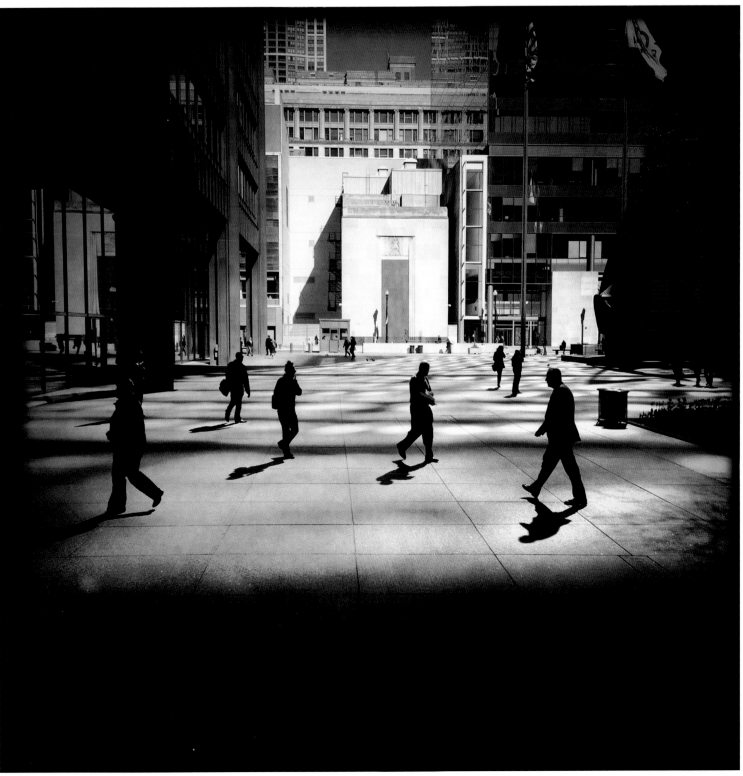

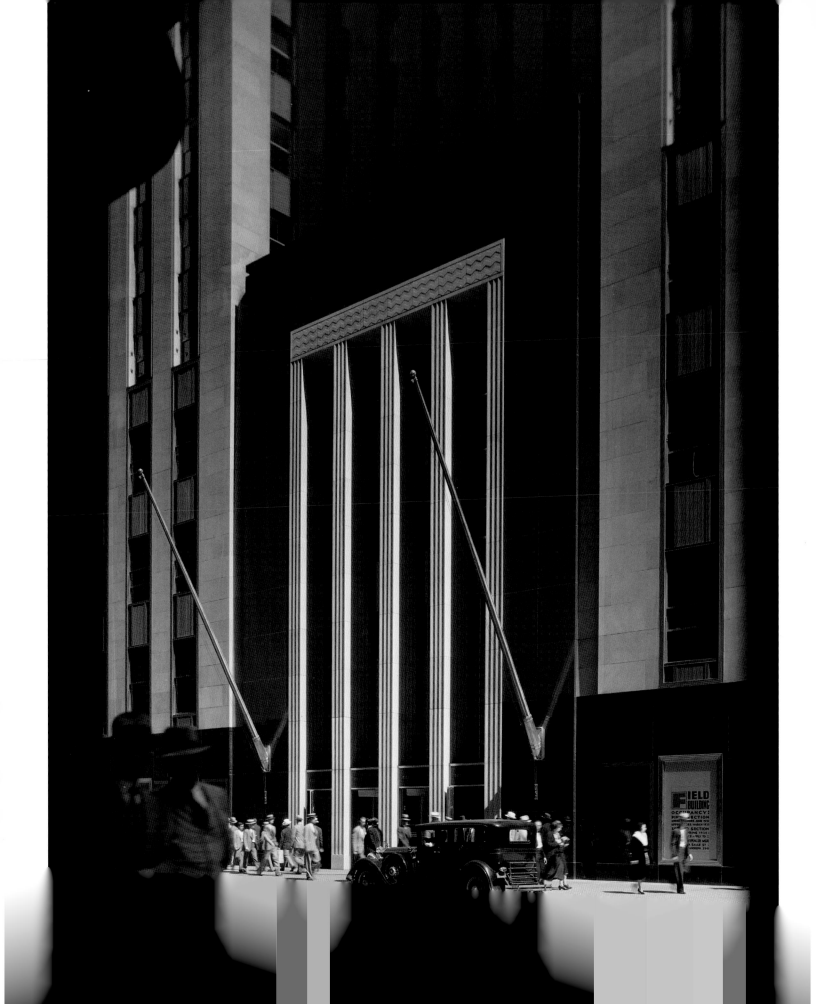

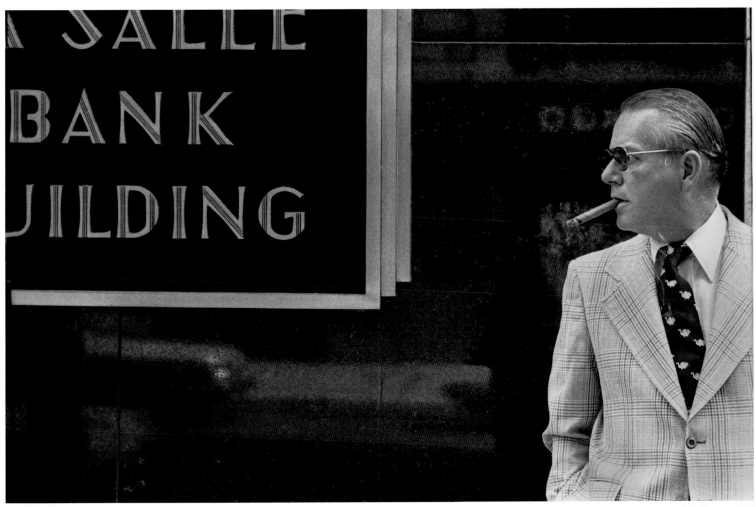

Eric Futran 1976

Money talks. **Opposite:** The Field Building, at 135 South LaSalle Street, when it opened during the depth of the Depression. Ken Hedrich (1908–1972) cofounded the architectural photography firm of Hedrich-Blessing in 1929. Hedrich was a stickler who refused to shoot skyscrapers until each window shade was pulled into its proper place. The firm became known for its dramatic and atmospheric work. "Instead of recording a mere image, you have etched in film the elements of architectural personality," Hedrich said. **Above:** Forty years later, Eric Futran (born 1948) returned to the Field, renamed the LaSalle Bank Building, for a *Chicago Reader* photo essay on the financial district. Futran was captivated by the man's suit and cigar: "He looked incredibly confident."

◁ **Ken Hedrich/Hedrich-Blessing/Chicago History Museum** About 1934

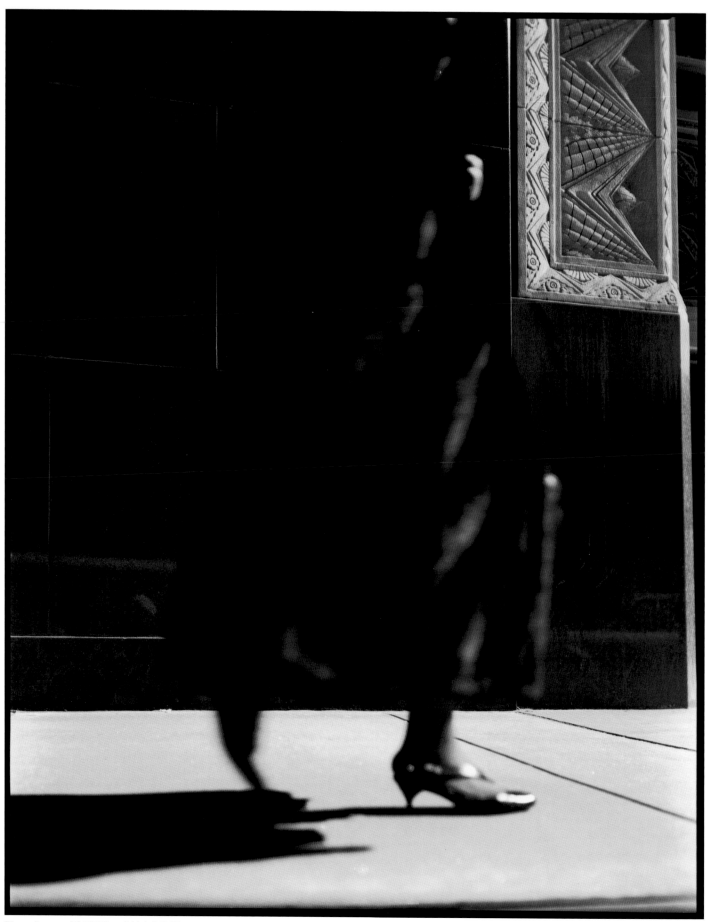

Marco Lorenzetti 2000 and (right) 1990

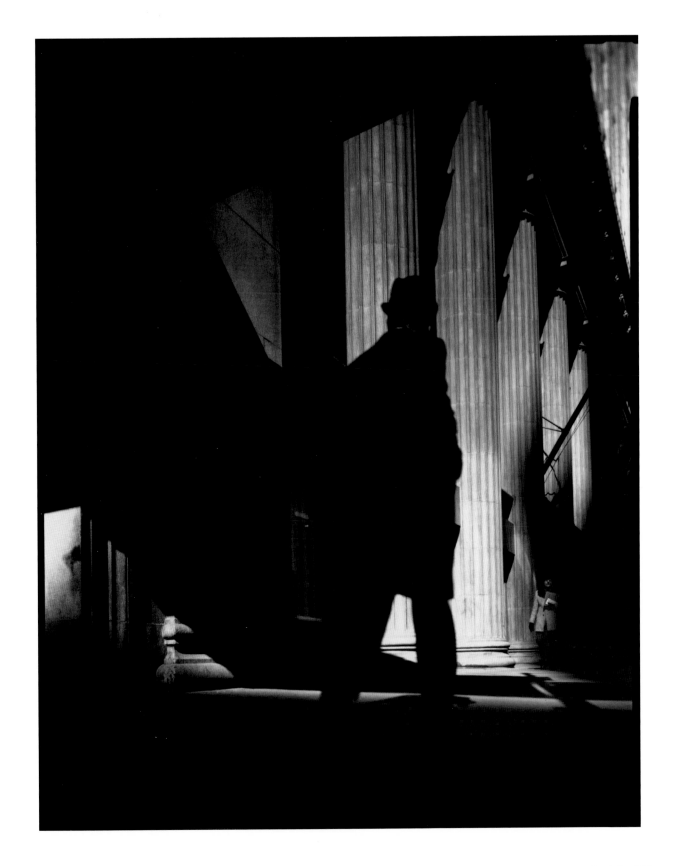

For more than a decade, Marco Lorenzetti (born 1964) took pictures in the canyon-like stretch of LaSalle Street north of the Chicago Board of Trade Building. Lying on the ground beneath a dark cloth and looking through the lens of his giant Deardorff view camera, Lorenzetti created quite a scene in the financial district. "I was drawn by the amazing light and history of the street," he said.

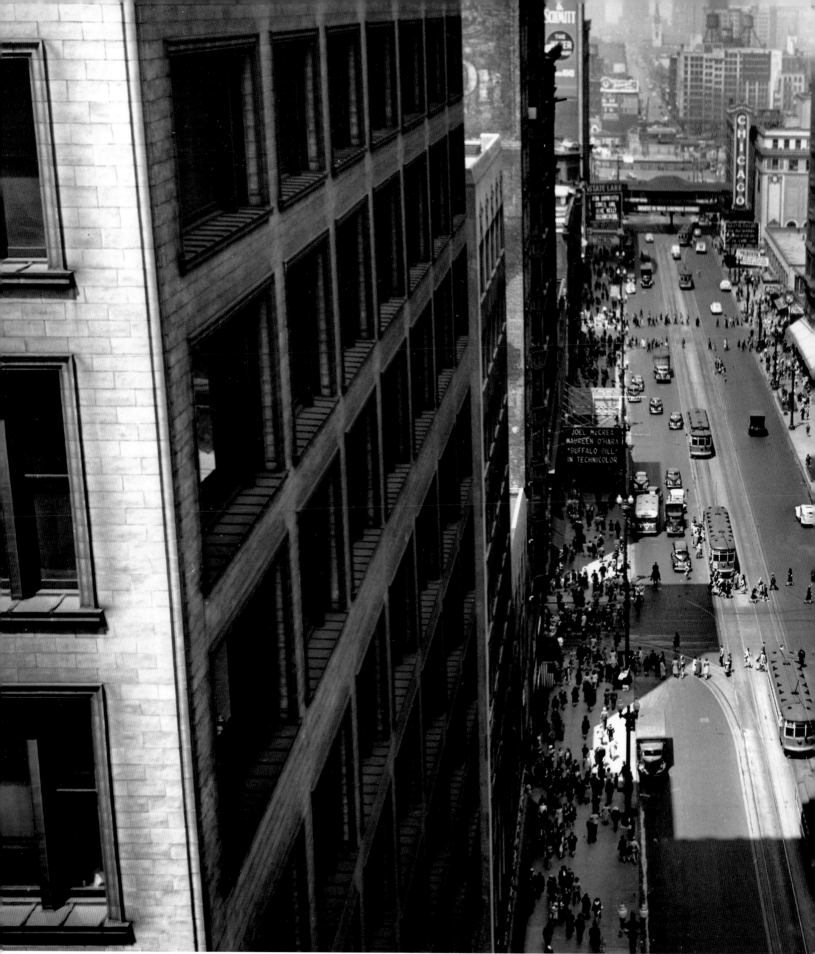

Gordon Coster 1944

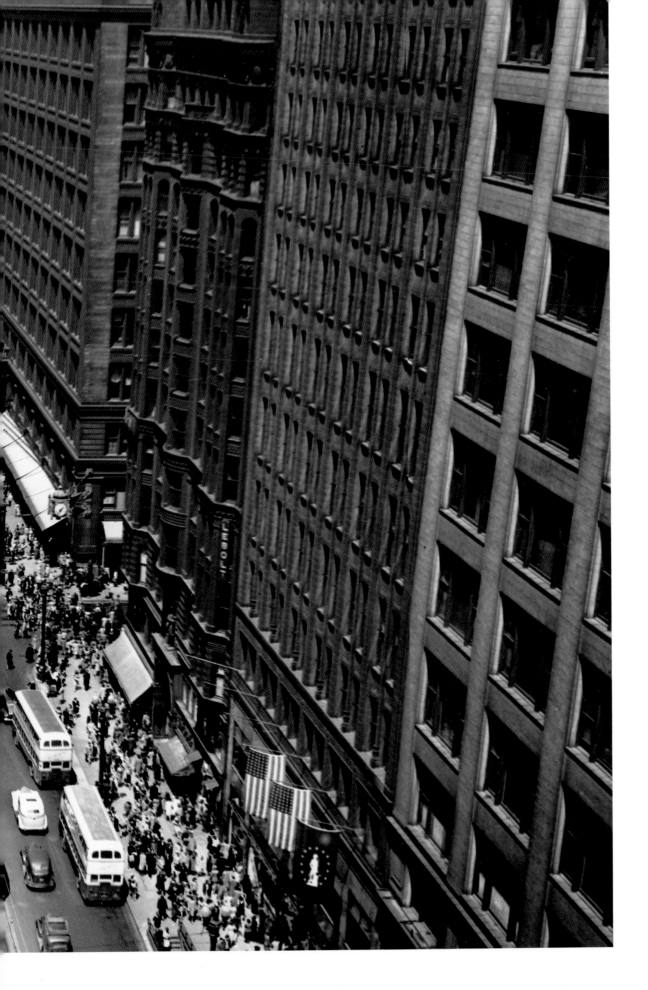

Looking north on State Street from Madison Street. Gordon Coster (1906–1988) was born in Baltimore, worked in New York, and arrived in Chicago just before the Century of Progress Exposition opened in 1933. He soon established a reputation as an innovative commercial photographer and later worked as an editorial photographer for *Life* magazine. "*Life* offered him a staff position, but he refused it because he didn't want to give up his independence," said his son, Peter Coster. He used that independence to document his adopted city. Said Peter: "Photography and Chicago were his loves."

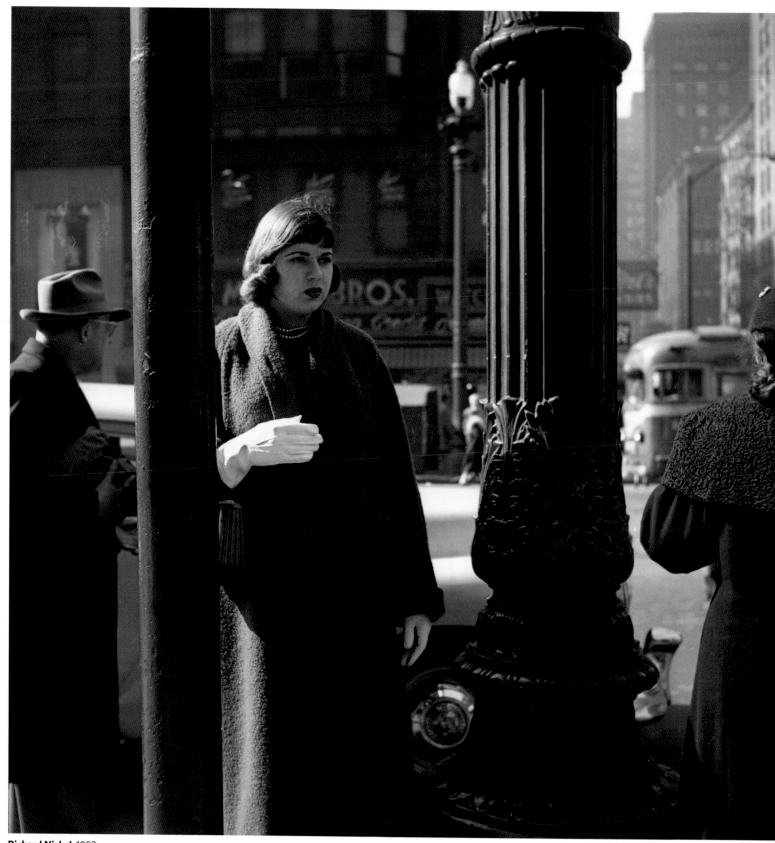

Richard Nickel 1953

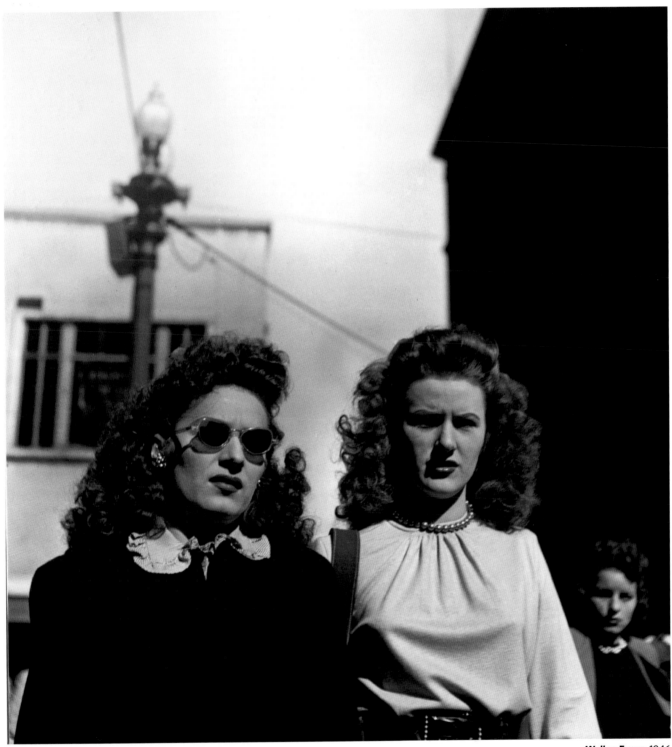

Walker Evans** 1946

At the corner of State and Randolph Streets. **Above:** Walker Evans (1903–1975) took hundreds of street photographs in 1946 to produce "Chicago: A Camera Exploration" for *Fortune* magazine. Evans, described by editors as "the most freewheeling member of the *Fortune* staff," worked there for two decades. He wrote: "Stare, pry, listen, eavesdrop. Die knowing something. You are not here long." **Opposite:** Richard Nickel returned to the same intersection for a class assignment.

Next spread: For that assignment, Nickel spent an afternoon photographing women in front of the State Street department store Marshall Field's, focusing on "their masks—furs, jewelry, makeup, and hats."

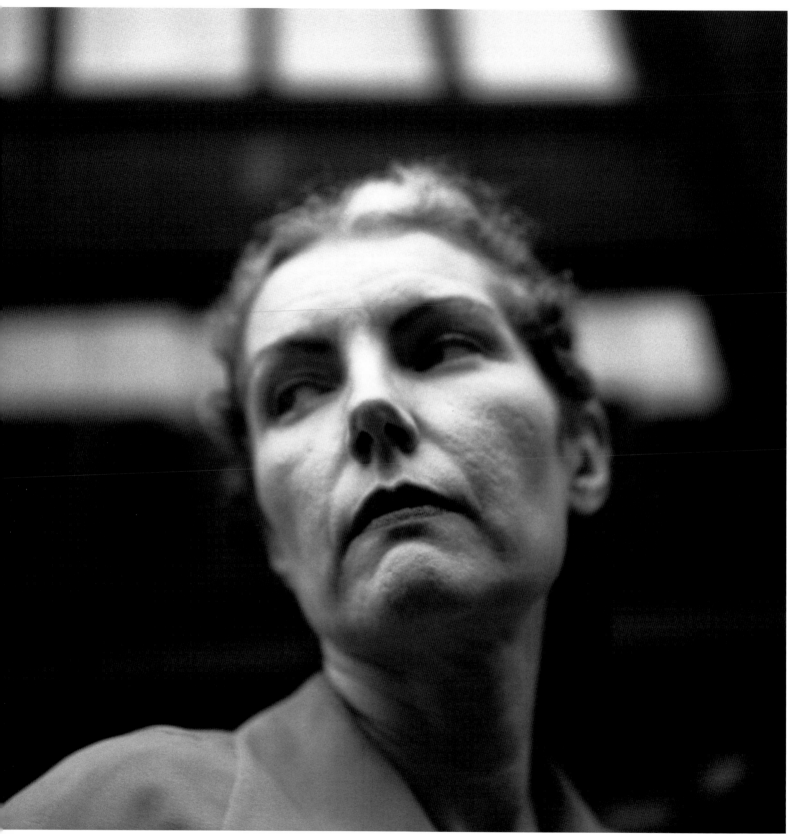

Richard Nickel 1953

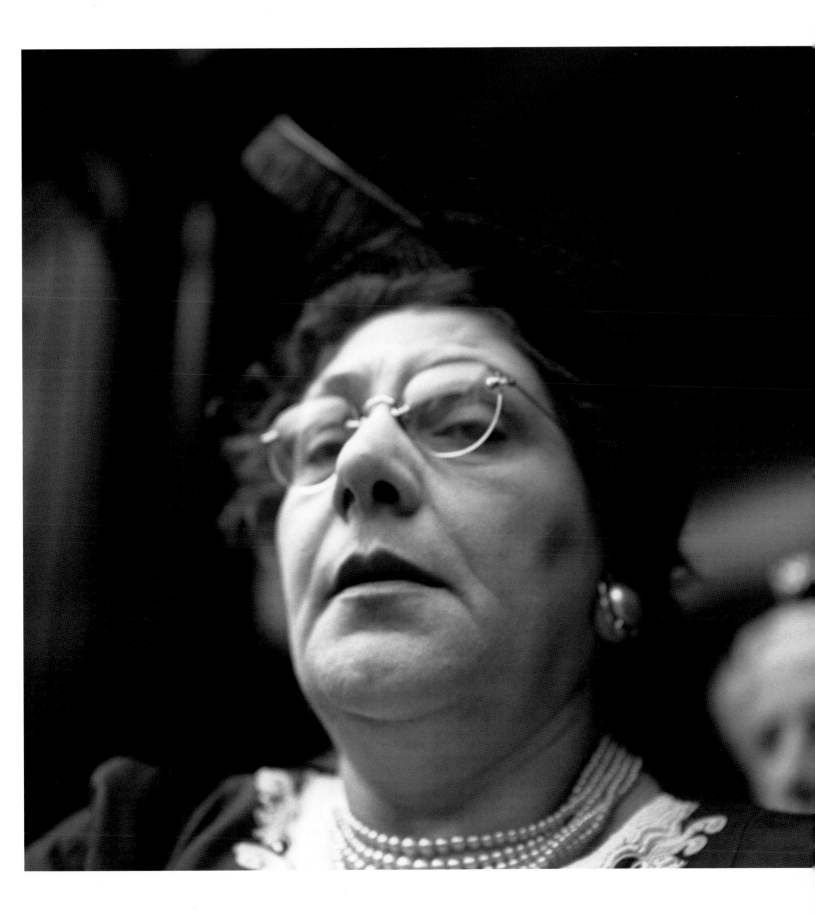

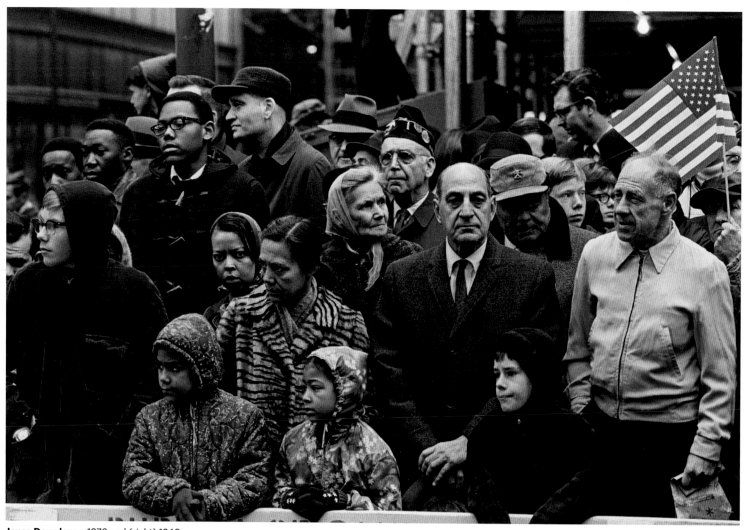

Jonas Dovydenas 1970 and (right) 1968

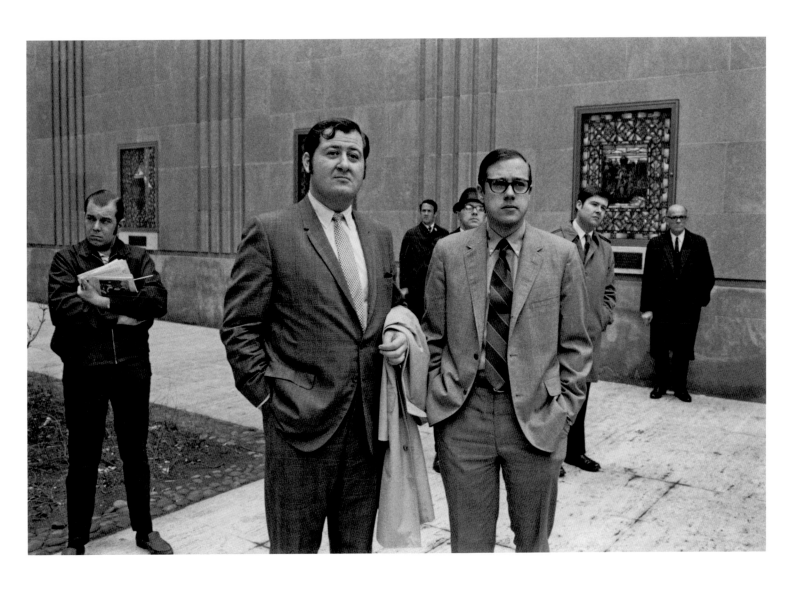

The passing scene. **Above:** Men watch a feminist rally at nearby Daley Plaza. Jonas Dovydenas (born 1939) arrived in the United States in 1949 from Lithuania and moved to Chicago in 1965 to take photography classes at the Institute of Design. He called this photograph "Bystanders." **Opposite:** The Veterans Day parade of 1968. Dovydenas found parades a perfect subject. "You could walk down the street with a camera and nobody paid any attention," he said. "This is a group portrait, but see how many individual portraits are here." Dovydenas left Chicago in 1981 for the East Coast and has spent more than two decades documenting war and peace in Afghanistan.

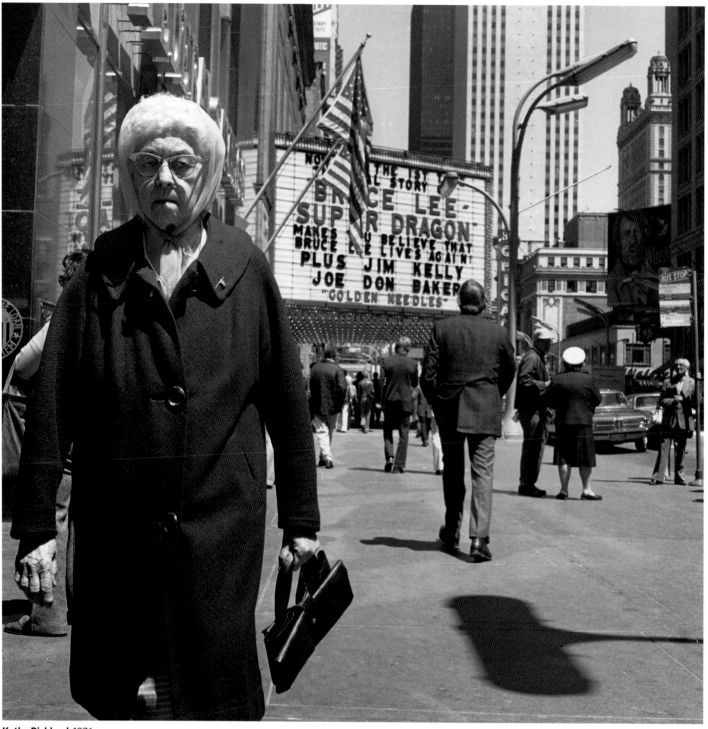

Kathy Richland 1976

Curbs and sidewalks. **Above:** Kathy Richland (born 1948) opened a business photographing children and families in the 1970s before becoming a newspaper photographer and turning her camera on the city. "I gave myself an assignment to shoot at the end of the day, when the light was contrasty," she said. "I wanted to get the rhythm of the street." This photo was taken for a magazine, but most of Richland's work was for the *Chicago Reader*. **Opposite:** Art Shay (born 1922), who moved to Chicago from New York City in the late 1940s, always carried a camera. "My take was that this woman was staring at death. Perhaps she was looking at herself."

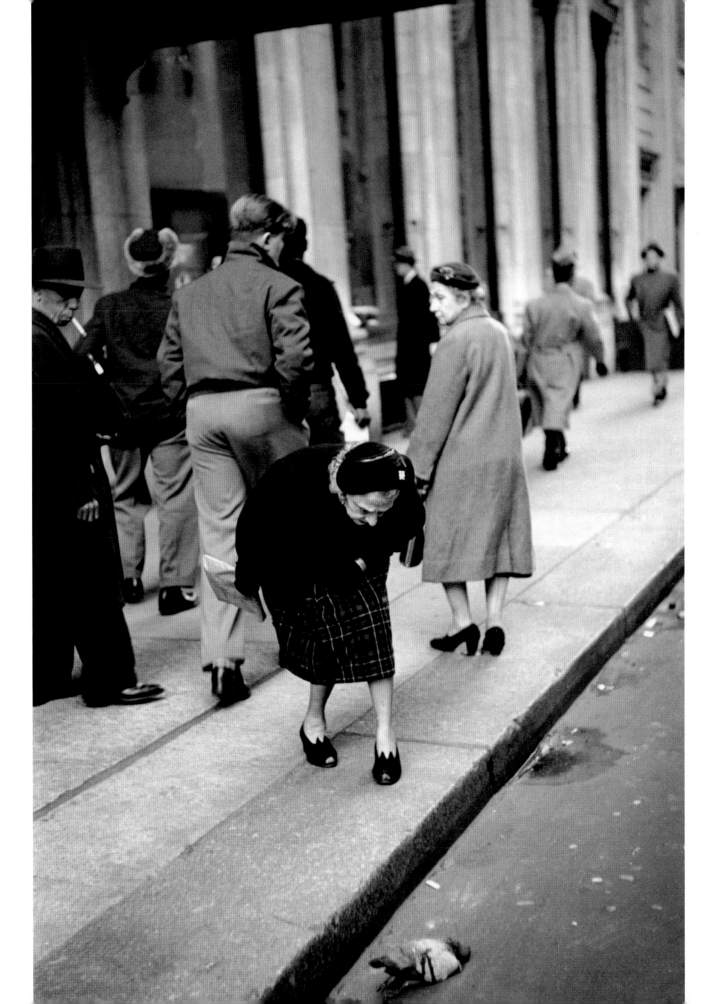

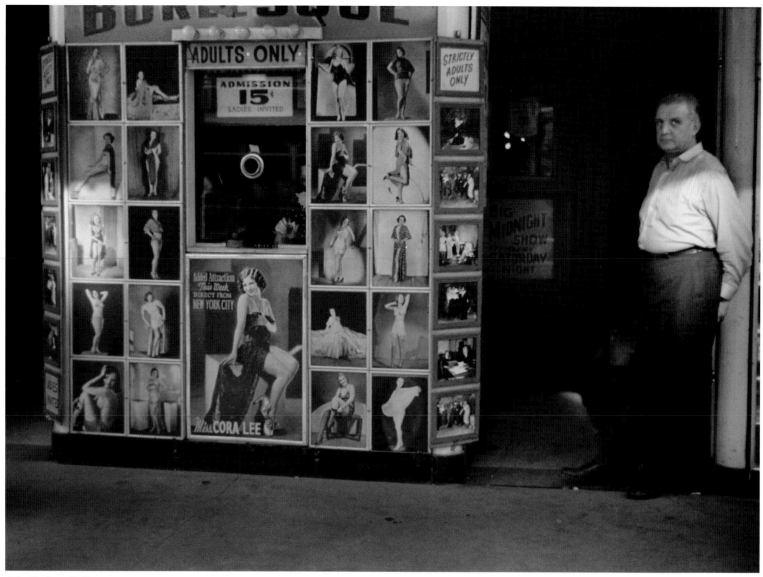

John Vachon 1941

Chicago was as well known for its South Side burlesque houses—the Rialto, Gem, Wonderland, Folly, State-Harrison, and others—as it was for its skyscrapers. **Above:** A South State Street strip club. **Opposite:** Art Shay recalled a South Loop theater: "What I remember: the smell of popcorn and cheap perfume."

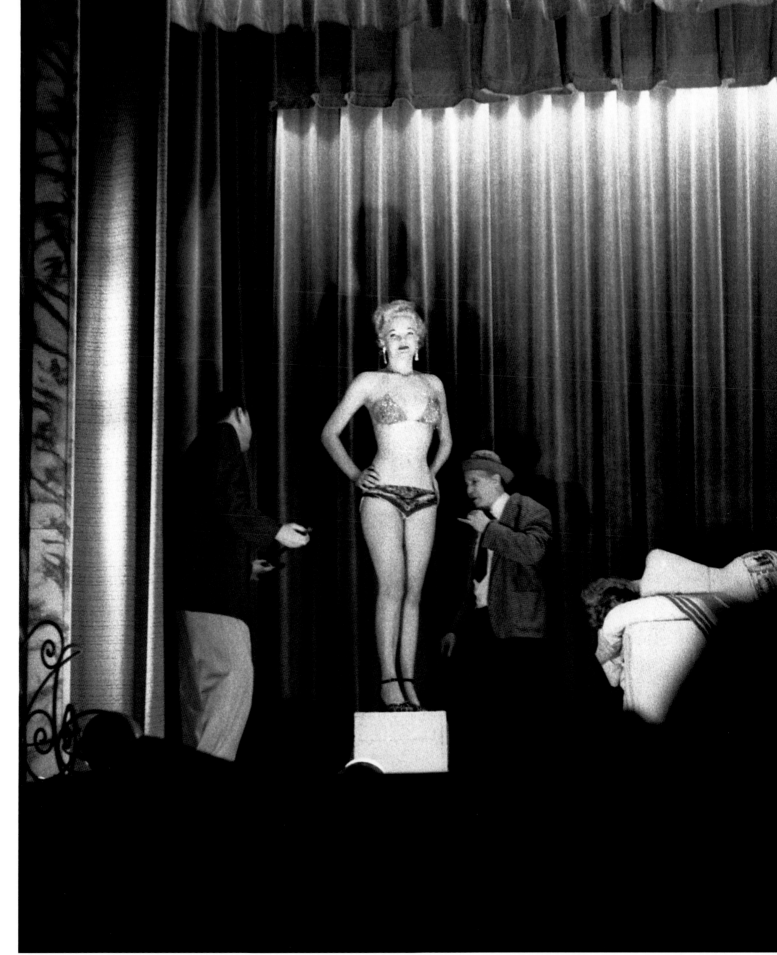

Art Shay 1950s

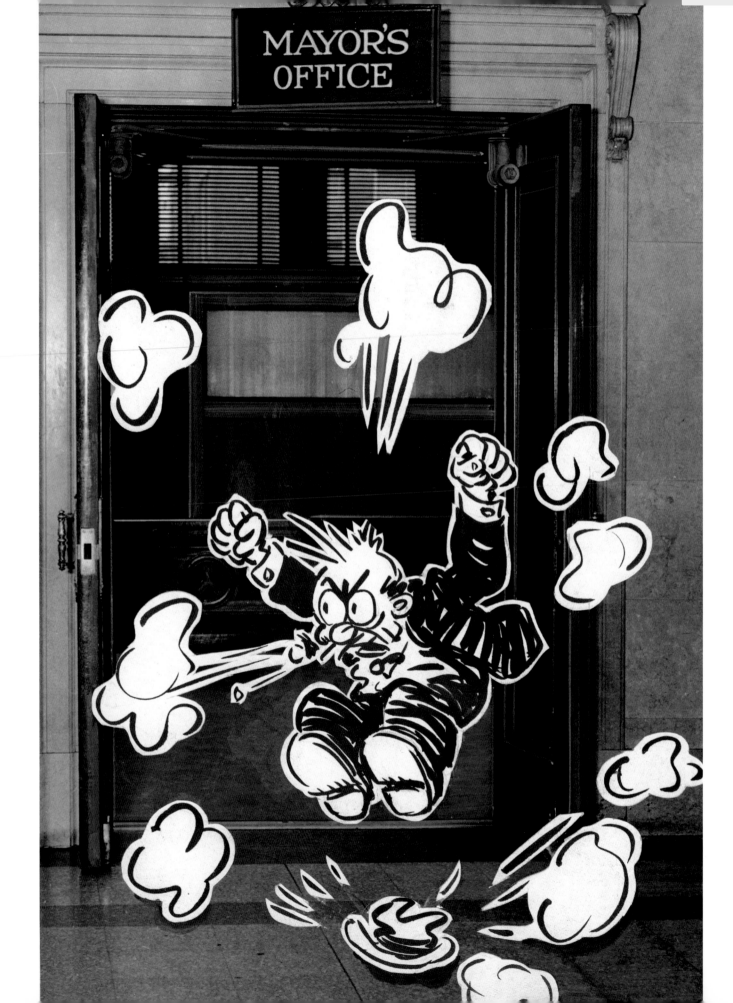

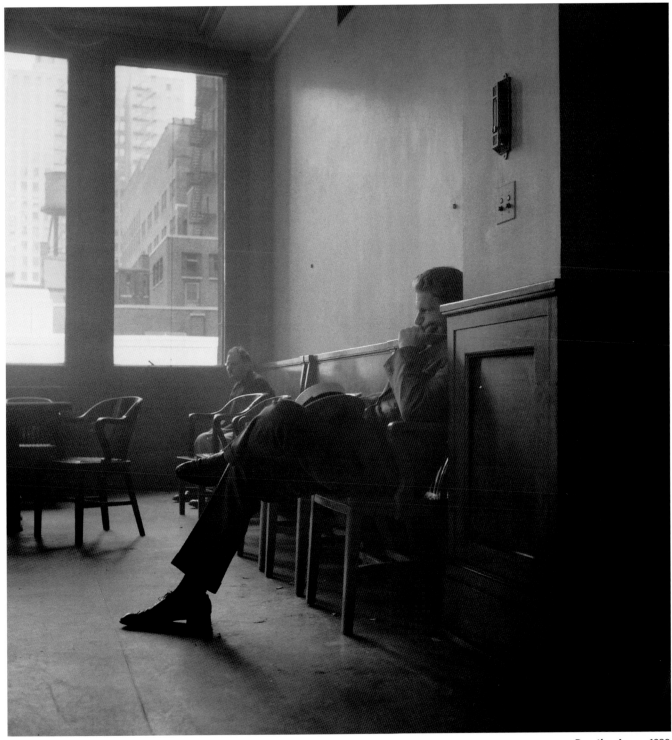

Dorothea Lange 1939

How to portray City Hall. **Above:** Dorothea Lange (1895–1965), who won fame in the 1930s for her portrayal of migrants heading west, came to Chicago only once during her years as a photographer with the Farm Security Administration. She photographed lonely spectators at a committee meeting of the city's Board of Aldermen. **Opposite:** *Chicago Daily News* cartoonist Vaughn Shoemaker (1902–1991) made this photo illustration to show the feelings of John Q. Public, a character he created to represent the average American beset by high taxes and incompetent public officials. Shoemaker often added the cartoon character to photographs.

◁ **Vaughn Shoemaker/Chicago Daily News** 1943

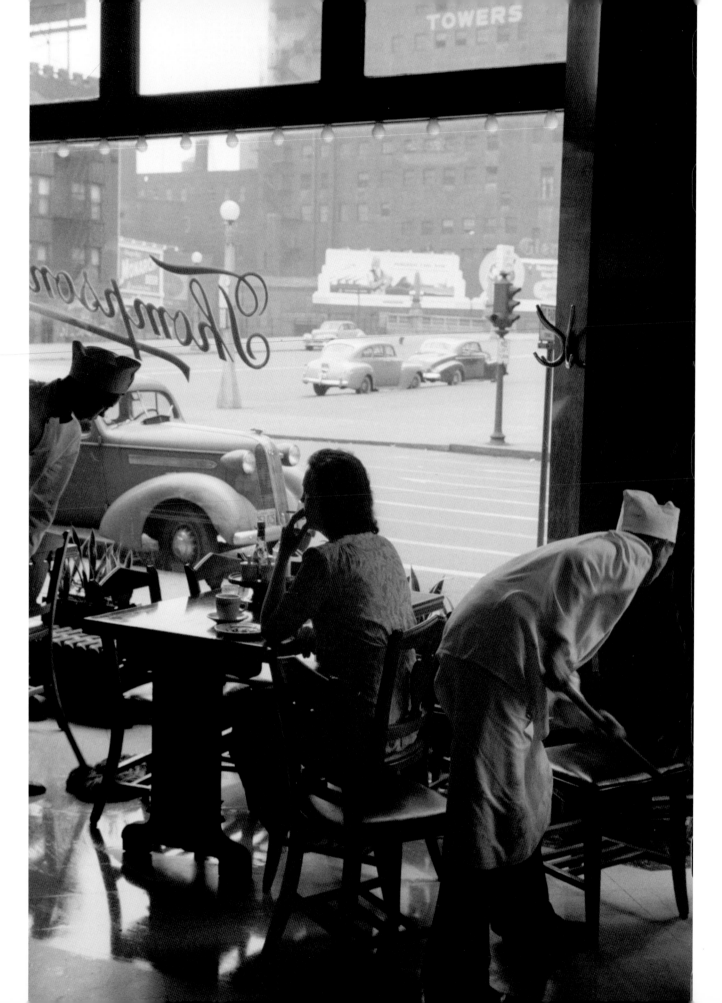

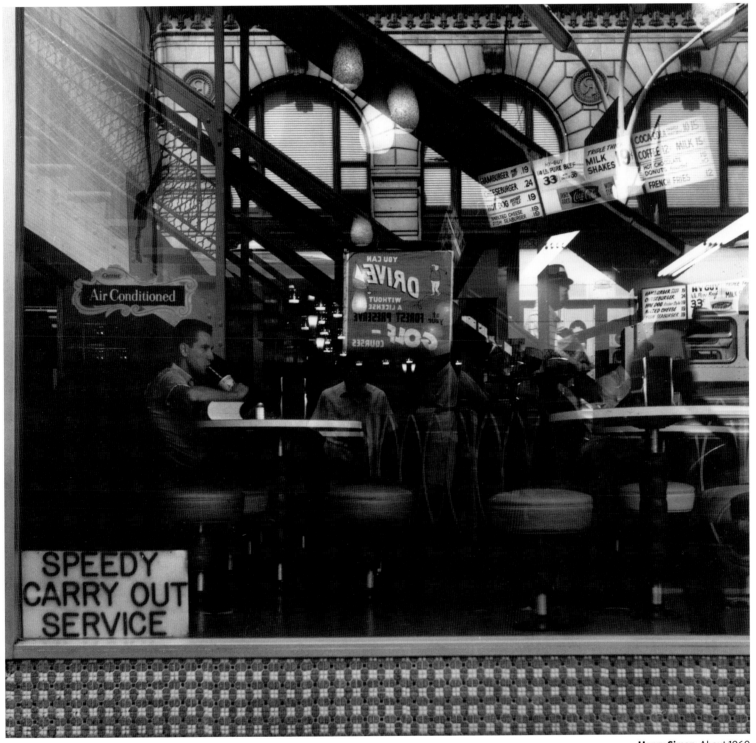

Henry Simon About 1960

Café life. **Above:** Henry Simon (1901–1995), a painter, printer, lithographer, and sign maker, turned to photography later in life. He first used the camera in the 1950s to document the electric signs he was making, then took to the street. "I looked for store window reflections caused by mannequins in the windows or by people outside, or for merchandise creating abstract patterns," he said. **Opposite:** Thompson's, a popular restaurant chain. John Vachon was sent to Chicago by the federal government to photograph the stockyards, but gaining access was difficult. "It's a swell town to wait in," Vachon wrote. "Of course I've been shooting my Leica off every day as I tramped around, so the taxpayers are getting something for their dough."

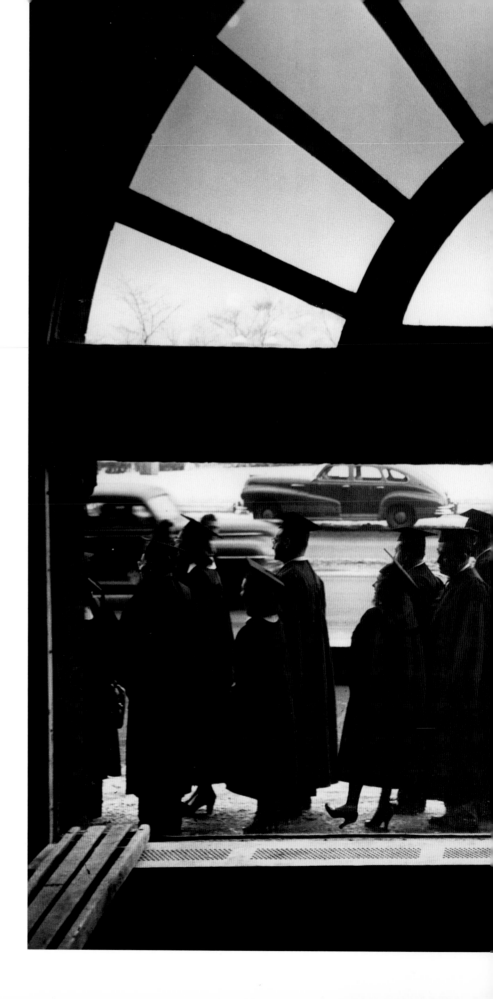

Graduates file past Roosevelt College for commencement ceremonies at the nearby Studebaker Theater. Now known as Roosevelt University, the school purchased its Auditorium Building home at 430 South Michigan Avenue for $1 and back taxes, according to lore. Joe Kordick (1916–1974) graduated from Lane Tech High School and entered the world of newspapers, working for more than forty years for the *Chicago Herald-Examiner, Chicago Sun, Chicago Times,* and *Chicago Sun-Times.*

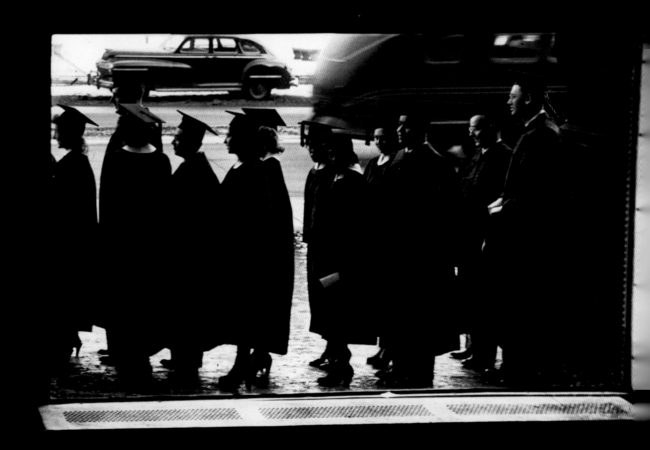

Joe Kordick/**Chicago Sun-Times** 1948

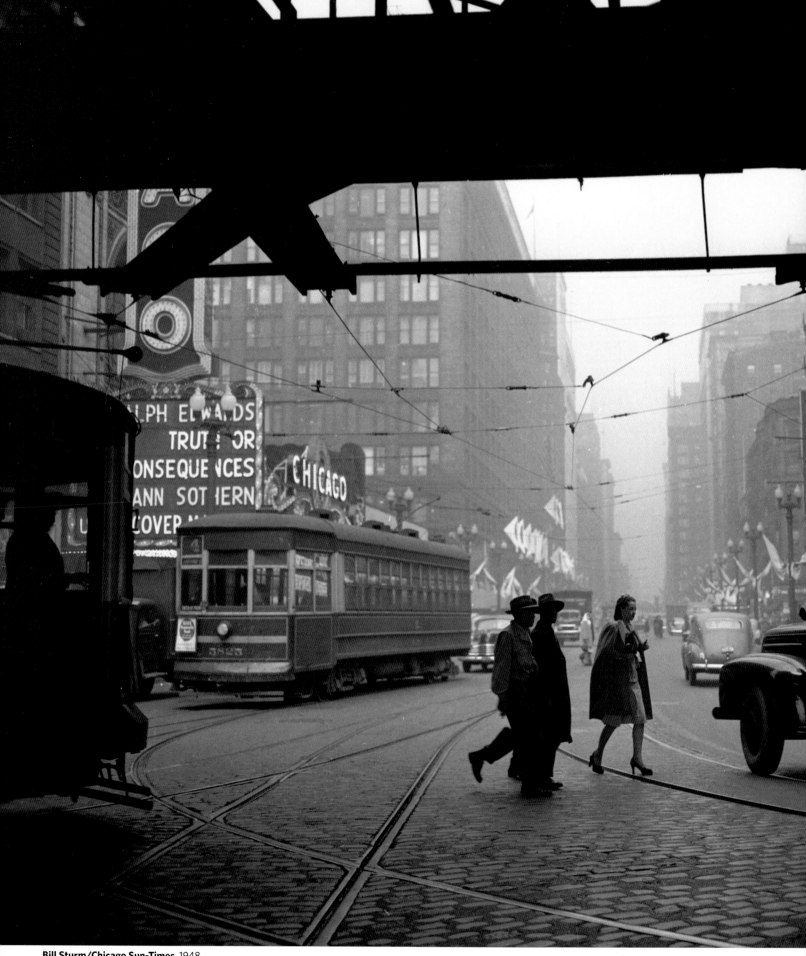

Bill Sturm/Chicago Sun-Times 1948

Richard Nickel 1950s

Under the "L." **Above:** Richard Nickel's teachers at the Institute of Design stressed the importance of photographing people. "I came to the conclusion that the most absolute significant thing was people," he said, "and so decided on close-ups with backgrounds out of focus." **Opposite:** Bill Sturm (1900–1973) labeled this picture "The Loop During a Dull Day." His view was looking north from the corner of State and Lake Streets. From the age of sixteen to sixty-four, Strum worked as a newspaper photographer. He started in Baltimore and Washington, D.C., and moved to Chicago to work for the *Herald-Examiner* and later for the *Sun* and *Sun-Times.*

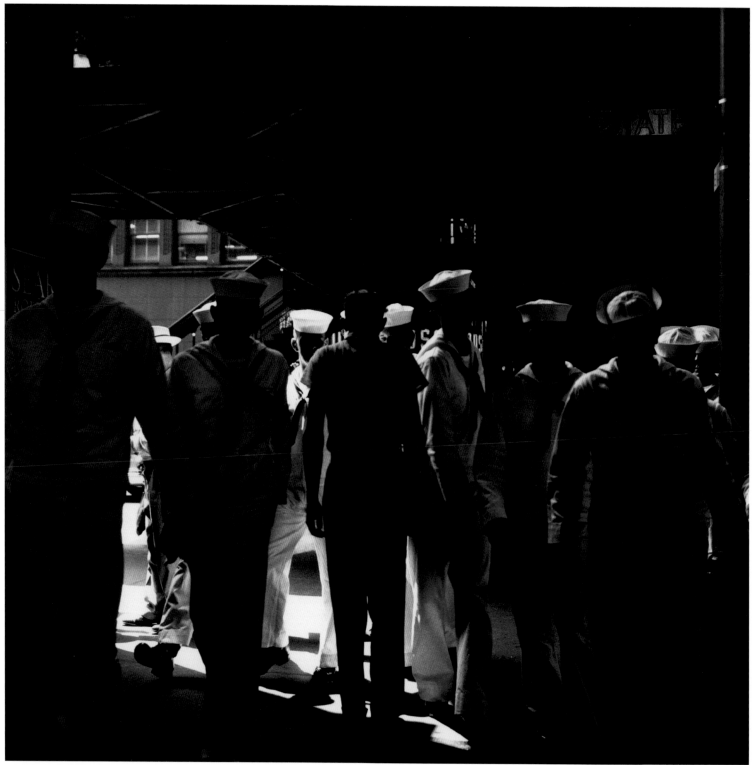

Ray Metzker 1958

Loop light. **Above:** "My Camera and I in the Loop" was the title Ray Metzker (1931–2014) gave his Institute of Design thesis. "I would see those relationships developing, and I would feel something fall into place," wrote Metzger, whose work was exhibited nationally. **Opposite:** John Vachon's notes on his work in Chicago: "Also much Leica work of crowds on street, heavy traffic on boulevards, people going up El steps."

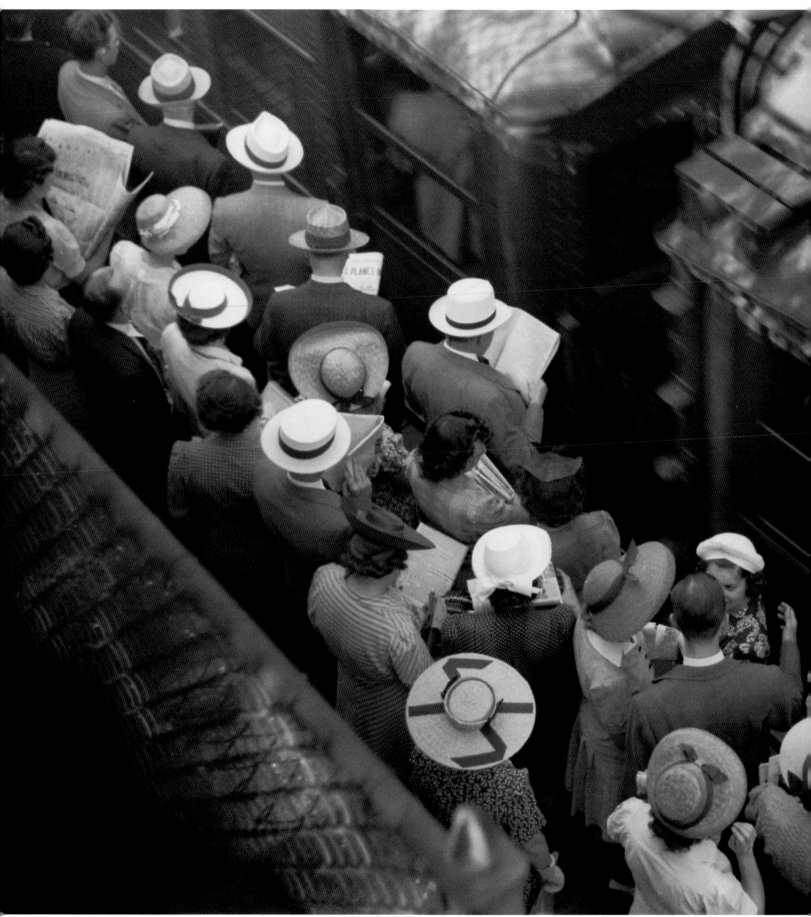

John Vachon 1941

2

THE GREAT TRAVELER

Commuters huddle for a southbound train. For Chicagoans, train cars, buses, and automobiles are a moving stage—a place for photographers to capture a city on the move. Little do travelers know they serve as models as they wait for buses, sit on trains, or just walk across the street. Exasperated, quiet, patient. Lost in a world of their own, or part of a surging sea. Thinking they are constantly moving, they are now trapped in time, forever motionless.

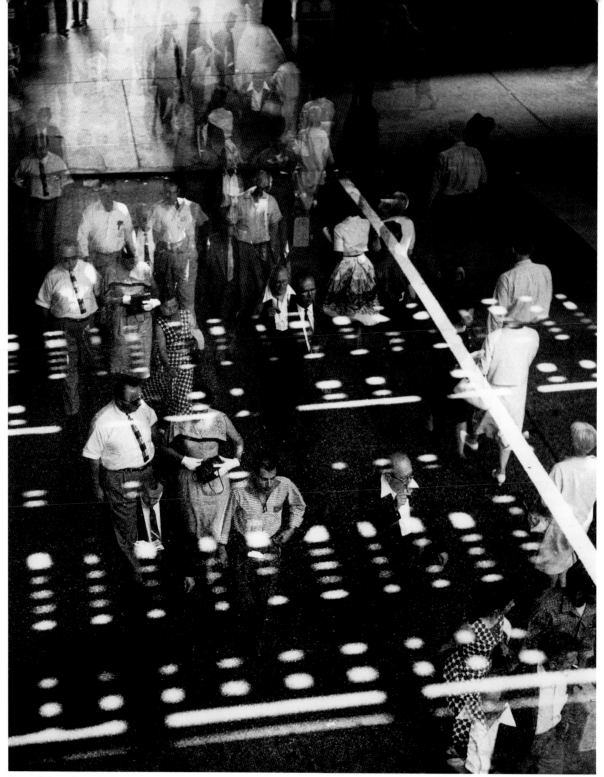

Kenneth Josephson 1961

Angles of repose. **Above:** Beams of light shine onto the intersection beneath the "L" station at Adams Street and Wabash Avenue. "On a very clear day they were intense," said Kenneth Josephson, who is considered one of the world's first conceptual photographers. "People were waiting for the traffic light to change, and it looked like a stage setting. Chance played such a great role in this image." **Opposite:** Jay King (born 1944) also shot from an "L" platform. "I think it's Belmont, but I'm not positive," he said. "Guess I should have kept a diary of where I went and when, but I never thought that far ahead."

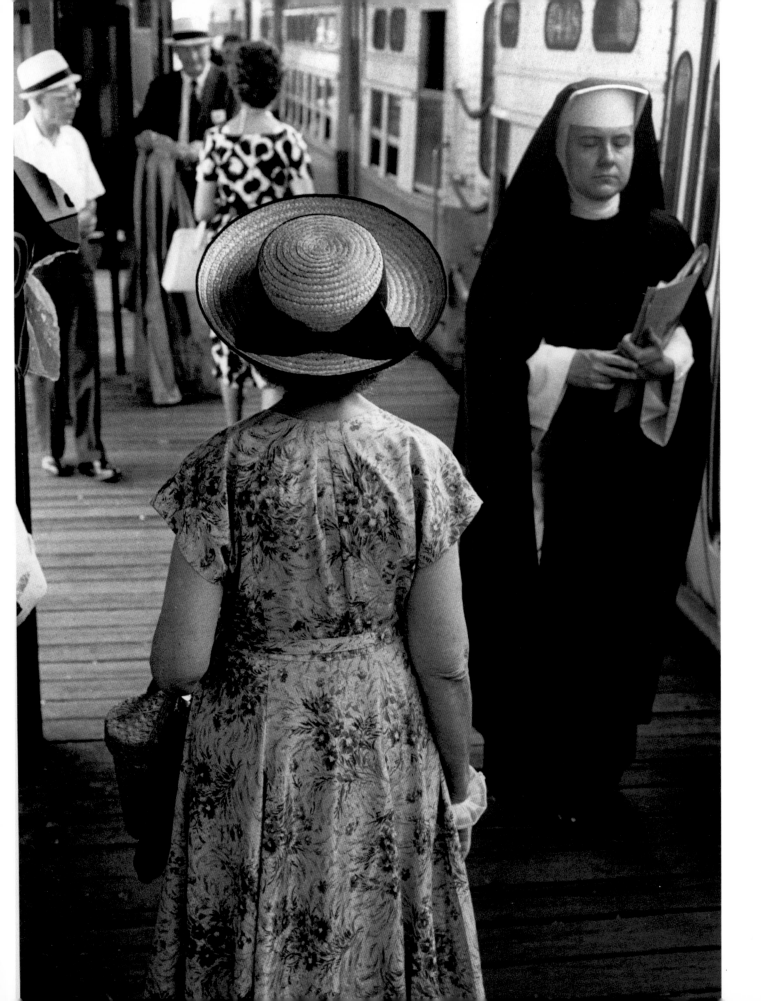

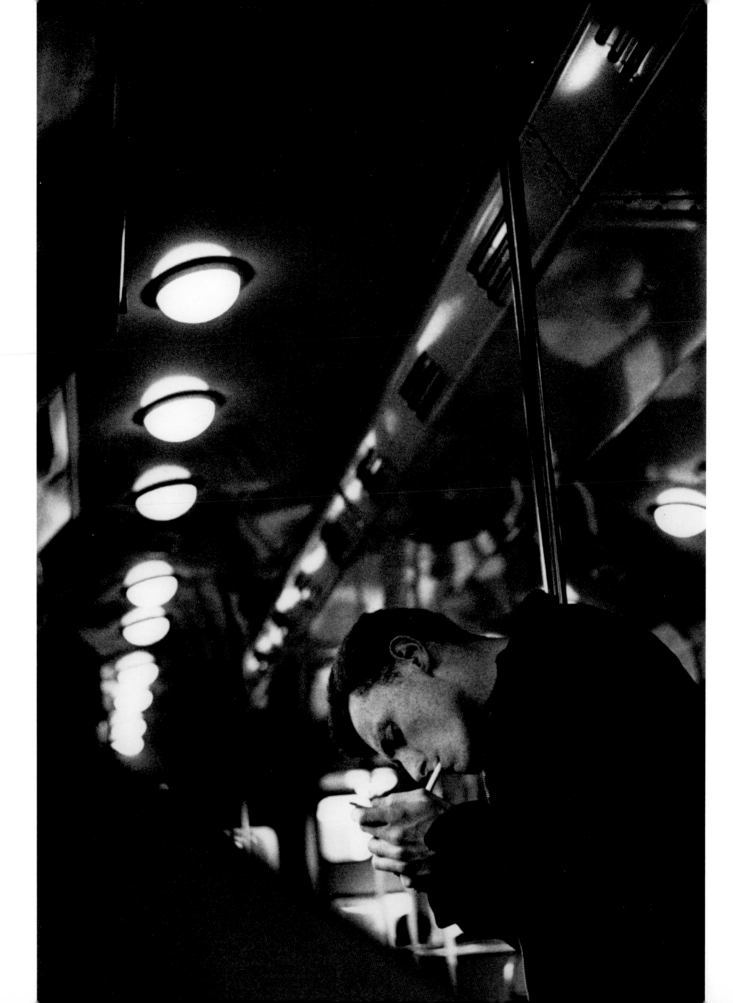

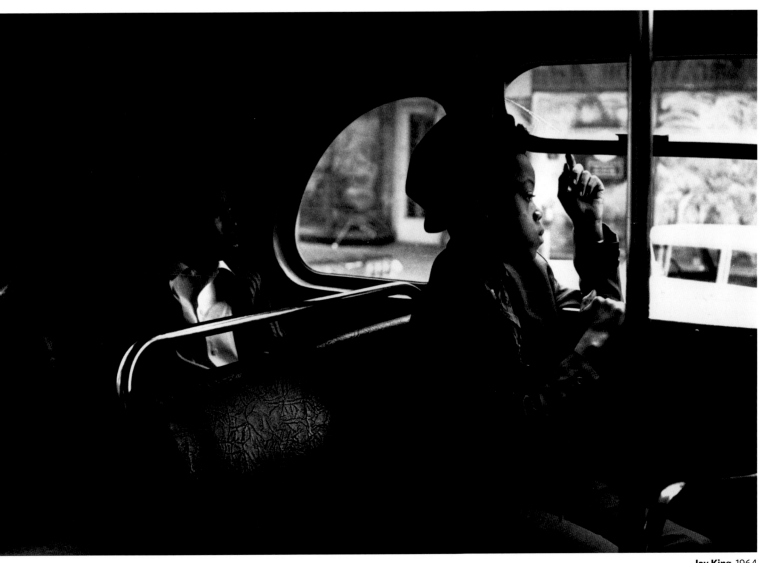

Jay King 1964

Jay King has been photographing the city since the 1960s. Born and raised in Chicago, he never formally studied photography, having majored in history in college. "I shot a lot and made a lot of mistakes," he said. "I'm not an innovator, and I don't do any jazzing up." His object is simple: to find people doing something interesting. "I don't have any great theory. If I liked it, I shot it." **Above:** Boys on a bus. "I just worked on my stealthiness," King said. He used a small, quiet camera and worked fast. "People didn't notice. I just blended in." **Opposite:** A man lights his cigarette just before leaving a subway car. King likes the picture: "The lights remind me of little Saturns."

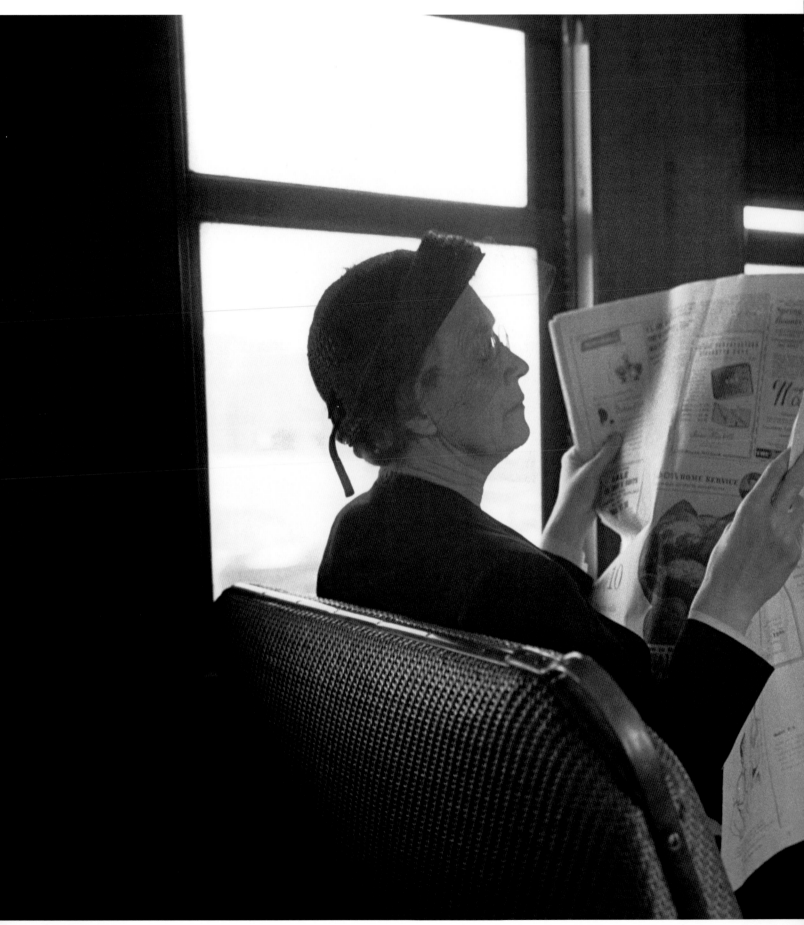

Esther Bubley 1948

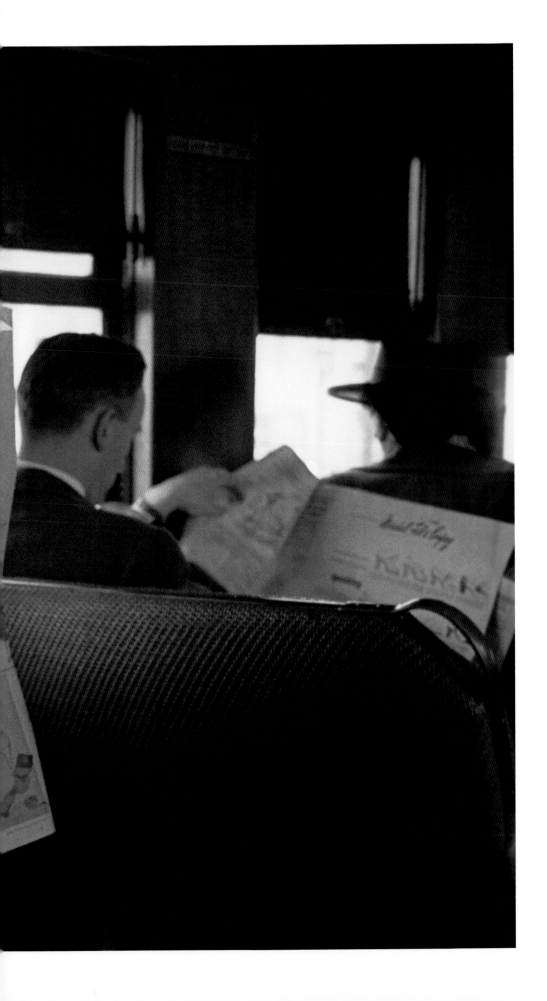

Esther Bubley (1921–1998) worked for the Office of War Information during World War II and was hired three years after the war to take photographs to mark the centennial of the Chicago, Burlington and Quincy Railroad Company. Many of those three hundred photographs, now housed at the Newberry, were of Chicago and the suburbs. Bubley specialized in finding art in everyday life. "Put me down with people, and it's just overwhelming," she said.

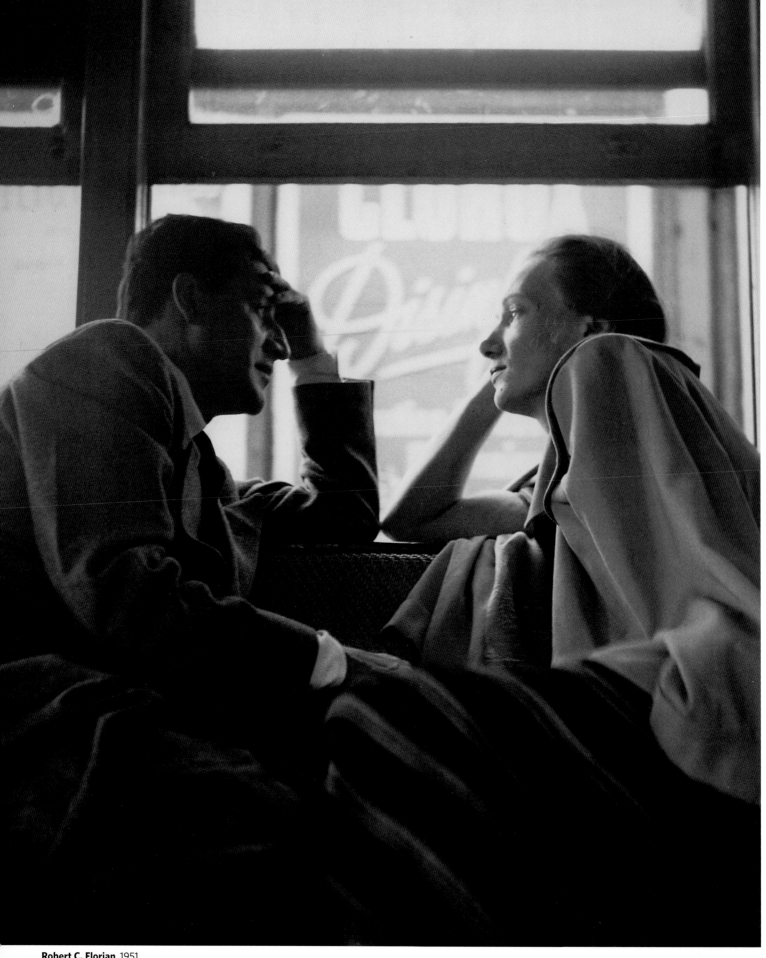

Robert C. Florian 1951

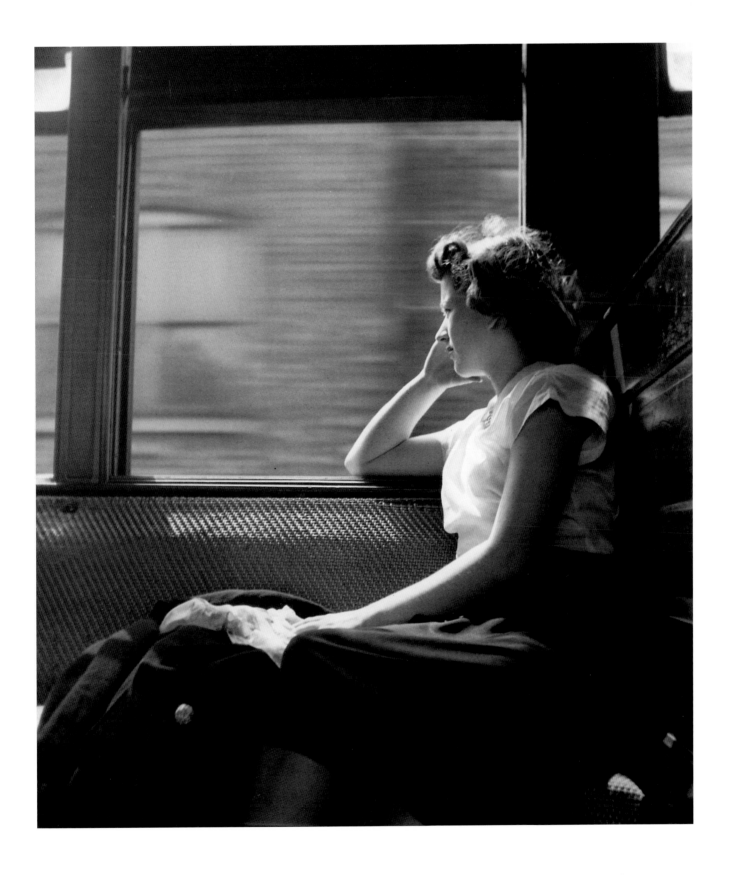

Robert C. Florian (1926–1989) was a student at the Institute of Design when he took a series of photographs of "L" riders. The pictures were for a class assignment marked "Cross-Section Middle-Class Chicagoans" and were found at the Chicago History Museum in the files of his instructor.

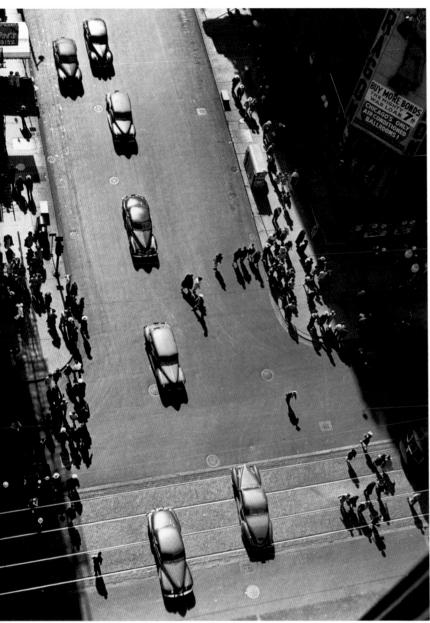

Ralph Frost Late 1940s

The rush of traffic. **Above:** Ralph Frost (1905–1982) started as an apprentice at the *Tribune* and became the chief photographer at the *Sun-Times.* "It's rather like trying to put together the ideal symphony orchestra, yet no musician has equal talents with all instruments," he said of heading up the photo staff. "Likewise very few photographers have equal talents in all phases of news-photography." **Opposite:** Morning commuters cross the Madison Street Bridge. The photo was taken from the seventeenth floor of the Chicago Daily News Building.

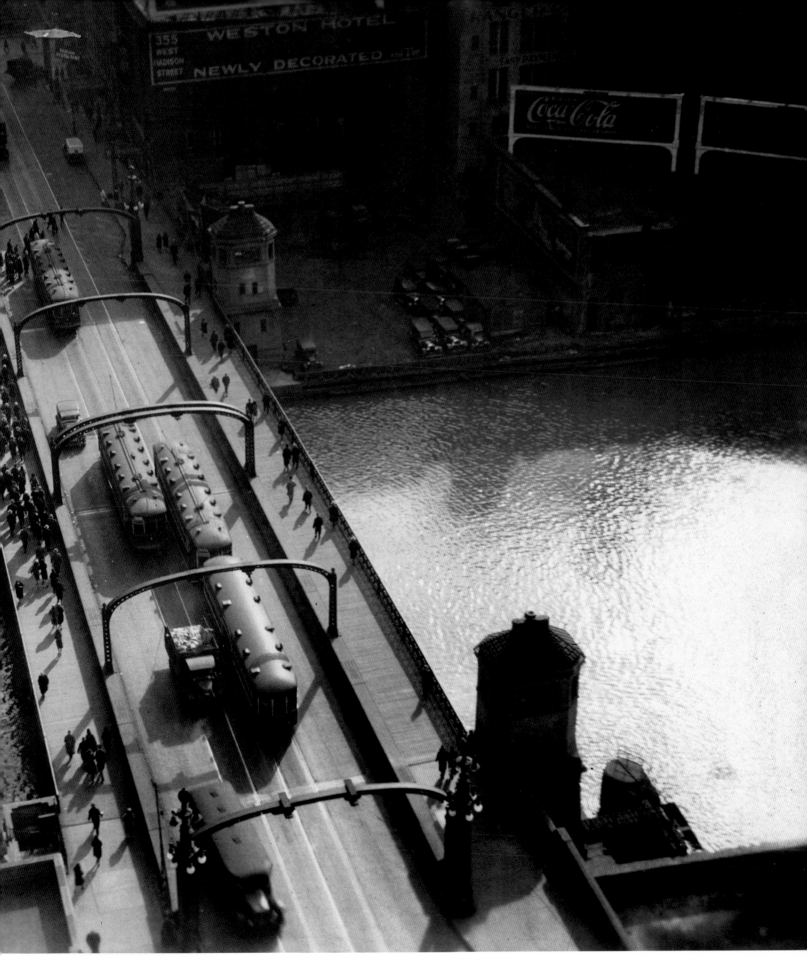

Unknown Photographer 1930

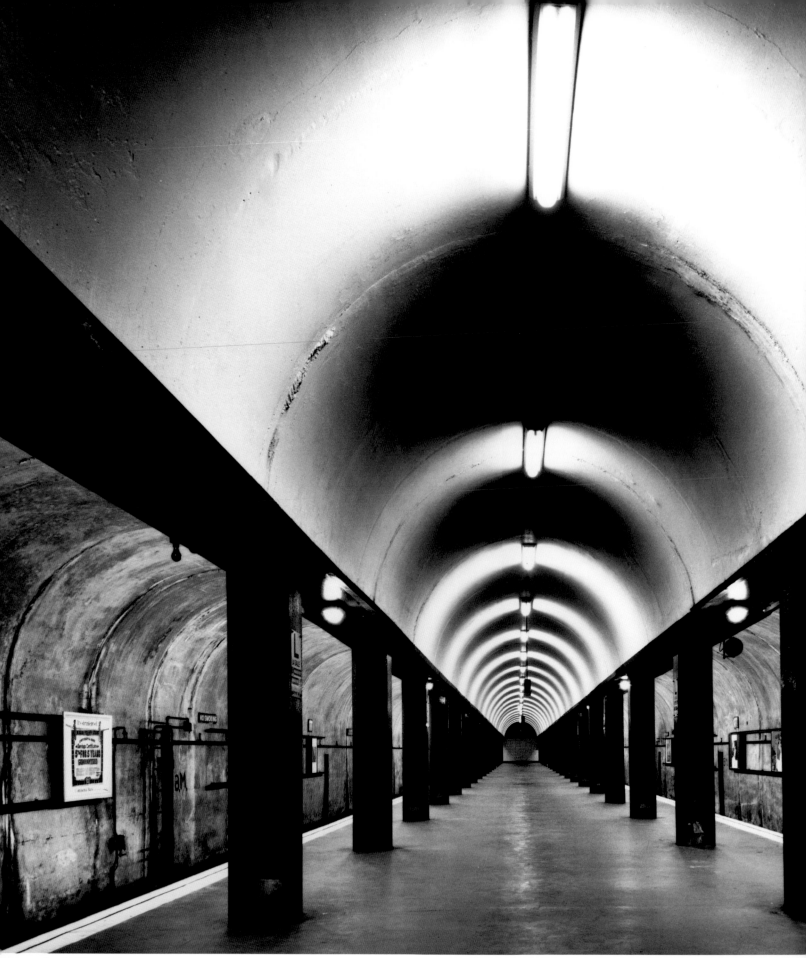

Harold Allen 1969

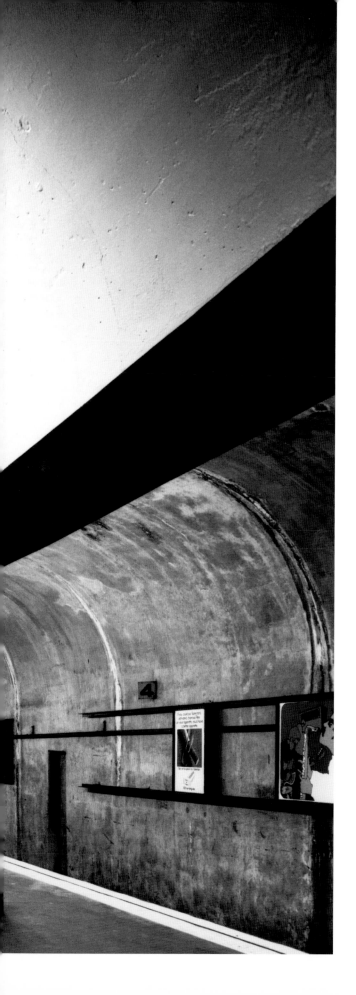

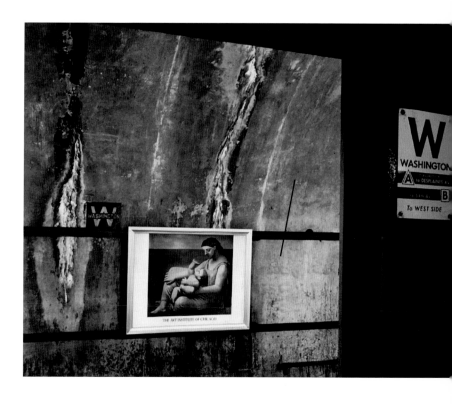

Harold Allen (1912–1998) moved from the Pacific Northwest to study at the School of the Art Institute of Chicago. He became an artist, teacher, scholar, and self-proclaimed Egyptomaniac—a lover of all things Egyptian. Groomed to be a fine art photographer, Allen preferred photographing architecture. "Let them take their peeling paint, their cracked mud, their nudes, their clever double exposures and blurred movement; I am going to be true to Architecture whether they like it or not," he wrote. **Above:** Washington Station in the Dearborn Street Subway, which is now part of the Blue Line. Allen called this photograph "Subway Vista." **Left:** LaSalle Station, also part of the Dearborn Street Subway. He called it "Picasso Poster in Subway."

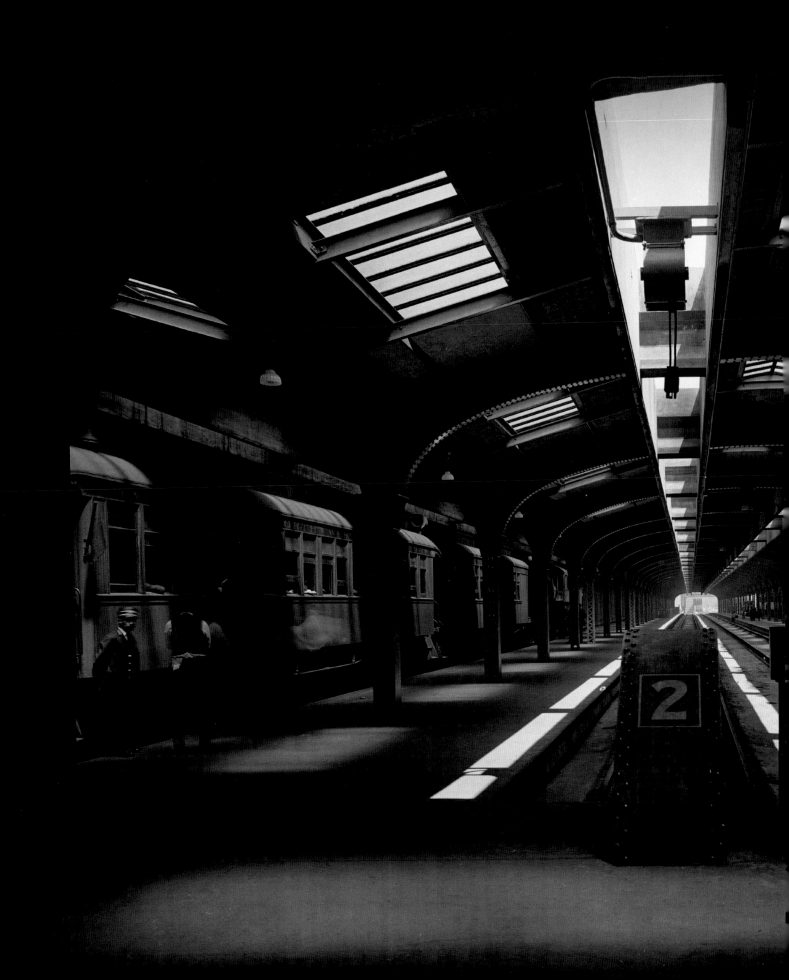

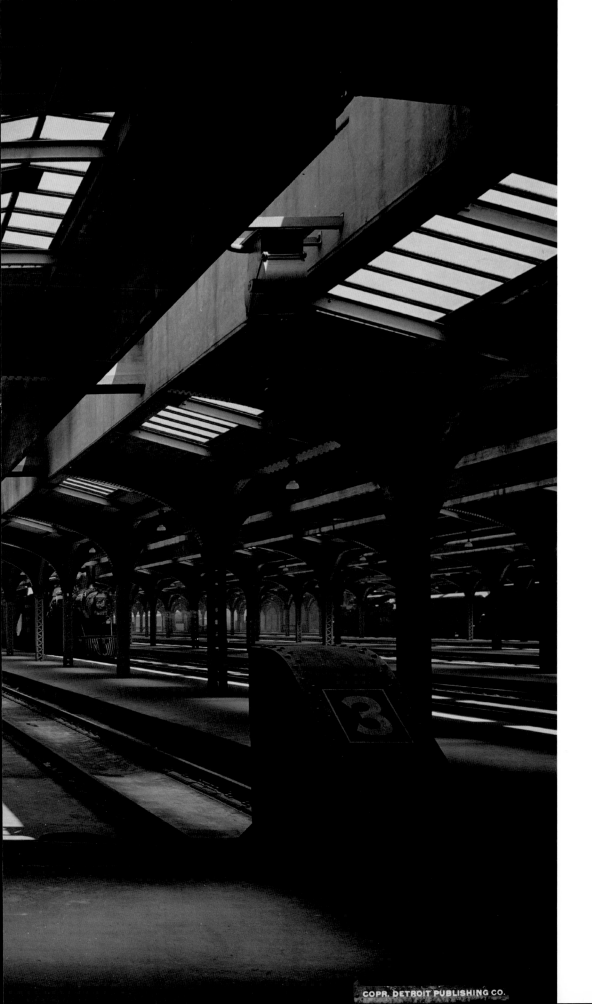

COPR. DETROIT PUBLISHING CO.

The train shed of the Chicago and North Western Railway Station soon after it opened. The station is now the Ogilvie Transportation Center, at 500 West Madison Street. Its once-grand main waiting room was torn down in 1984, but much of the shed remains. Headed by the famed photographer William Henry Jackson, the Detroit Publishing Company sought to photograph the world during the late nineteenth and early twentieth centuries. Its employees took more than two hundred pictures of Chicago. The company produced millions of postcards a year but went bankrupt in 1924.

Detroit Publishing Company 1911

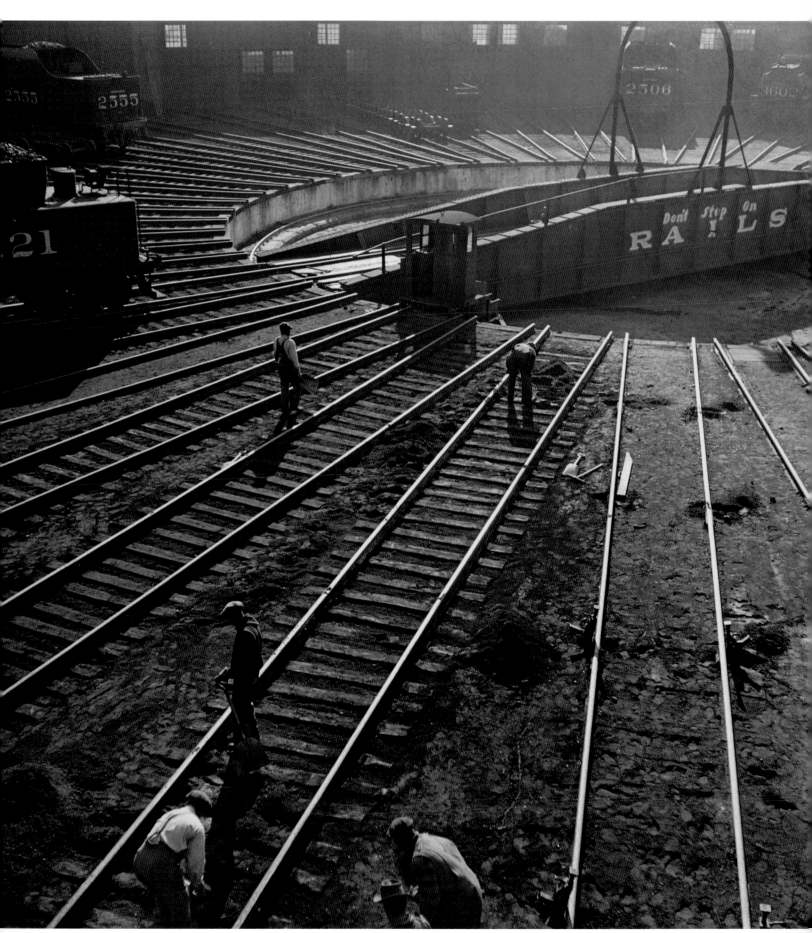

Jack Delano 1942 and (right) 1943

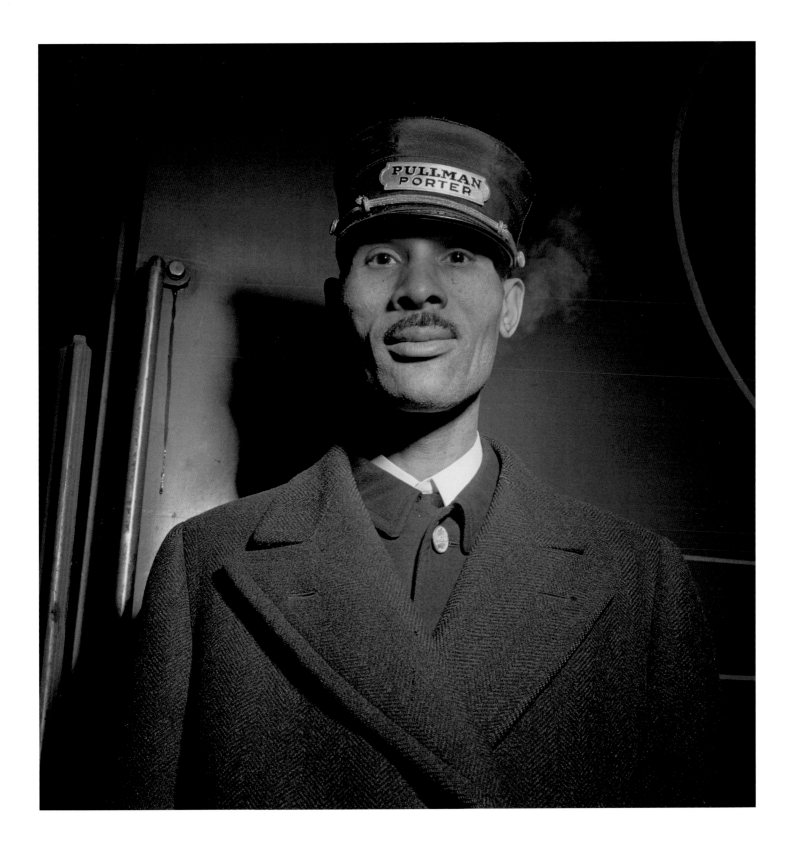

Jack Delano (1914–1977) traveled to Chicago to document the railroad industry for the Office of War Information. The hub of all rail transportation, Chicago played a key role during World War II. **Above:** A Pullman porter at Union Station. **Opposite:** The Illinois Central Roundhouse, at Twenty-Seventh Street and the lake, where trains were repaired. "I think it is my lifelong concern for the common people and appreciation of their value that have been the driving force in everything I have done," Delano said.

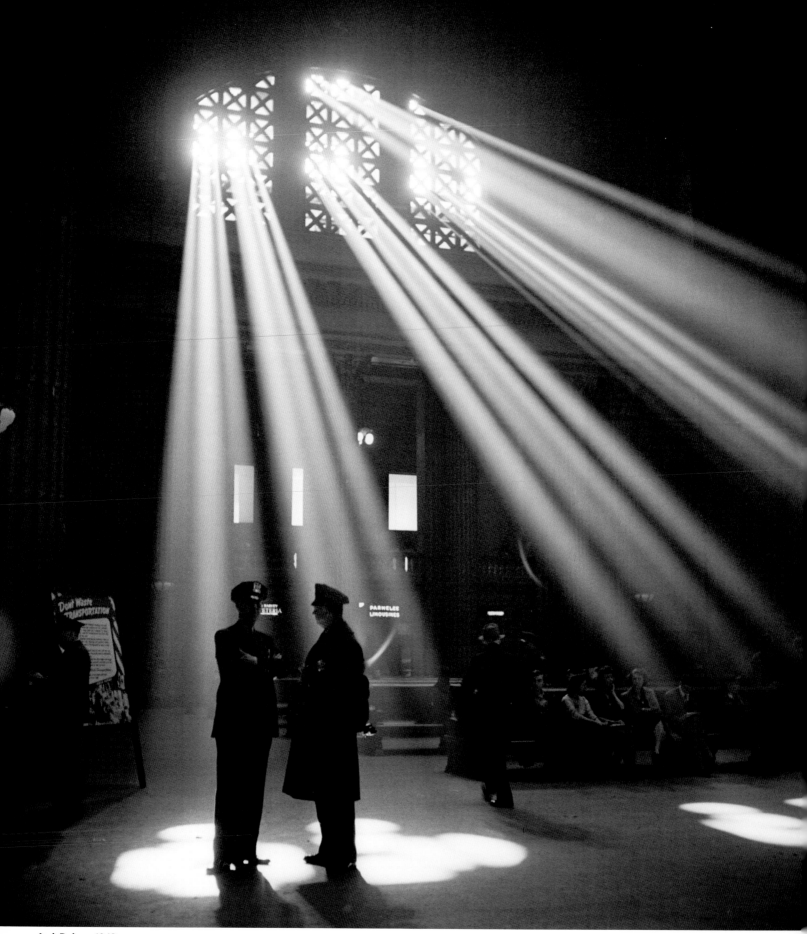

Jack Delano 1943

"Union Station was always bustling with activity," wrote Jack Delano, "passengers buying tickets for overcrowded trains, servicemen taking leave of their girlfriends or wives and children, porters lugging baggage, and people crowded around the information booth and at the taxi stands." After the war, Delano moved to Puerto Rico, where he made documentary films, composed music, and continued work as a documentary photographer.

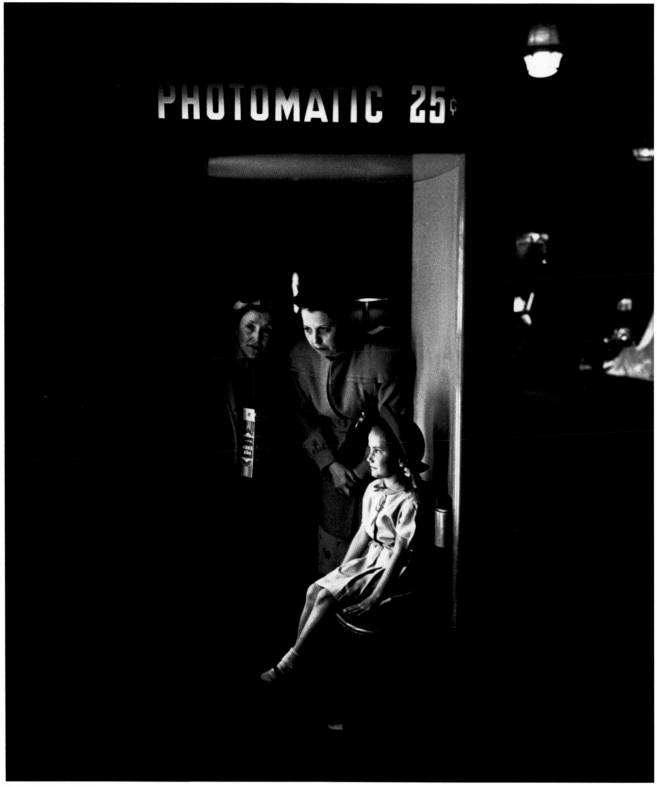

Esther Bubley 1948

The joy of photography. **Above:** The Photomatic, an early photo booth, produced instant portraits rimmed by sleek metal frames. **Opposite:** The Union Station portico. Algimantas Kezys (1928–2015), a Jesuit photographer, was known for highlighting and exploring design in his photography. "Part of the magic of taking pictures consists for me in the fact that photo compositions come so easily to me," he said.

Algimantas Kezys 1966 ▷

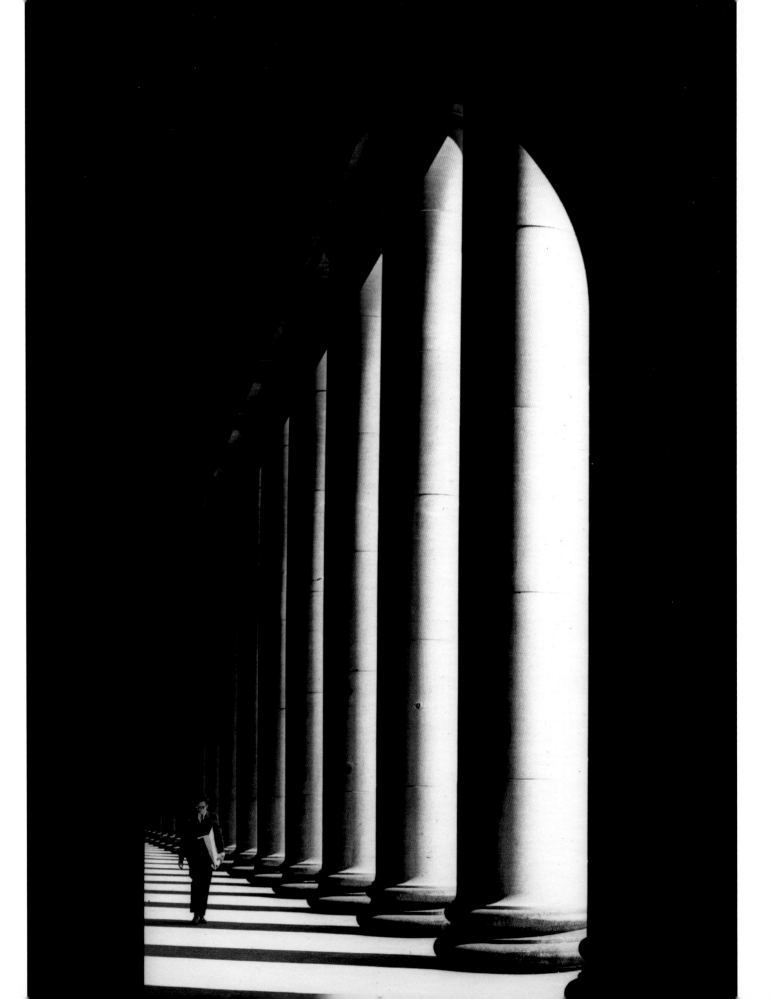

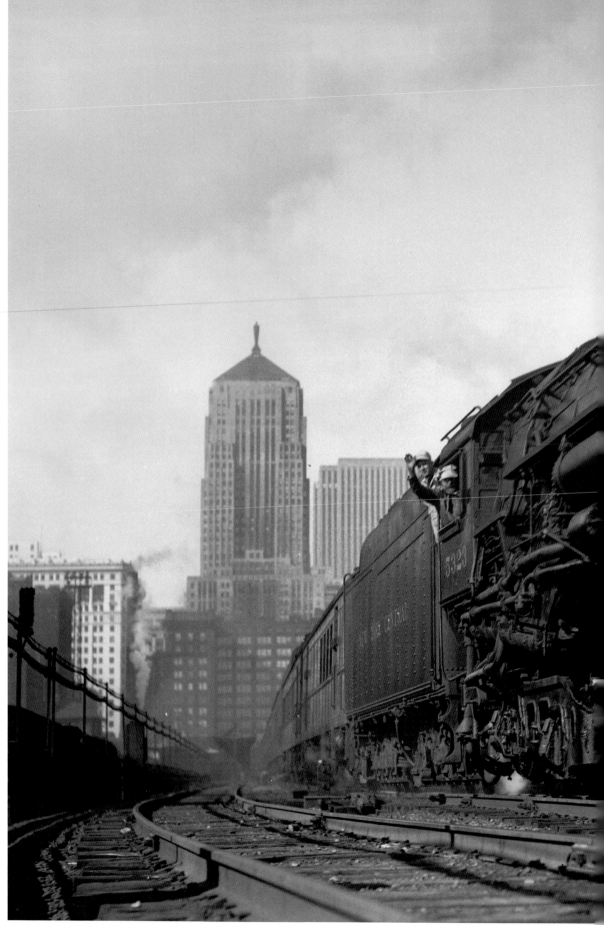

The 20th Century Limited leaves Chicago bound for New York City. The express train, which ran from 1902 to 1967, could make the trip in less than twenty hours. This photo was taken by a rail enthusiast south of the LaSalle Street Station, a favorite spot to capture slow-moving trains leaving the city.

Unknown Photographer 1937

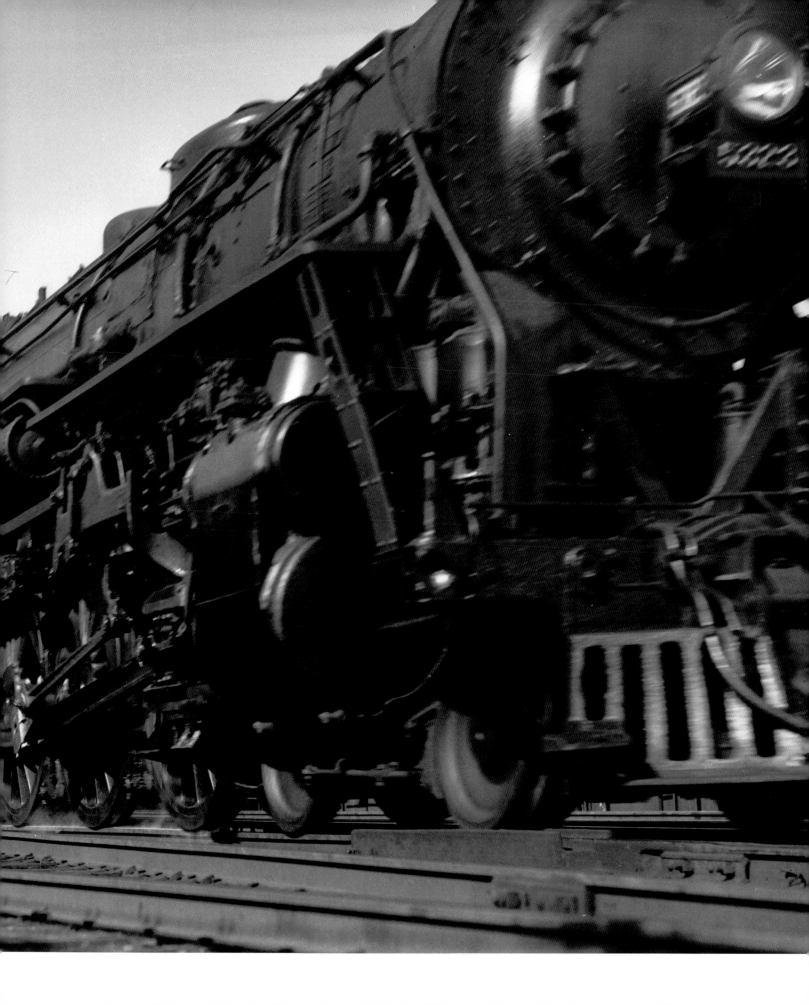

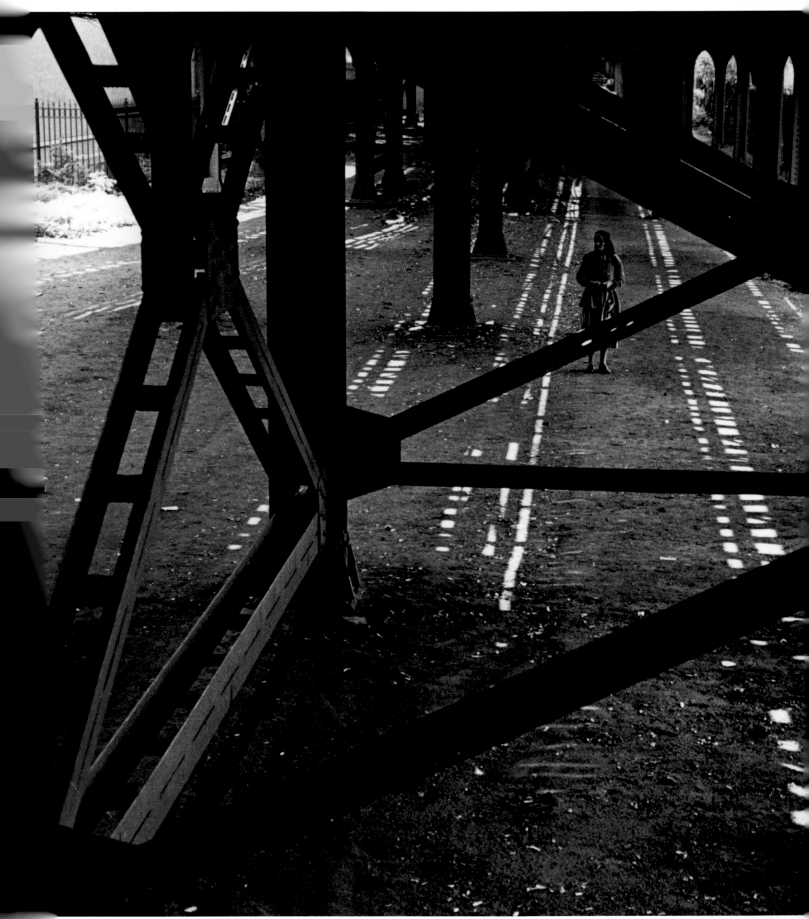

King Mid-1960s

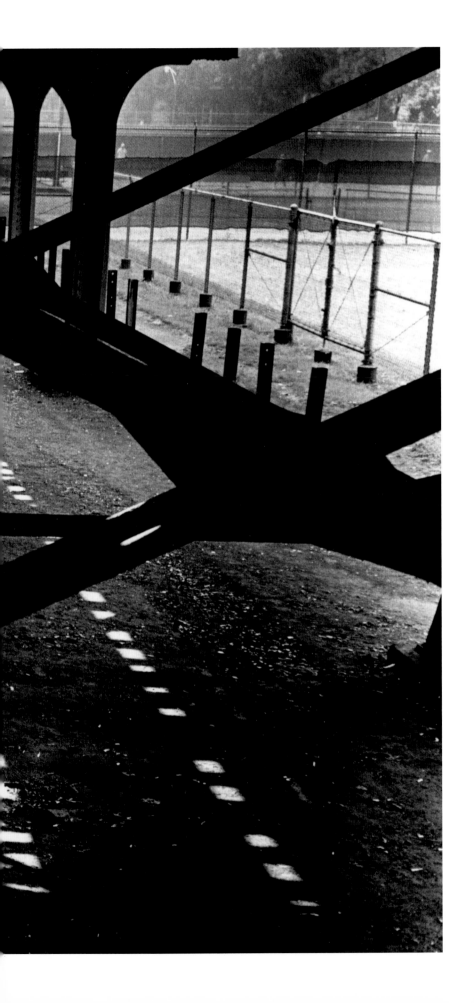

THE WAY HOME

The street is a lab for
photographers. It is the
place where they blend
into the scene and observe.
They spread across Chicago
without a plan, led only by
their cameras. They look
for children at play in alleys
and courtyards. They follow
people under "L" tracks.
They stalk movie theaters
and ballparks, and even
make their way onto back
porches. They do it because
they know that Chicago's
neighborhoods are home.

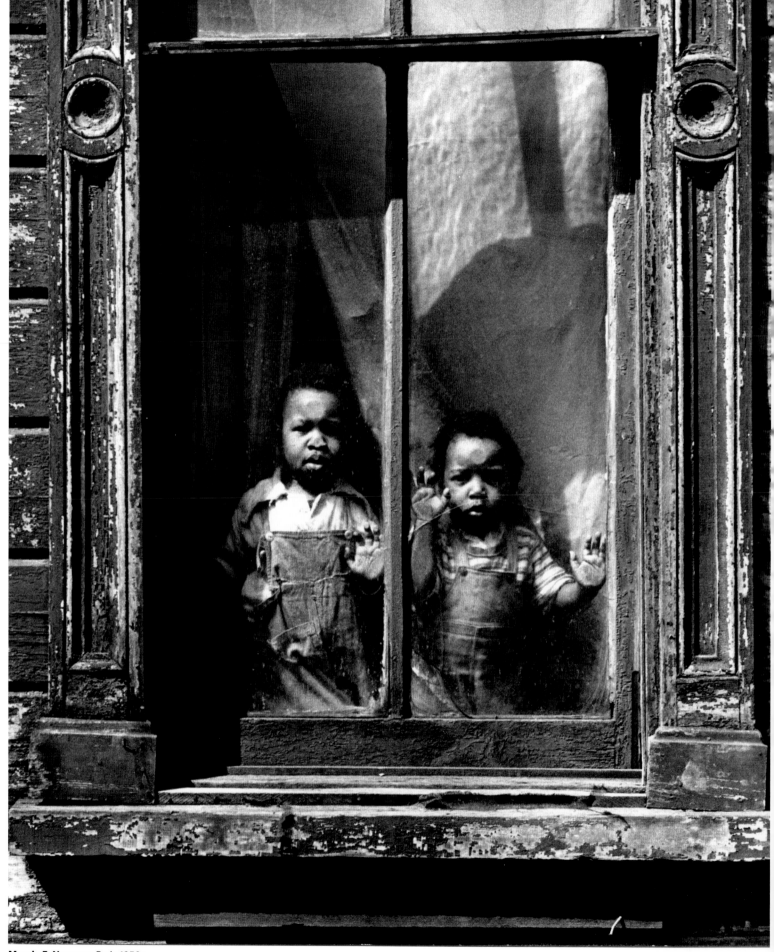

Marvin E. Newman Early 1950s

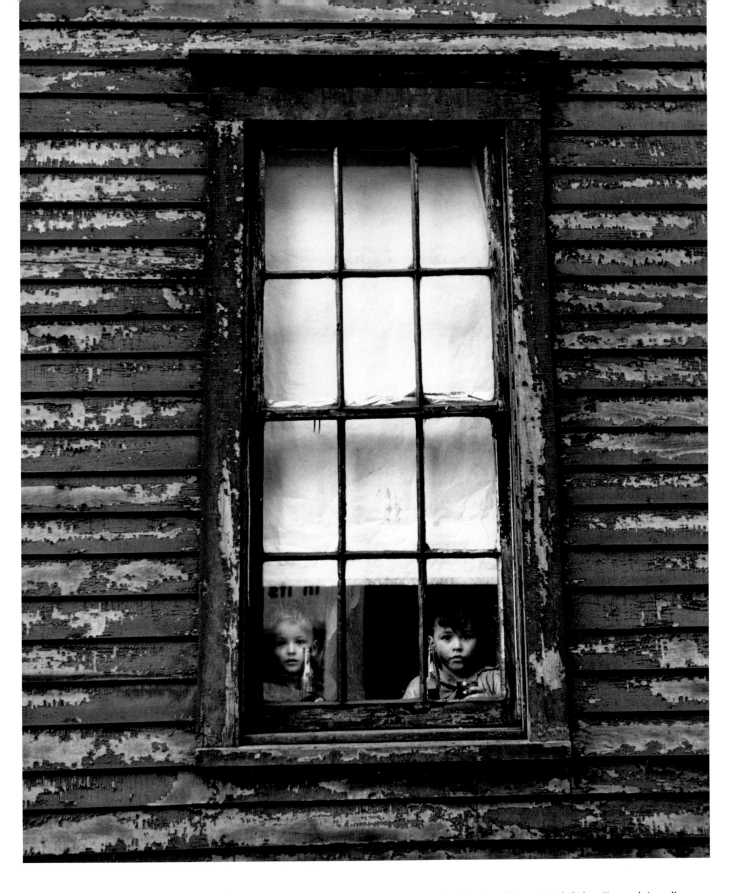

Marvin E. Newman peeked into windows to document the living conditions on the South and Near North Sides. "I was doing all kinds of social studies to show the rest of the city what these places were like," he said.

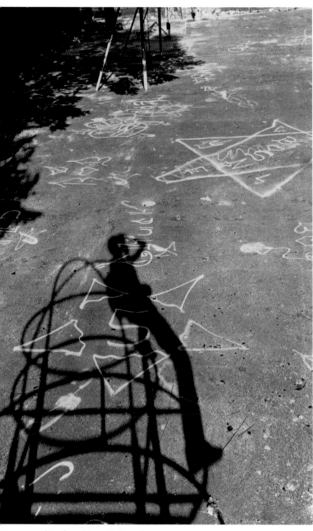

Stephen Marc Late 1980s

The way things were. **Above:** A self-portrait of Stephen Marc (born 1954) on a South Side playground near where he grew up. The jungle gym was familiar, but Marc was surprised by the gang tags that covered the asphalt when he returned decades later: "It was overwhelming." **Right:** The French photographer Henri Cartier-Bresson (1908–2004) roamed Chicago's neighborhoods and downtown during his 1947 visit. Cartier-Bresson, author of *The Decisive Moment,* was one of the first influential street photographers. "One must seize the moment before it passes," he wrote, "the fleeting gesture, the evanescent smile."

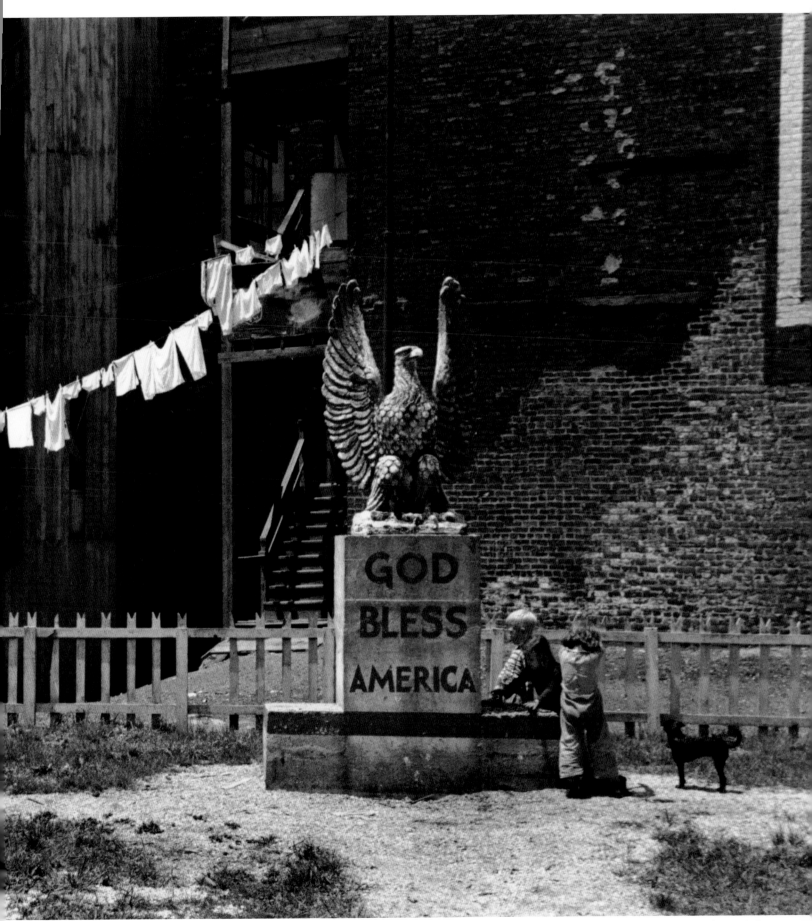

Henri Cartier-Bresson/Magnum Photos 1947

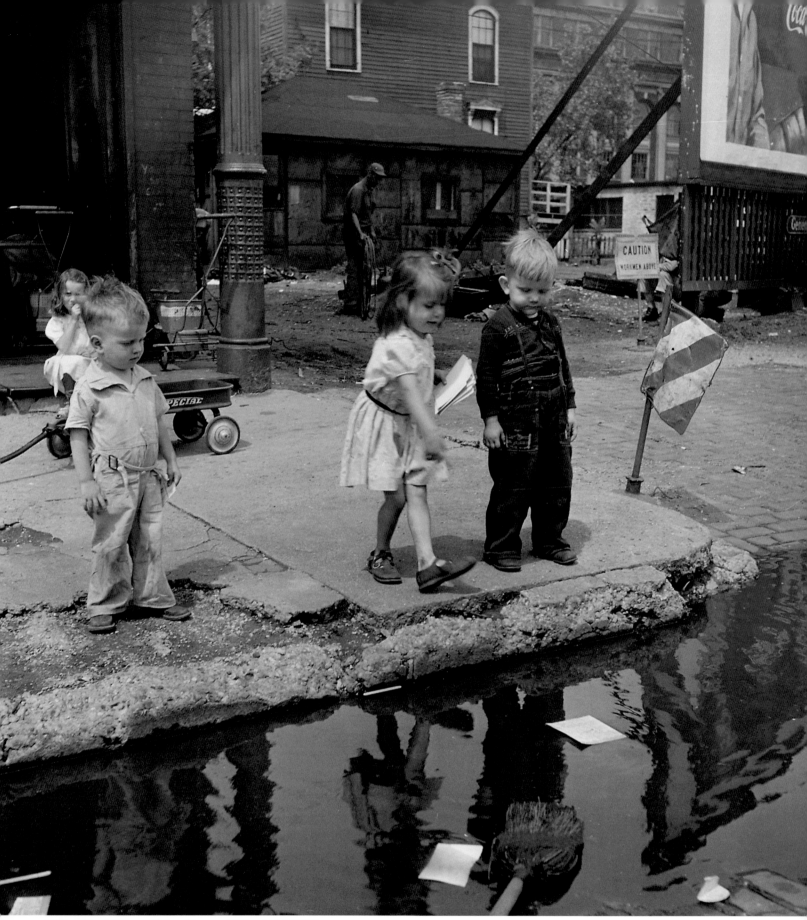

Mildred Mead/Chicago History Museum 1953 and (right) 1951

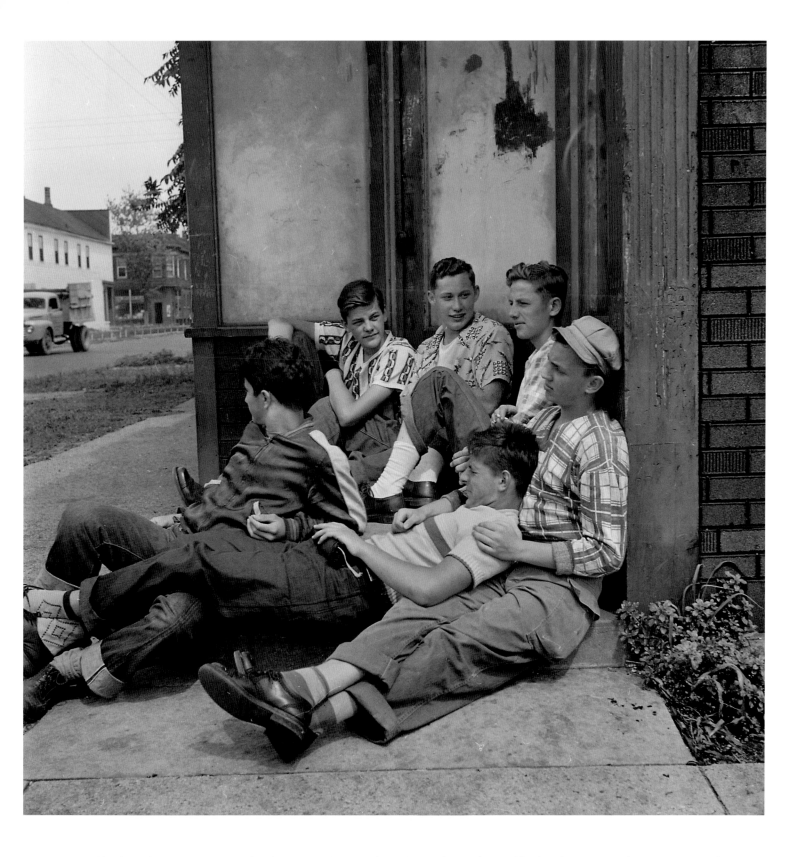

Neighborhood life. **Above:** Boys gather by an abandoned Fuller Park storefront. The neighborhood was torn up by construction of the Dan Ryan Expressway. **Opposite:** Children play on Sixty-Ninth Street near Stewart Avenue in Englewood. Mildred Mead (1909–2001) documented the South Side for the Metropolitan Housing and Planning Council and other agencies from the late 1940s to the early '60s. Her photographs of street life on the South and West Sides are in the collections of major Chicago institutions.

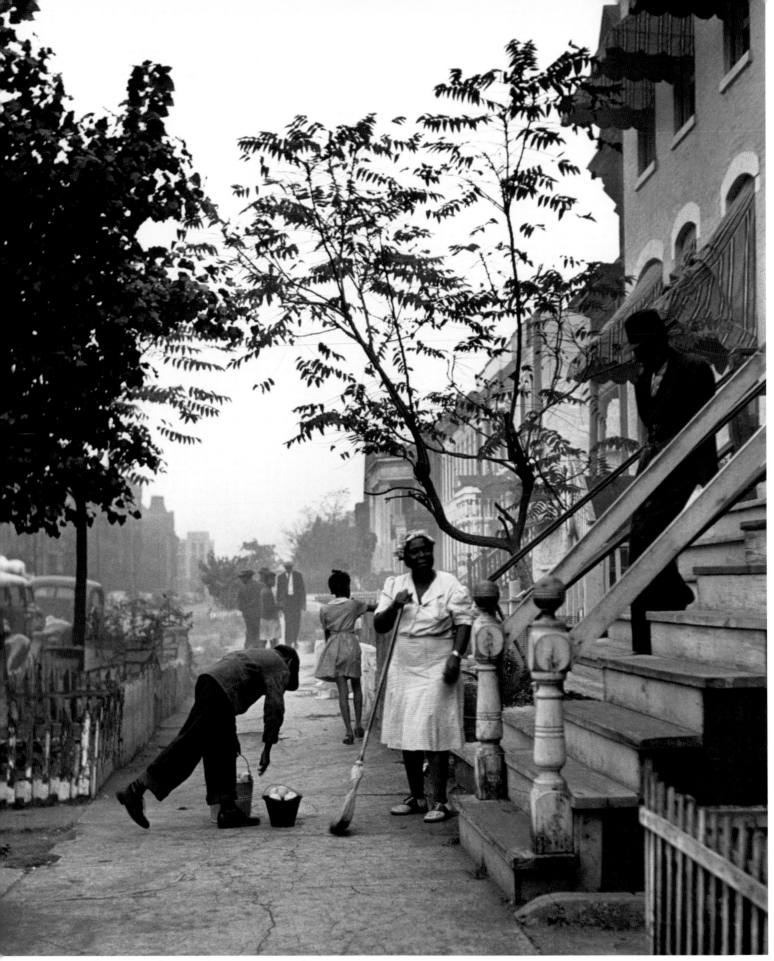

Wayne Miller/Magnum Photos 1940

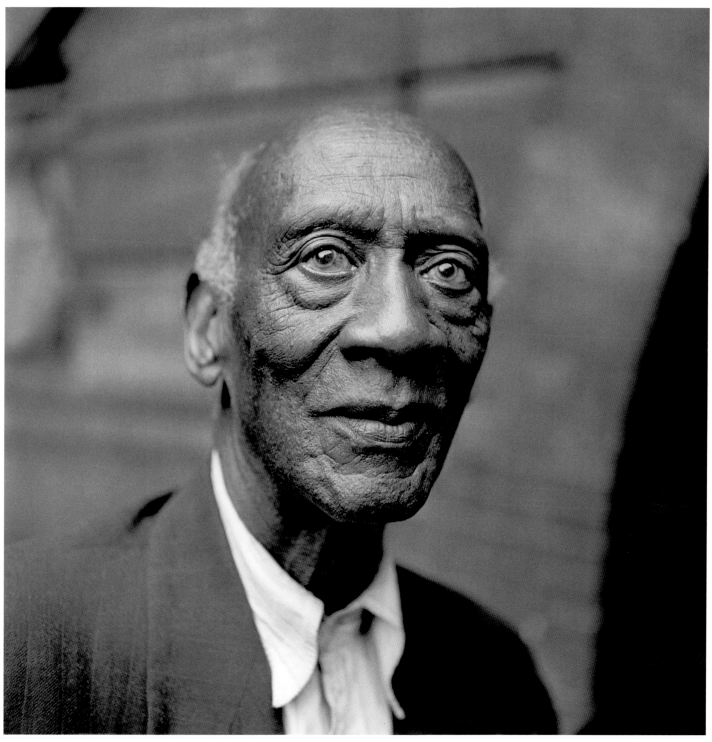

Robert Natkin 1950s

Just around the corner. **Above:** A hundred-year-old South Side man, photographed by Robert Natkin (1919–1996) for a story about centenarians for Chicago-based Johnson Publishing. Natkin was one of the original photographers for *Ebony* magazine. **Opposite:** Wayne Miller (1918–2013) spent three years creating "The Way of Life of the Northern Negro," a photo project funded by the Guggenheim Foundation. "I walked the streets and alleys of the South Side day and night," he wrote. "Some mornings, on certain blocks, it had the feel and flavor of a small town. Men and women were on their way to work, sidewalks were swept, grocery stores opened, kids packed off to school."

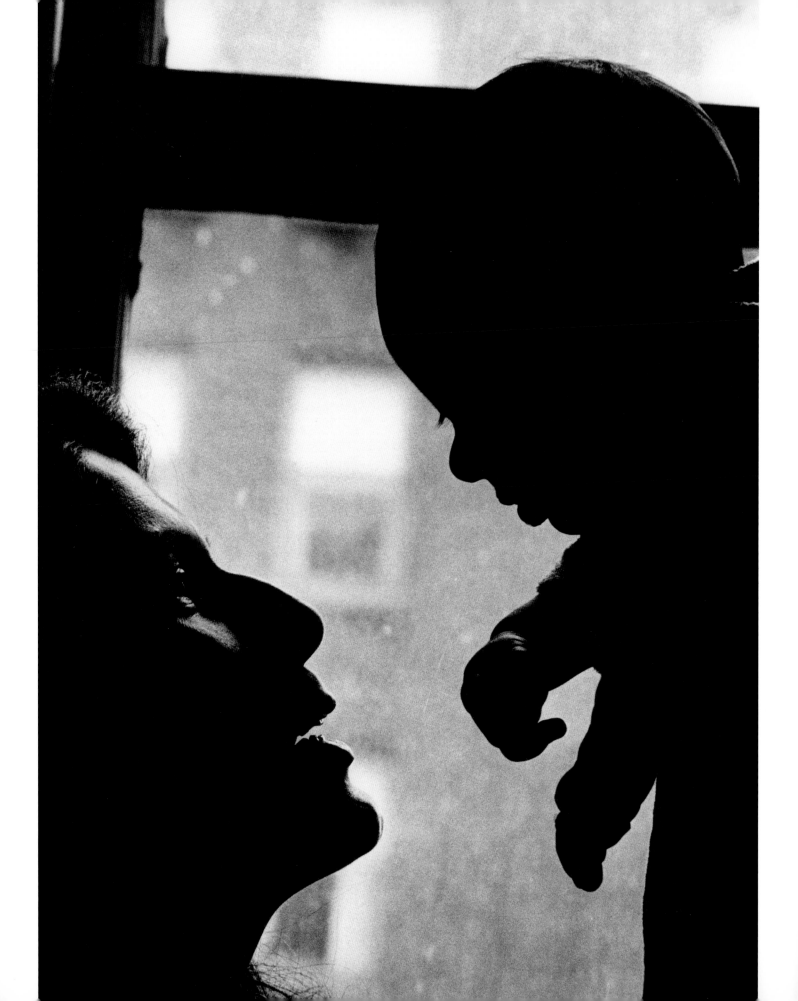

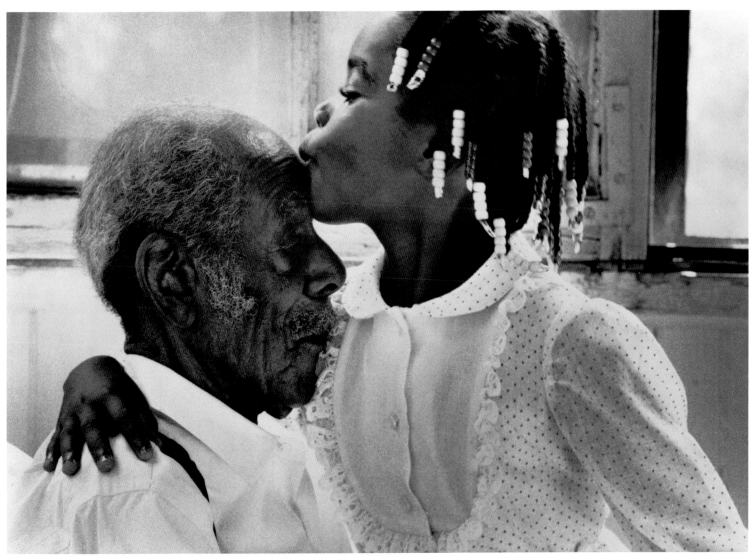

Bob Black/Chicago Sun-Times 1983

Spanning generations. **Above:** Rutherford B. Hayes Elmore, 112, and his great-great-great-granddaughter Kiowa Natchez Gray at the South Side home where he lived. Bob Black (born 1939) won the top prize in the World Press Photo contest in 1984 for this photograph. A friend had told Black about Elmore and his daughter Elsie Whittington, who tenderly cared for him. "After taking a series of portraits, this little girl kissed him on the forehead," he said. "That was the picture." **Opposite:** "Mother's Day Special" by John Tweedle (1936–1981). The first African American photographer to work for a metropolitan Chicago newspaper, Tweedle mentored several African American photojournalists, including Bob Black. Tweedle is remembered for his coverage of Martin Luther King Jr. in 1966, when the civil rights leader rented an apartment in Chicago to protest housing segregation.

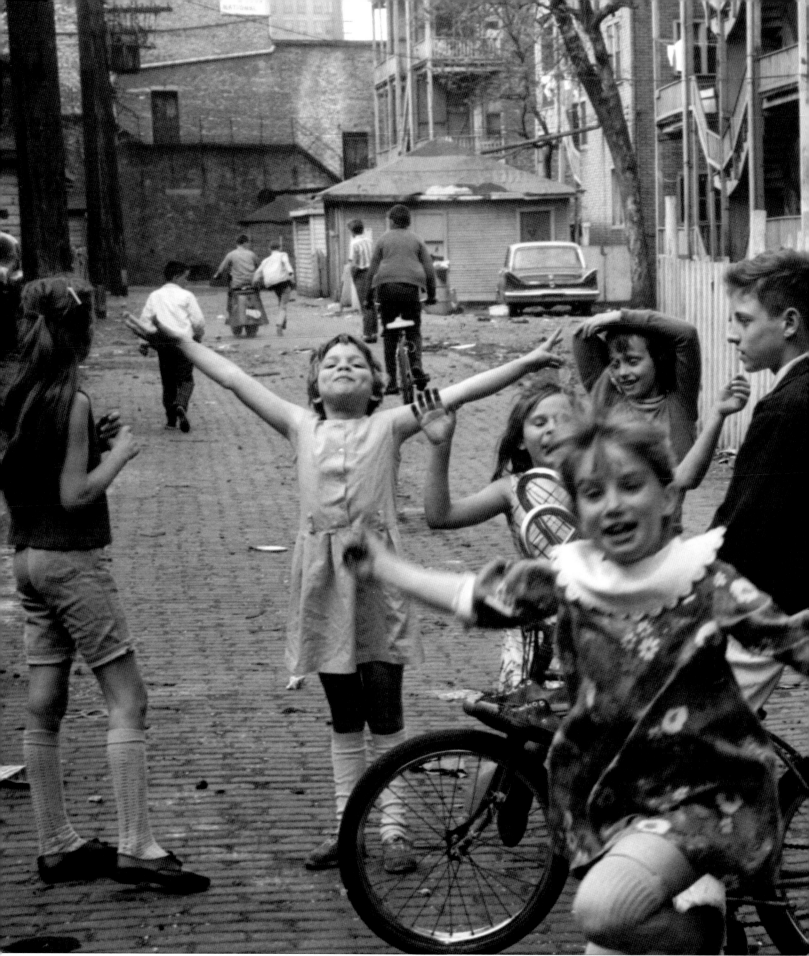

Art Shay 1960s

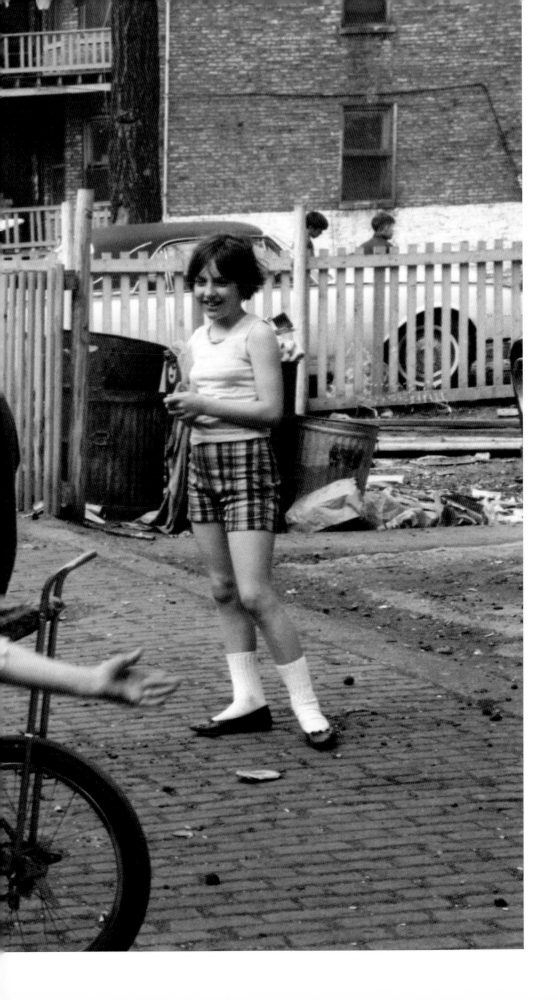

For half a century, Art Shay was known as Chicago's photographer of the rich and famous. He photographed Marlon Brando when the young actor visited his family's home in suburban Libertyville, Nelson Algren during the writer's tumultuous years with the French feminist *Simone de Beauvoir*, *Playboy* founder Hugh Hefner and his bunnies, and hundreds of other celebrities. What makes Shay unique is that he was just as comfortable on the streets in search of everyday life. He was Chicago's flâneur with a camera. Here, Uptown kids show off their alley hangout. Shay said they were proud to have a photographer in their private domain. "They liked the whole experience."

Next spread: On assignment for *Forbes* magazine, Shay took this photograph in a back alley just south of the Loop, around Roosevelt Road, which he titled "Backyard Olympics."

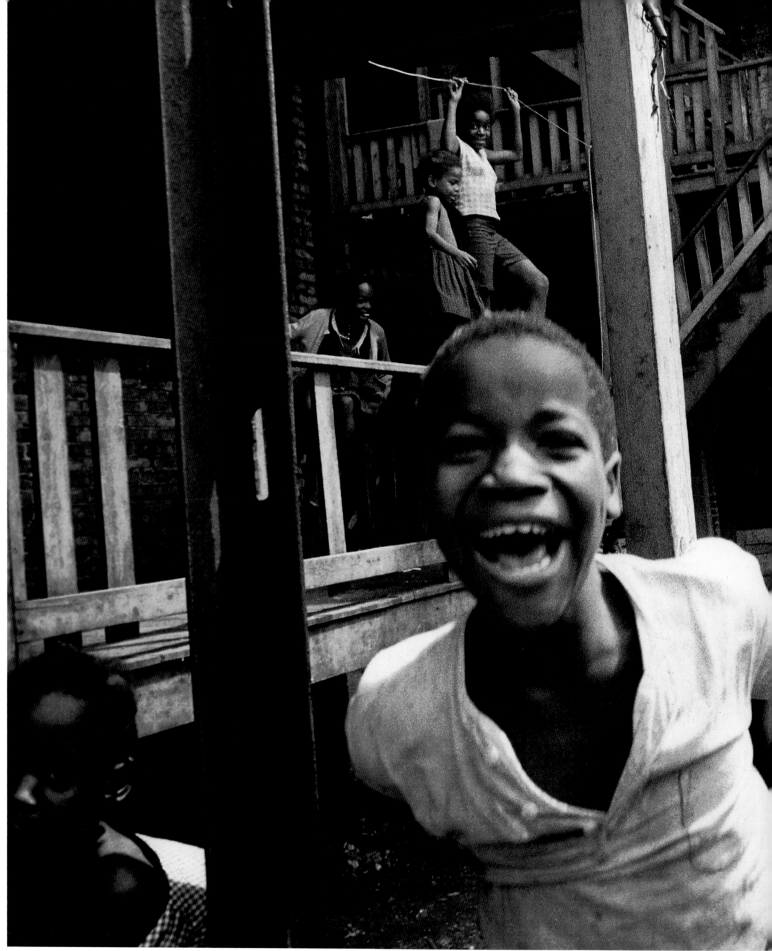

Art Shay 1968

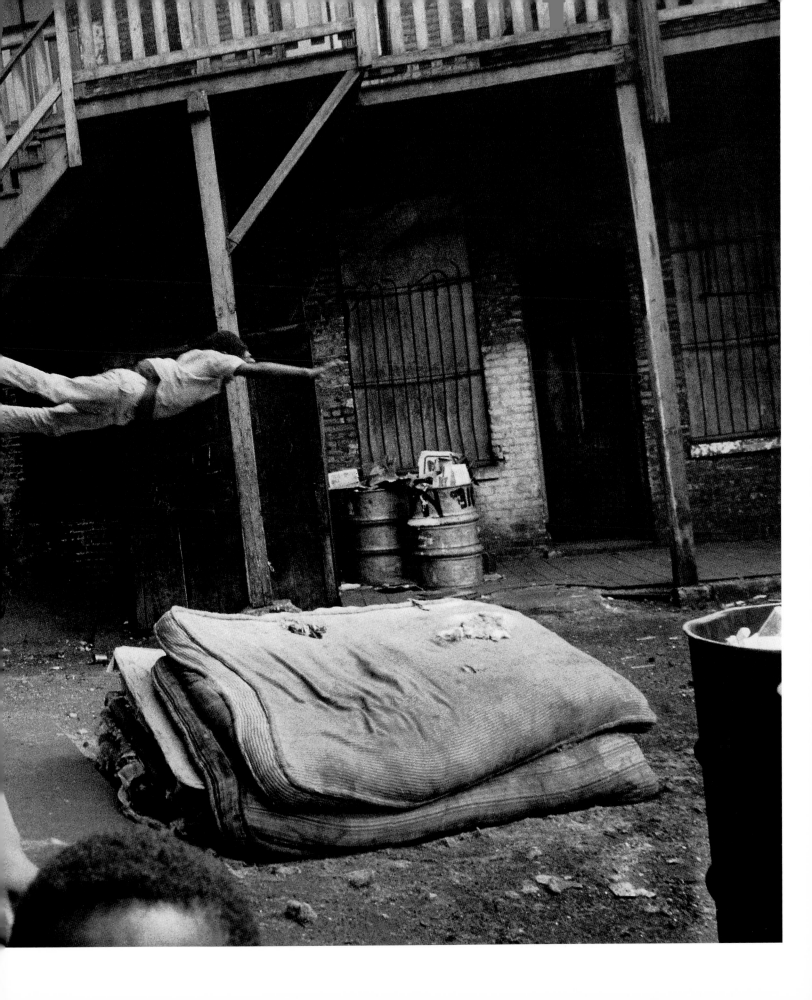

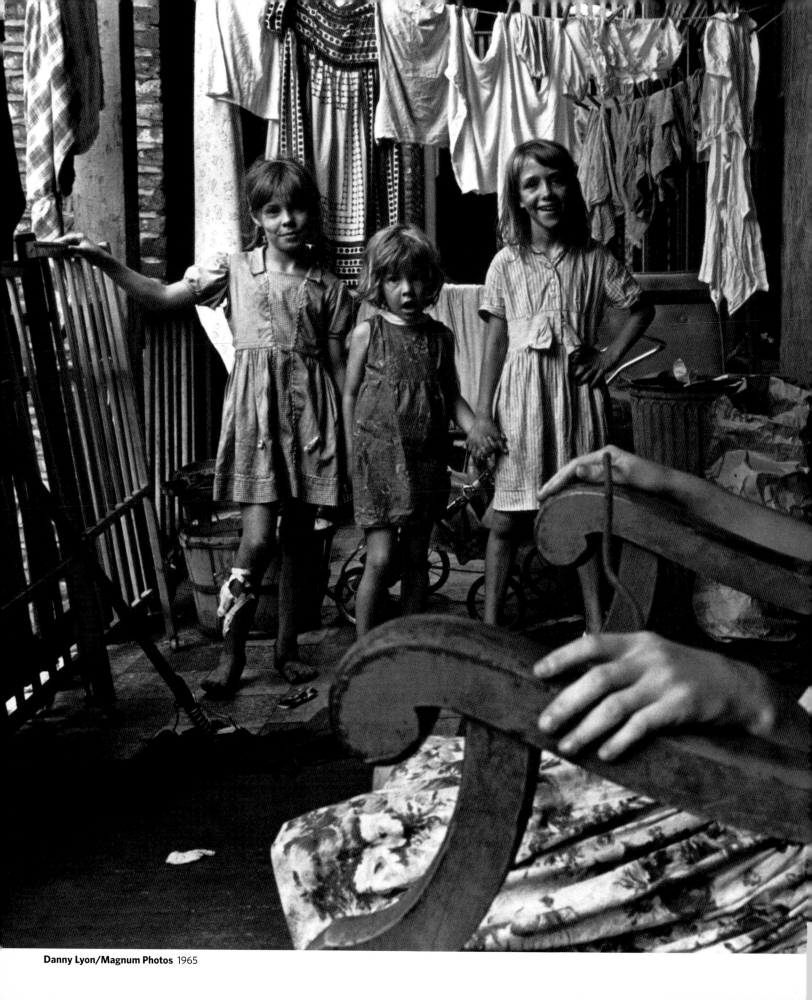

Danny Lyon/Magnum Photos 1965

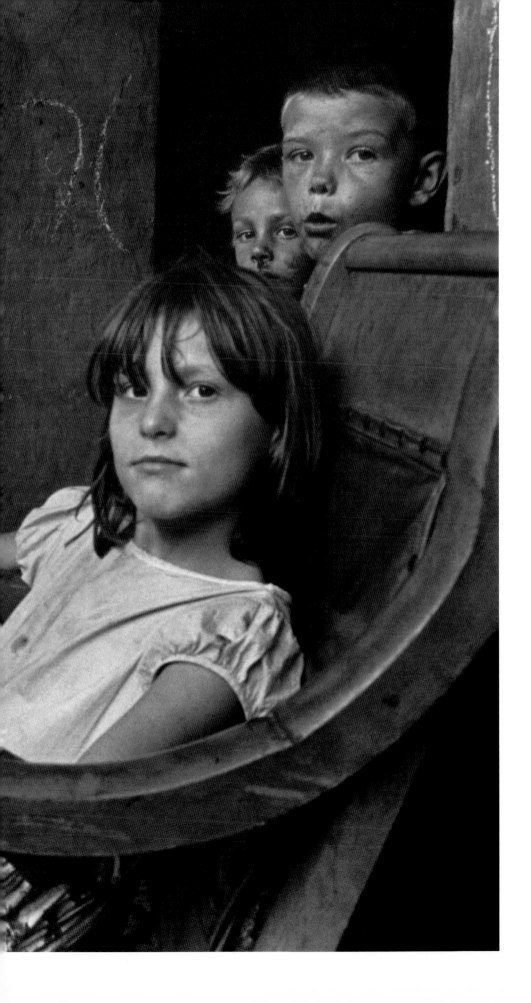

"I never intended to be a photographer," wrote Danny Lyon (born 1942). "I never intended to be anything." Lyon came to Chicago as a University of Chicago student. He left to photograph the civil rights movement for the Student Nonviolent Coordinating Committee and returned in 1965. "I stayed in Chicago for more than two years. And with a Rolleiflex lent to me by Hugh Edwards made pictures in Uptown, a North Side neighborhood of Southerners," he wrote. A curator at the Art Institute of Chicago, Hugh Edwards was the first to recognize Lyon as a major photographer. This picture was taken with a 35 mm camera, but most in the series were made with the medium-format Rolleiflex. Said Lyon, "You put a camera in my hand, I want to get close to people."

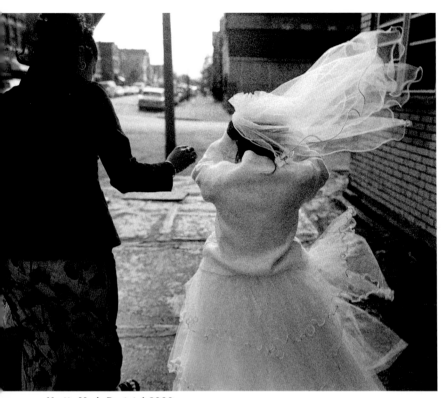

Yvette Marie Dostatni 2000

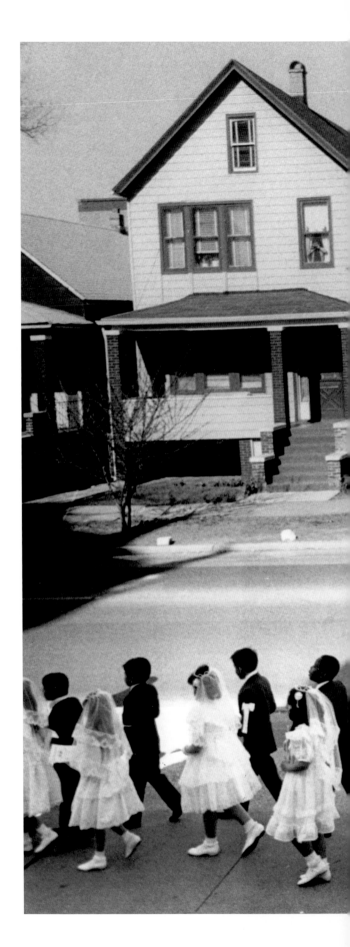

Holy days. **Above:** Yvette Marie Dostatni (born 1971) found Zuleyma
Alatoore and her older sister as they braved the wind after Zuleyma made
her first communion in Pilsen. Dostatni was a full-time photographer for
CITY 2000, a photo project that documented Chicago in the year 2000.
Right: Children walk toward St. Michael the Archangel Catholic Church
for their first communion. Antonio Perez (born 1962) photographed the
procession from the church rectory on South Shore Drive between Eighty-
Second and Eighty-Third Streets. He was familiar with the scene; he had
attended the school. "I remember the nuns lining up the kids like little
soldiers," he said. He shot for Changing Chicago, a photo project in the late
1980s, and for CITY 2000.

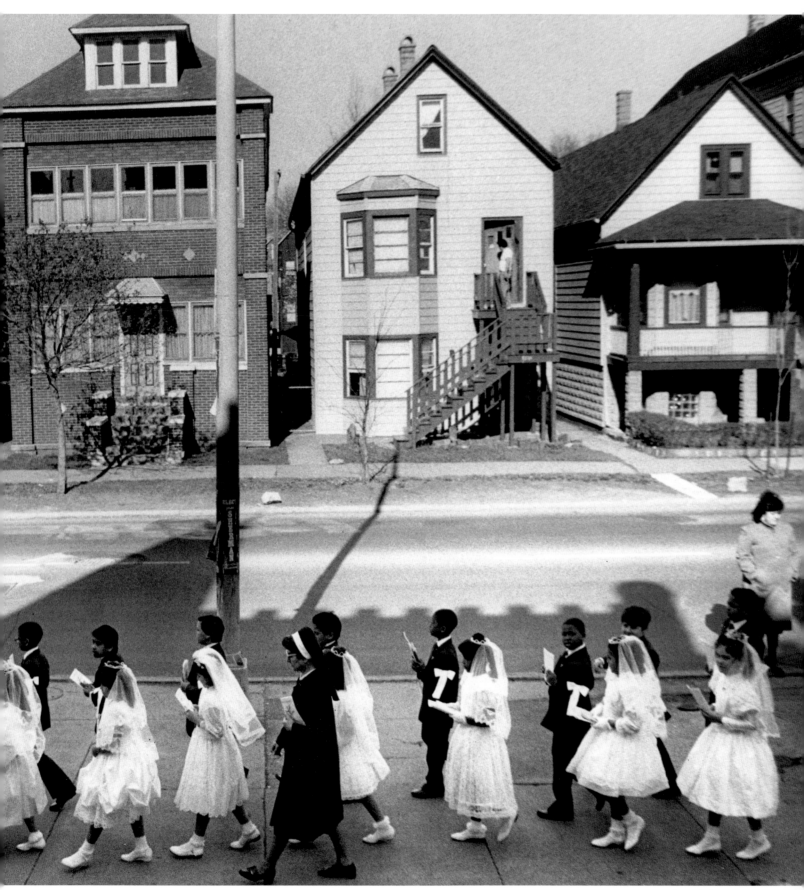

Antonio Perez 1987

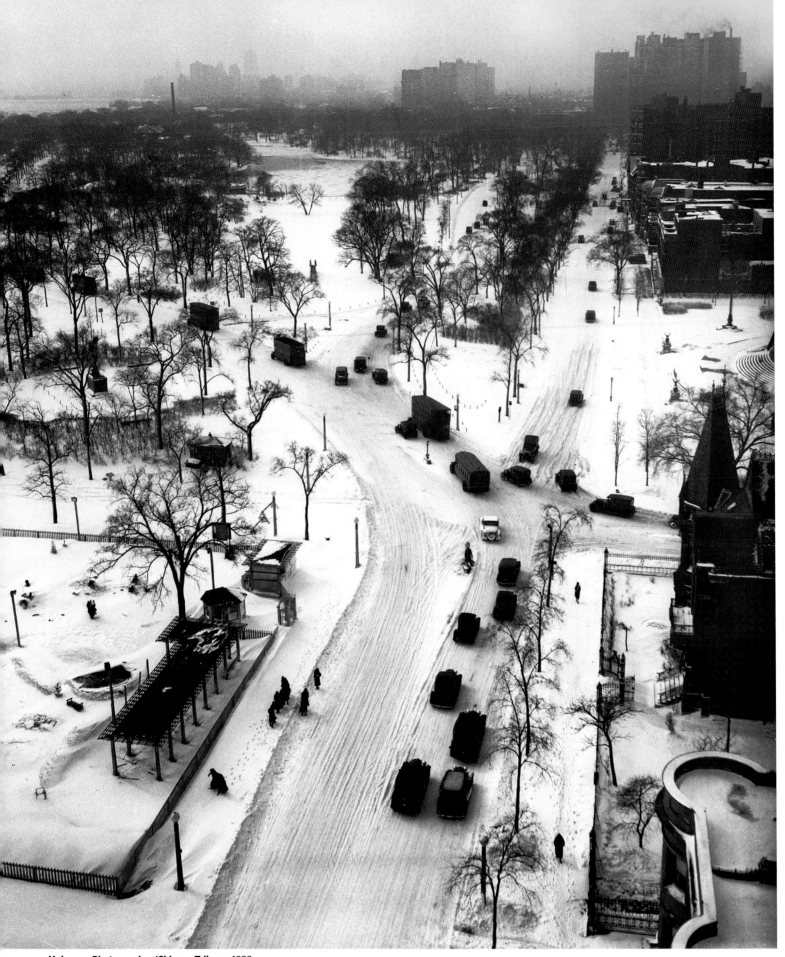

Unknown Photographer/Chicago Tribune 1932

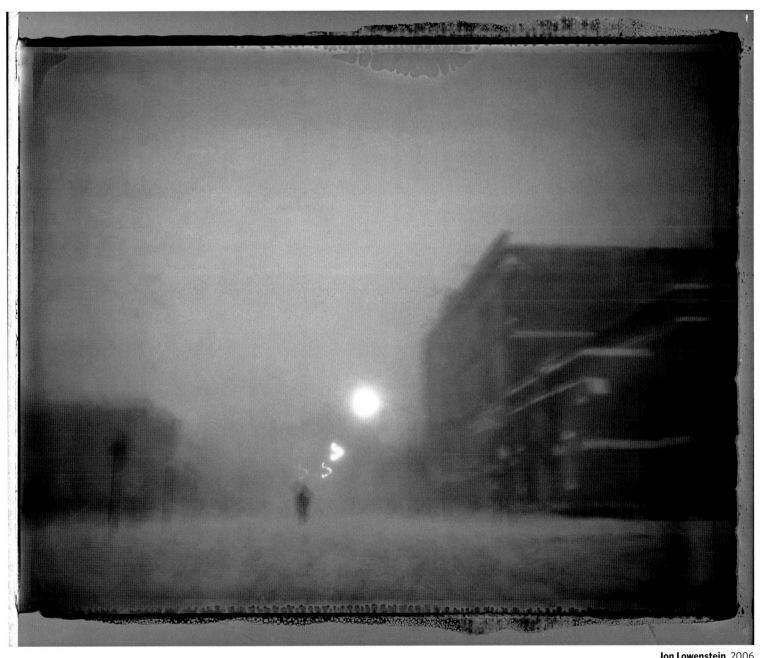

Winter transforms Chicago. **Above:** Trudging along Seventy-Second Street near Ellis Avenue. Jon Lowenstein (born 1970) used a Polaroid to document the South Side. "The camera was so automatic it gave me the chance to just respond—not to think." Because the instant camera produced positive and negative images, Lowenstein was able to give the positives to his subjects, which created a bond. **Opposite:** Looking south from atop the Park Lane Hotel onto Diversey Parkway and Cannon Drive in Lincoln Park.

Easter morning. Russell Lee (1903–1986) spent two weeks photographing Chicago's African American neighborhoods for the Farm Security Administration. He was guided around the South Side by the author Richard Wright, who introduced Lee to all types of people—from undertakers to physicians. Nearly a decade later, Lee wrote: "Whenever they asked me, 'What are you doing out here taking pictures?' I said, 'Well, I'm taking pictures of the history of today.' And they understood this." This photo was taken outside the Savoy Ballroom, at 4733 South Parkway, now Dr. Martin Luther King Jr. Drive.

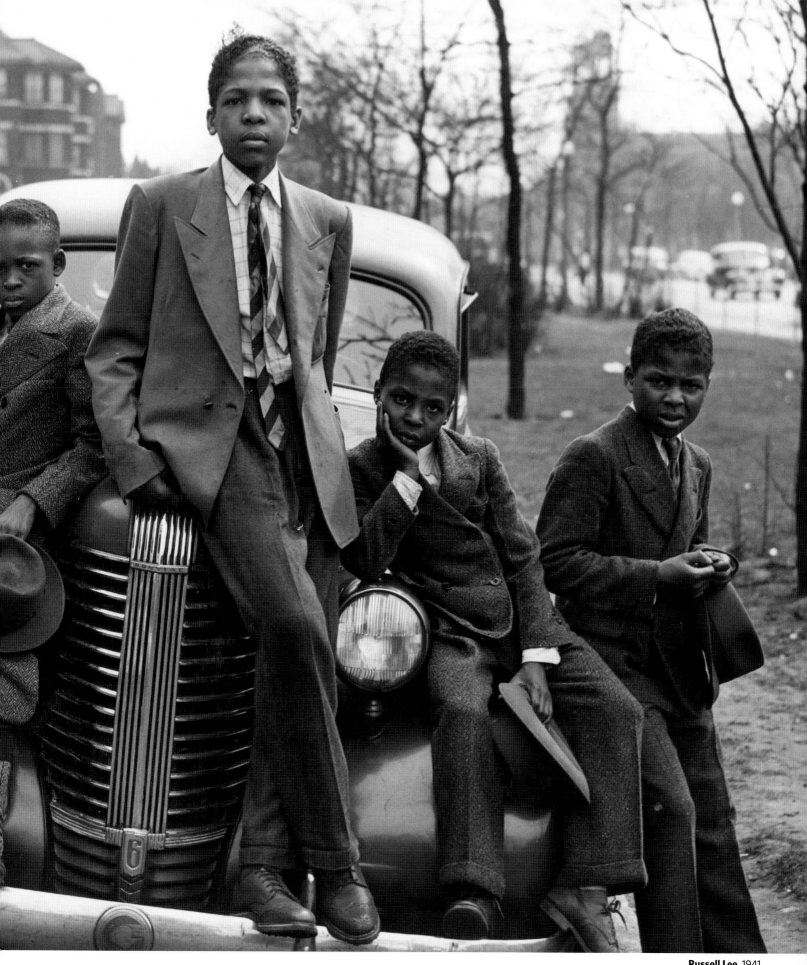

Russell Lee 1941

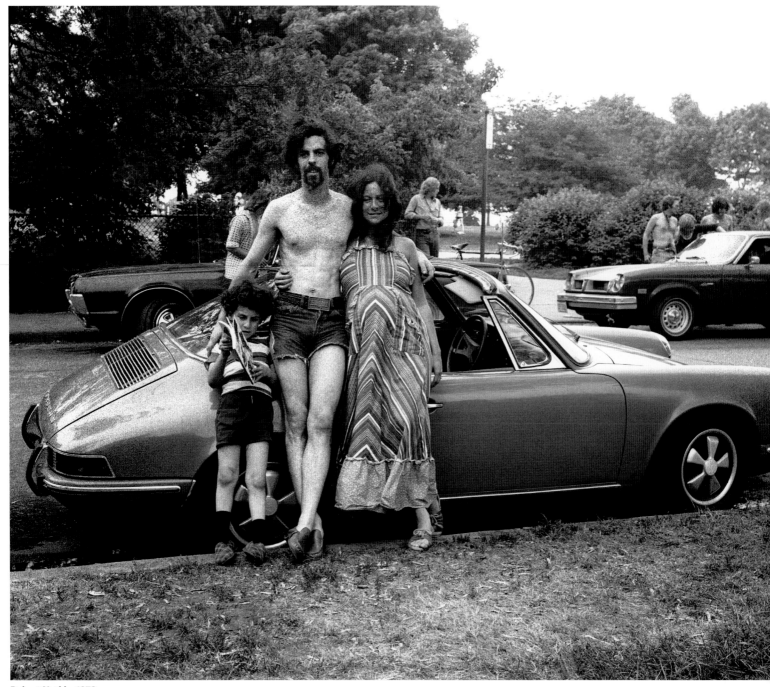

Robert Natkin 1973

Robert Natkin was born in Chicago and learned photography during World War II as a gunner in the Army Air Forces. He photographed for the Chicago Housing Authority after the war and took hundreds of freelance jobs all over the city. "He never looked at it as art," said his son Paul Natkin, himself a photographer. "It was like somebody working at a gas station." But by the 1970s, Natkin realized the historical importance of his work. He decided to return to the neighborhoods he had photographed to show how they had changed. Some might have concentrated on the architecture; Natkin focused on the people.

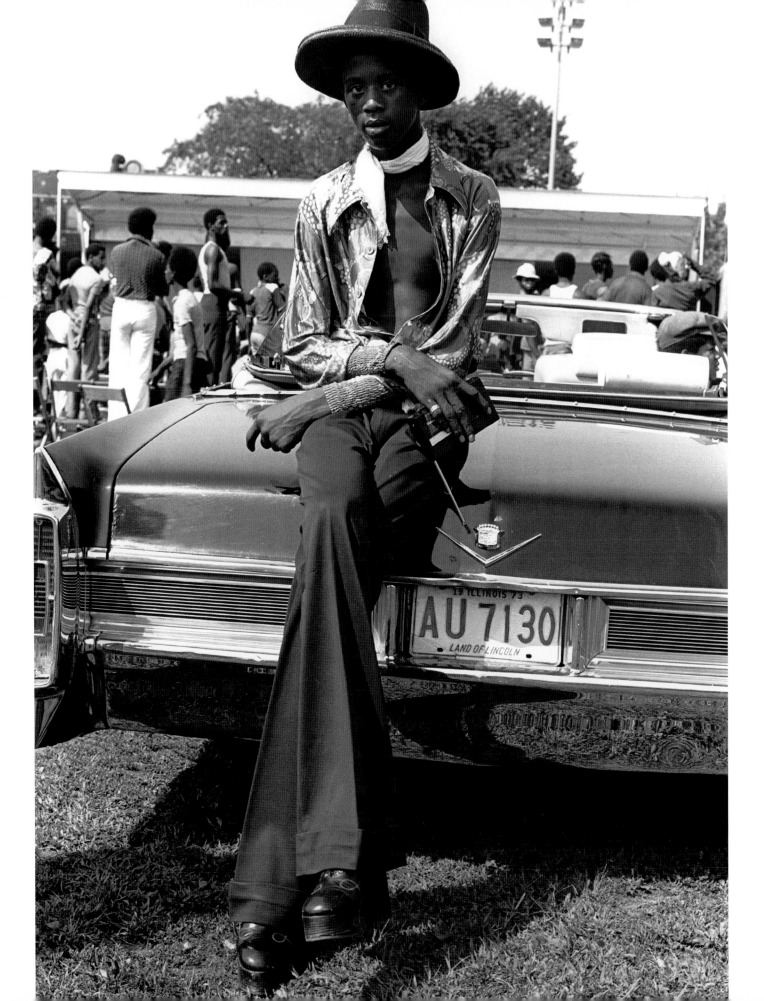

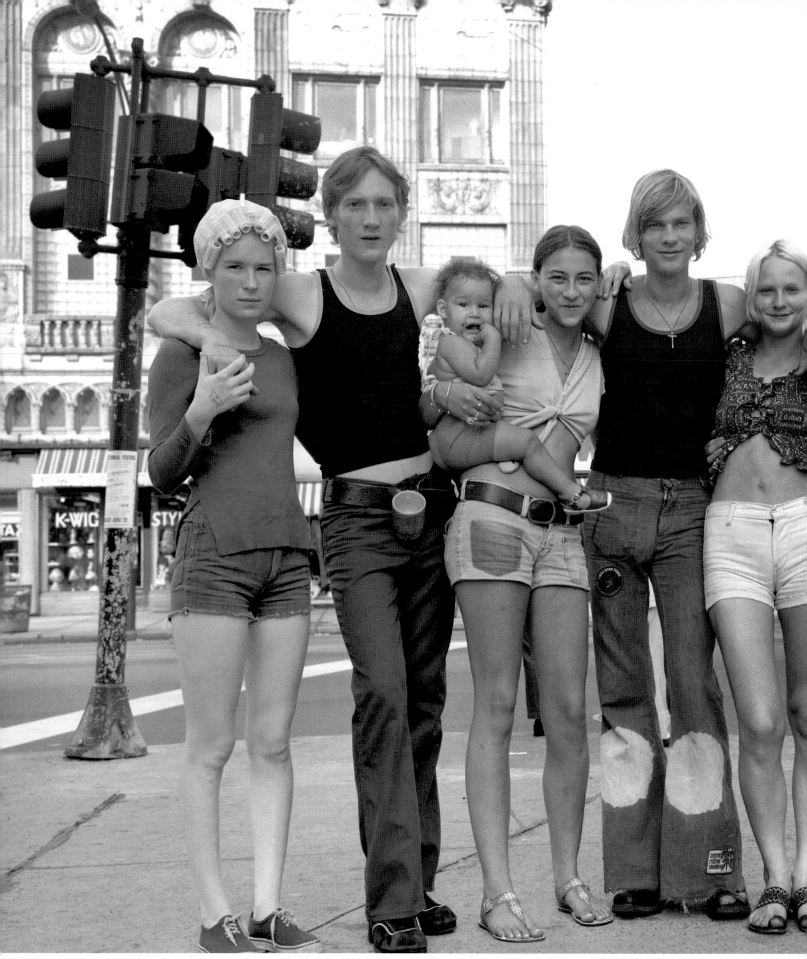

Robert Natkin Early 1970s

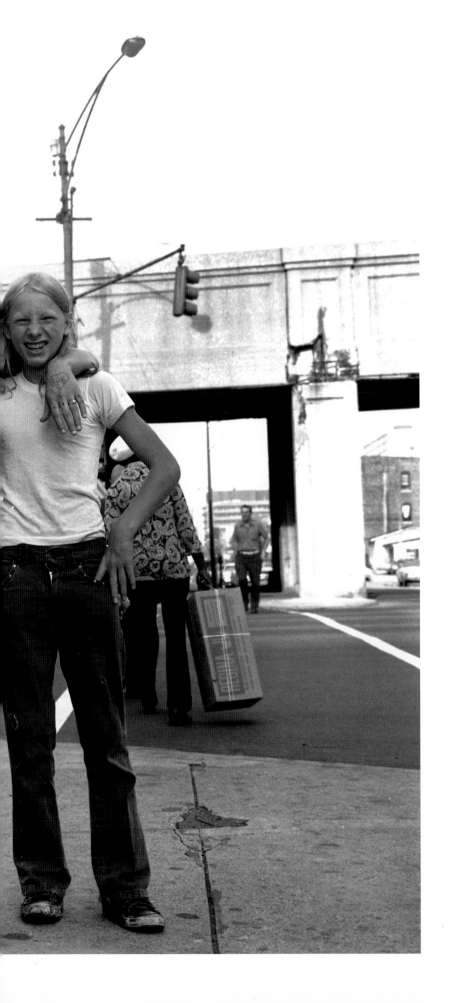

Robert Natkin roamed the city for several years, making intimate street portraits of the people he met. His trademark technique was to introduce himself, build a short but real relationship, and then ask to take a picture. "He didn't need a long lens," said son Paul Natkin. He took this photograph at the corner of Leland Avenue and Broadway in Uptown. Not long afterward, while he was relaxing on a bench after a neighborhood photo shoot one afternoon on the South Side, somebody walked up behind him, told him not to turn around, and ordered him to give up his equipment. "It totally destroyed his view of the world," said Paul. "From that day forward he never photographed people on the street again."

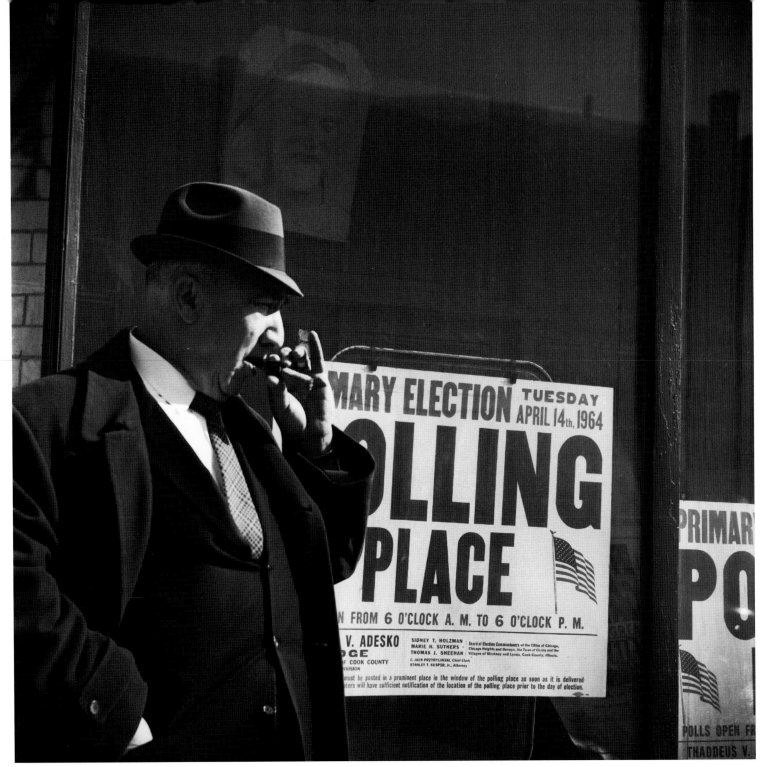

Stephen Deutch/Chicago History Museum 1964

The Chicago way. **Above:** "The Boss" is what Stephen Deutch (1908–1997) called his photograph of a ward heeler in front of a South Side polling station. Wrote Studs Terkel: "Is he watching a live one enter? Is he counting? He's biting hard on his stogie. He exudes confidence. Or does he? Deutch has us wondering. And mesmerized." **Opposite:** A drug deal on the Near North Side. Art Shay decided to photograph a heroin transaction after befriending Nelson Algren, who wrote *The Man with the Golden Arm,* a novel about a morphine addict.

Art Shay 1949 ▷

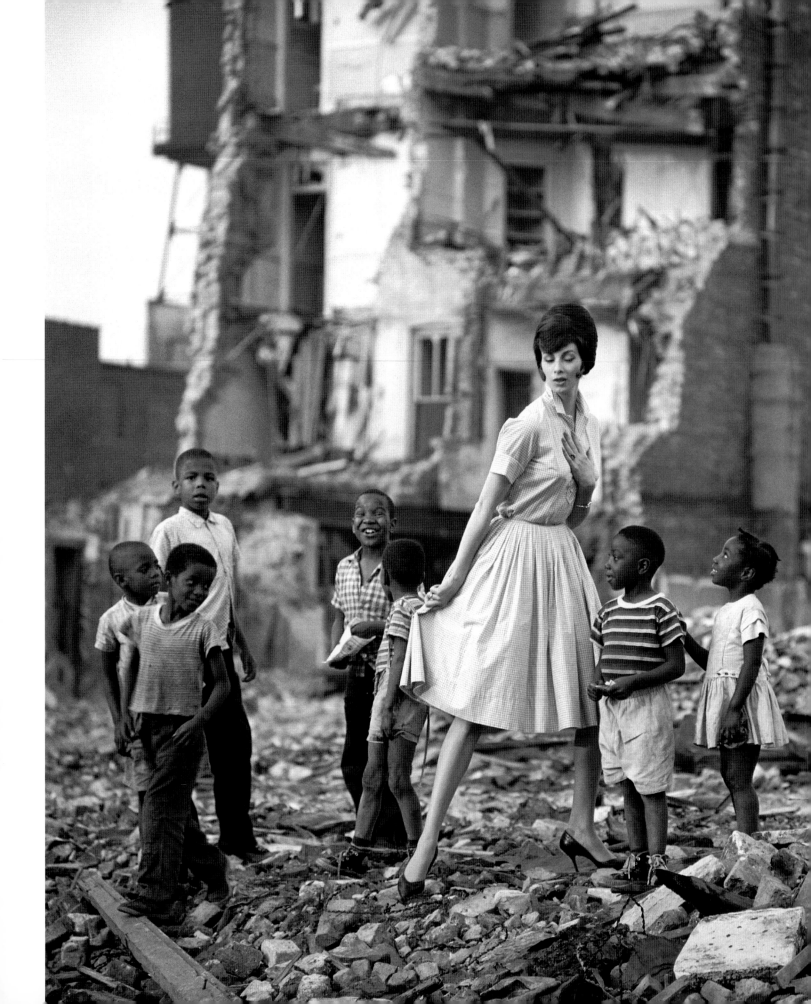

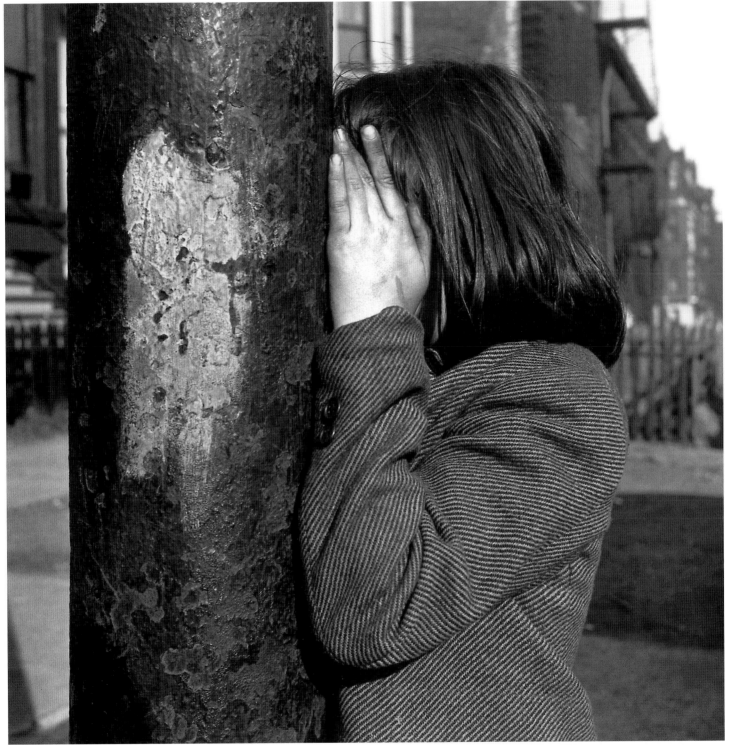

James P. Blair 1953

A quick look. **Above:** A child plays hide-and-seek on the Near North Side. **Opposite:** The aspiring model Gertrude Wilhelmina Behmenburg needed composite photos, so George Kufrin (1926–2016) took her to pose among the ruins of a furniture factory on Wells Street on the North Side. The children just showed up, Kufrin said. They never posed. Behmenburg changed her name to Wilhelmina and soon became a supermodel. She appeared on the cover of three hundred magazines, including twenty-eight times on *Vogue*. She later said she was "one of the few high-fashion models built like a woman."

◁ **George Kufrin** 1960

A crowd lines up for tickets at the Regal Theater, at 4719 South Parkway, just north of the Savoy Ballroom. Wrote Edwin Rosskam, who accompanied Russell Lee in photographing Bronzeville: "The children in front of the motion-picture house in the majority of cases come from 'kitchenette homes.' It is continually astonishing to see the high standard of appearance and clothing among people living in the worst slum conditions." Despite appearances, Lee wrote, the South Side was a "very depressing place." He returned to Chicago in 1948 to work with Esther Bubley to create the visual history of the Chicago, Burlington and Quincy Railroad Company.

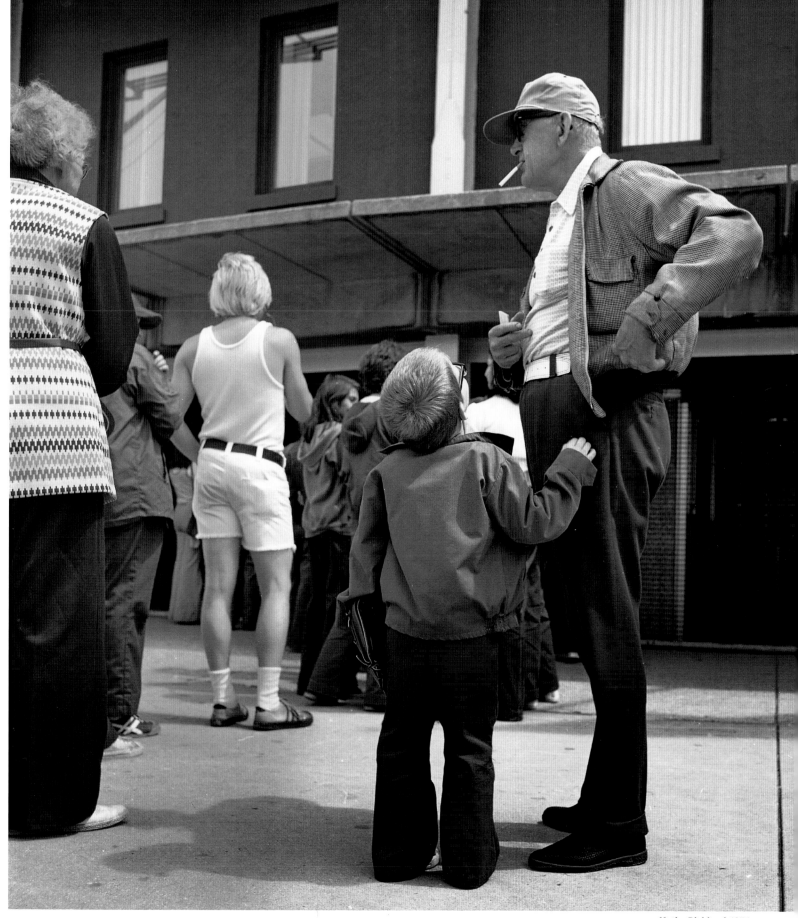

Kathy Richland 1976

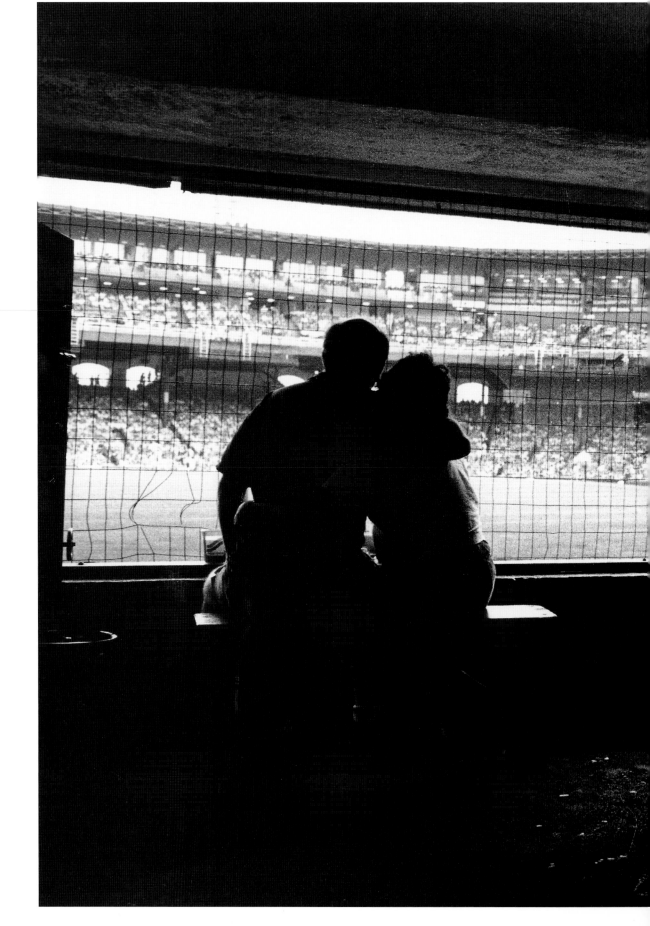

The picnic area at Comiskey Park, where people could watch a game from ground level in left field while eating a meal. Tom Harney (born 1946) started documenting the ballpark in the 1970s and continued until the last game there in 1990. "I came because I knew Comiskey would soon be gone," he said. Harney was attracted to the architecture and the fans. "Some would come to watch the games and keep score. Some went just to sit. Guys went to read newspapers and women to knit." Harney's photos were collected in his 2012 book *Portraits from the Park.*

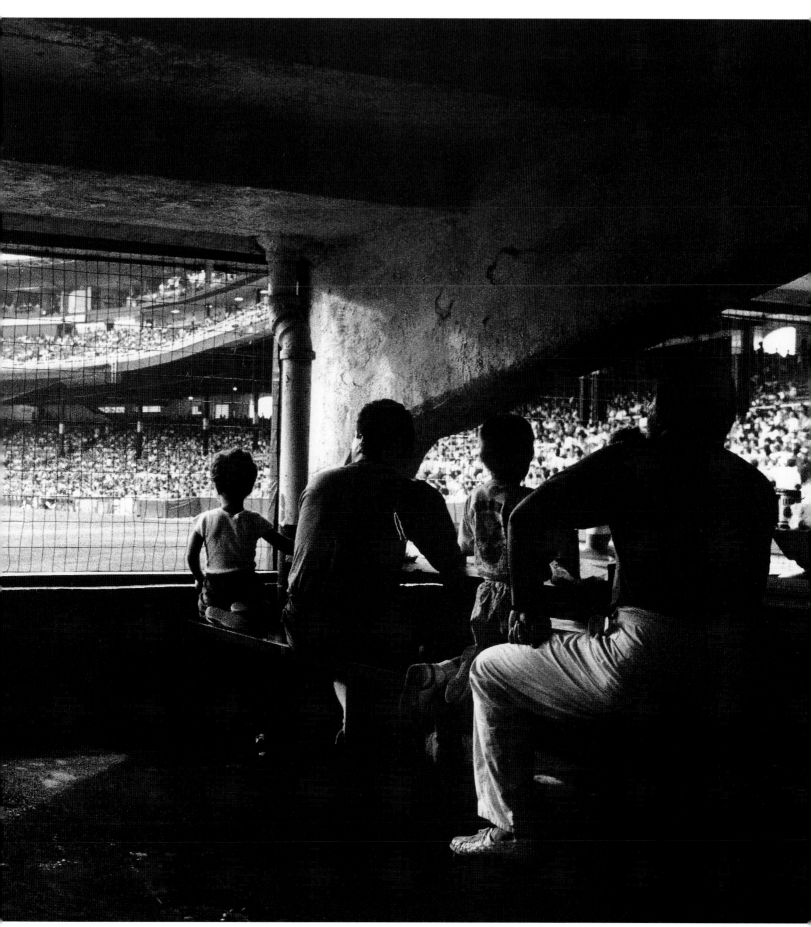

Tom Harney 1988

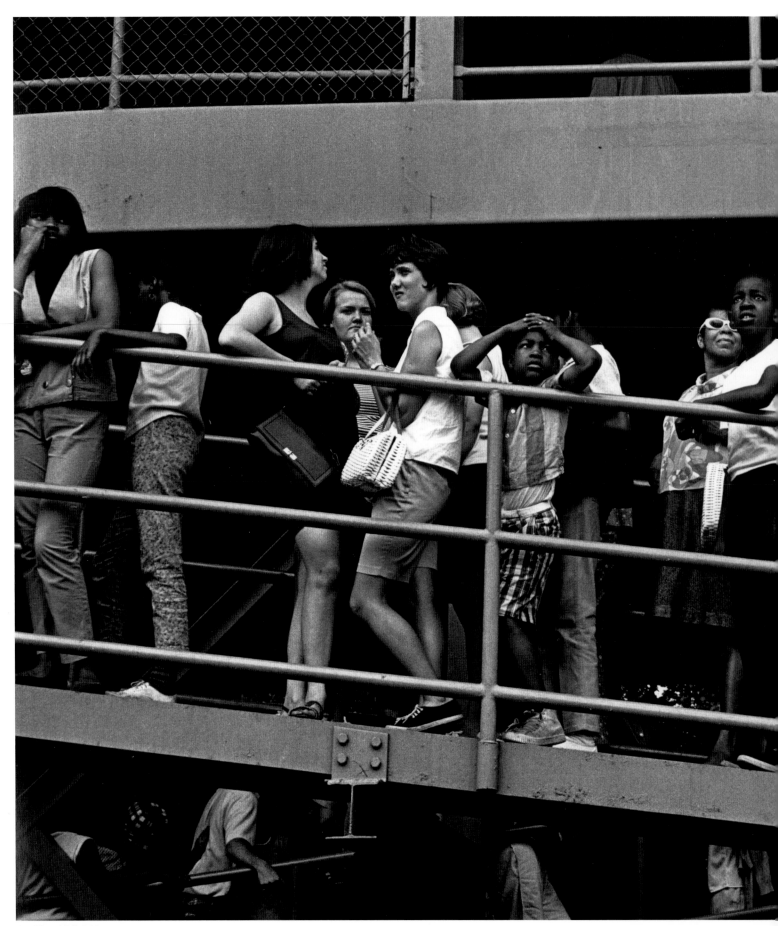

Jay King Mid-1960s

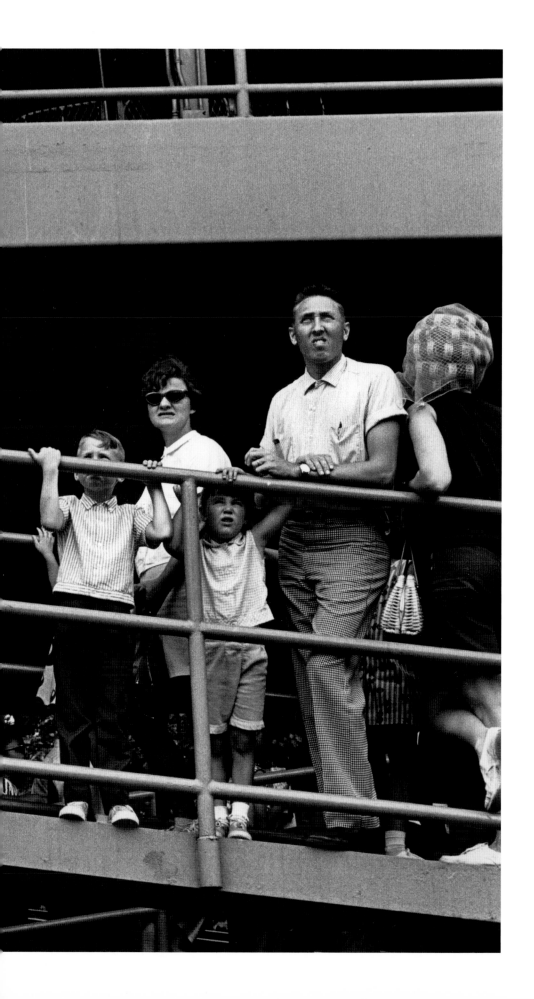

Waiting for a ride at Riverview amusement park, near Belmont and Western Avenues. Jay King had no long-term plan when he took up photography. "I thought capturing time was very interesting," he said. "I could snap a picture and have a permanent reminder of that moment." King was attracted to the random, unpredictable nature of what he and his camera found. "You go on the street and anything can happen. You are immersed in action." He uses a digital camera now because pressing the shutter button requires less commitment and costs less money. The results, he said, are just as fascinating.

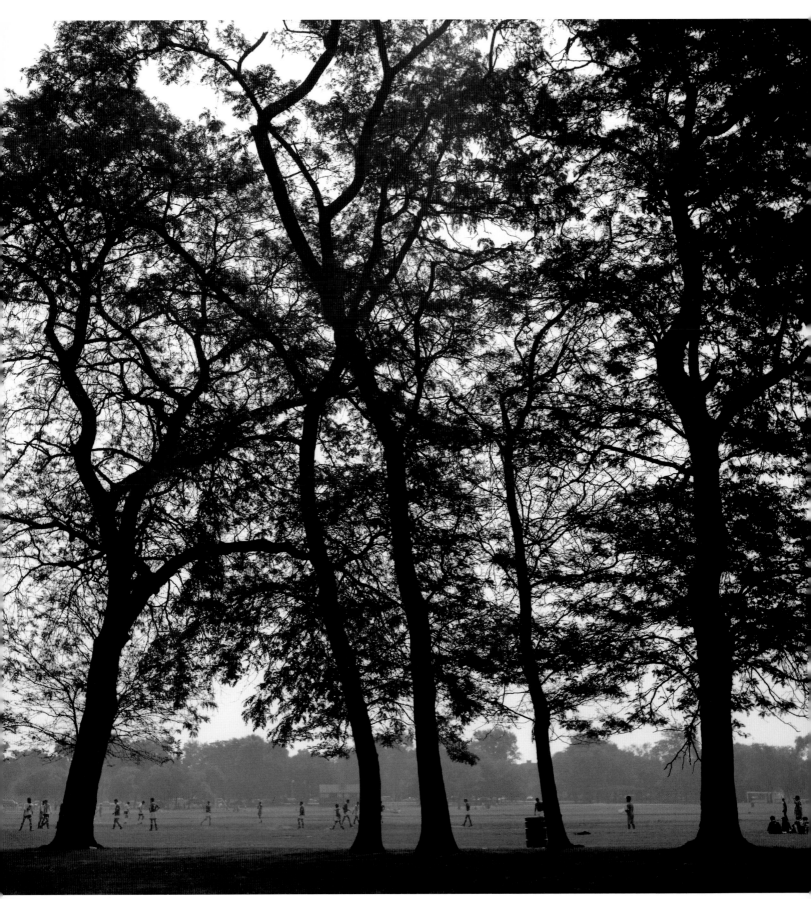

James Iska 1995

Joseph D. Jachna 1960

The natural order. **Above:** Joseph D. Jachna (1935–2016), a graduate of the Institute of Design, grew up in Chicago with a love of the natural world. "Every day so much happens—and I don't see it," he wrote in a diary in 1966. "Hardly anyone does. These limitless, complex, and often beautiful occurrences ought to be observed." **Opposite:** James Iska (born 1958), another graduate of the institute, started photographing city parks in 1995. Iska wanted to show that the work of the landscape designers Jens Jensen, Frederick Law Olmsted, and Alfred Caldwell is as integral to Chicago as the work of its famous architects. This is a soccer game in Jensen's Douglas Park.

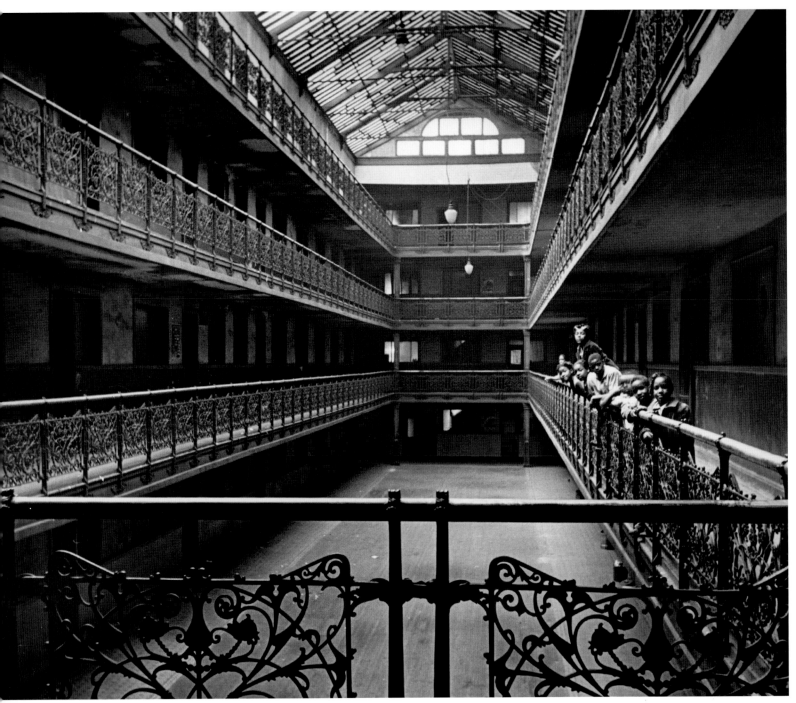

Gordon Coster 1944

Wrought-iron memories. **Above:** The Mecca Flats, an apartment building at Thirty-Fourth and State Streets, during its last decade. Built as an architectural gem just before the World's Columbian Exposition of 1893, it became a notorious slum before it was razed in 1952. **Opposite:** From the porch of 1521 North Hoyne Avenue in Wicker Park. Clarence John Laughlin (1905–1985), known for his surreal photographs of the South, traveled to Chicago to document the "roles of fantasy and decoration" in the city's Victorian homes. "Everything, everything, no matter how commonplace and how ugly, has secret meanings," he said.

Clarence John Laughlin/Chicago History Museum 1962 ▷

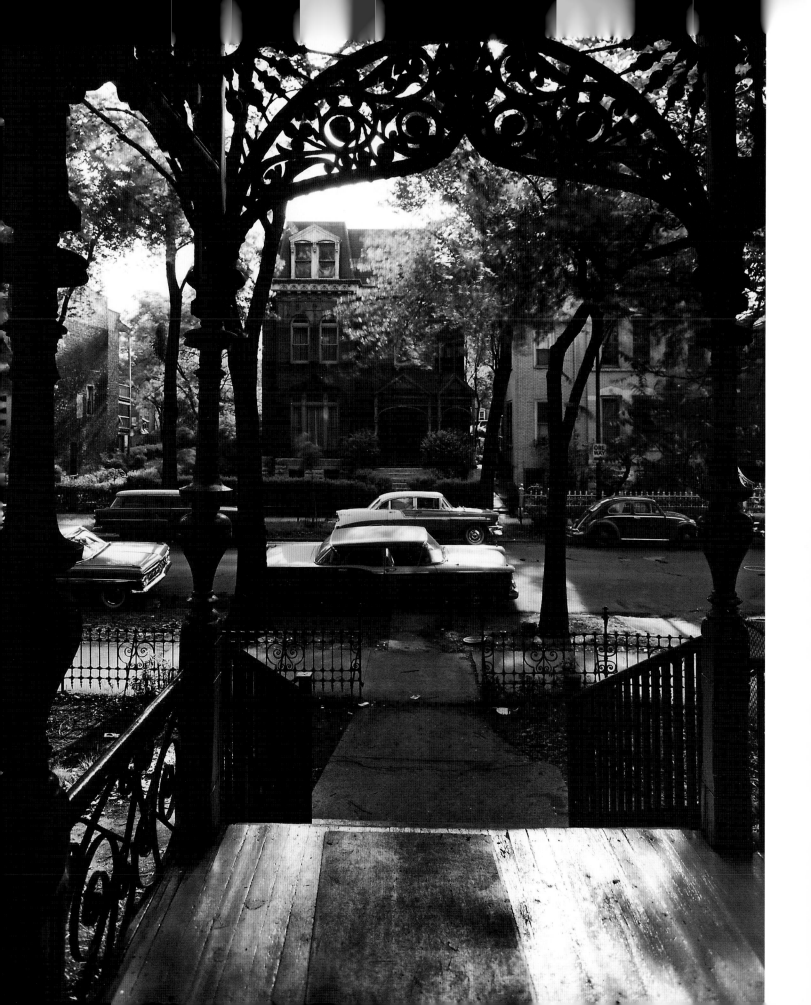

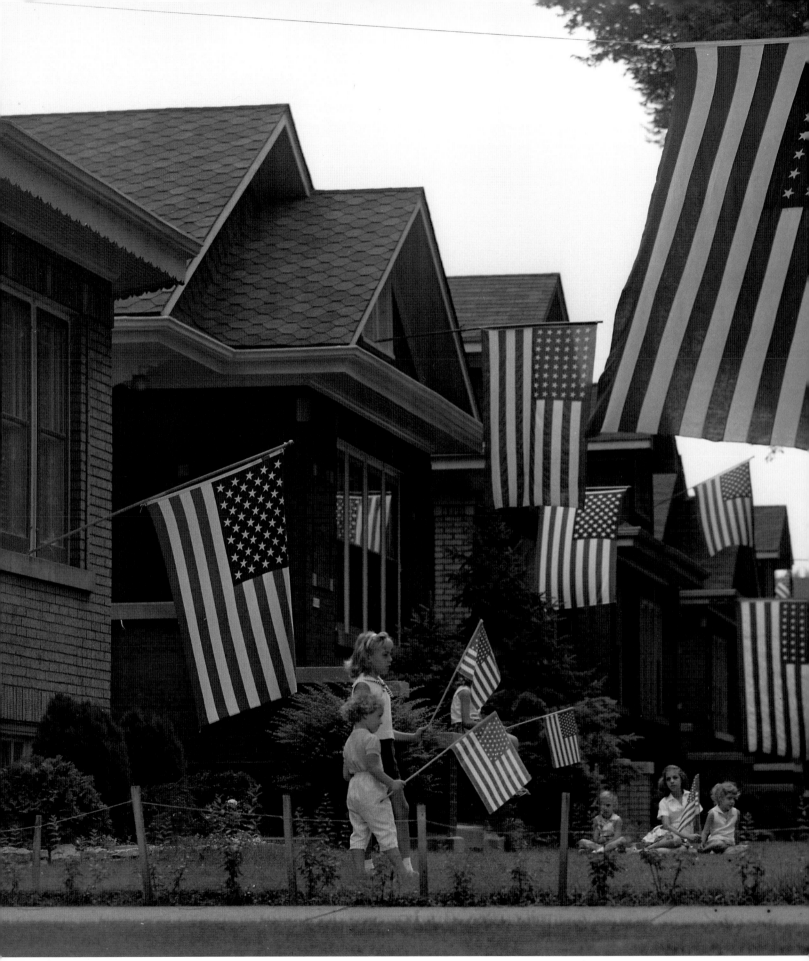

Ralph Arvidson/Chicago Sun-Times 1962

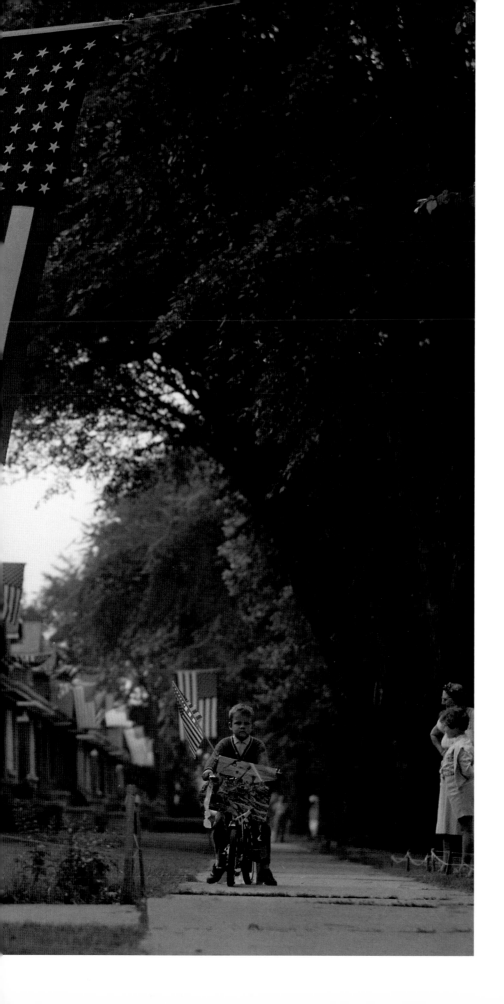

Fourth of July on the 6100 block of West Eddy Street. About eighty thousand single-family homes in Chicago are bungalows. Most are in neighborhoods on the outskirts of the city, like Portage Park on the Northwest Side. Ralph Arvidson (1926–2006), who worked for more than four decades for the *Chicago Sun-Times,* wrote that every home and every child on the block was given a flag to mark the holiday.

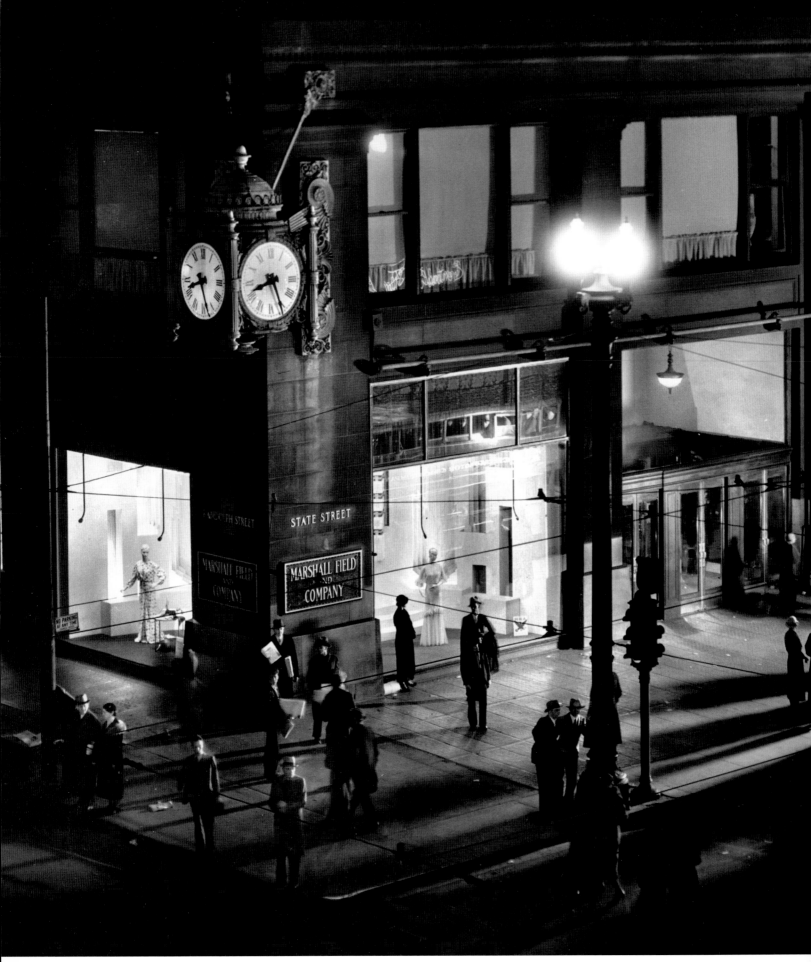

Gordon Coster 1930s

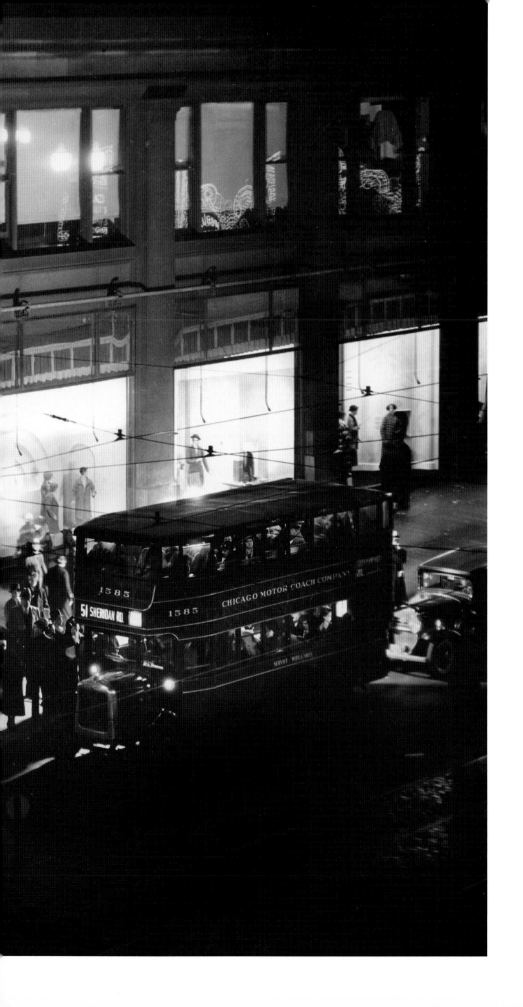

MRS. SARDOTOPOLIS' EVENING OFF

4

Chicago after dusk is seductive. Buses run through the Loop. Stores are open late, and windows reflect the city's white ways. The intensity and energy of its jazz clubs and blues joints, its fairs and carnivals, spill into the neighborhoods. Night moves are less formal. The air is charged— soft and enveloping. Cameras, now almost secret, can peer with hardly a notice. All is framed in black.

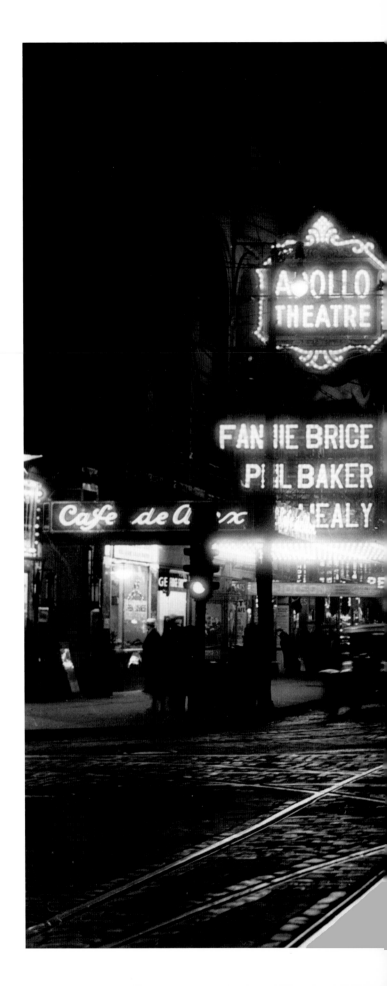

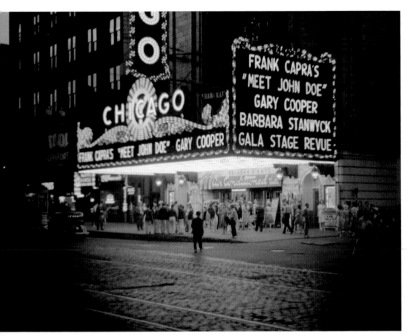

John Vachon 1941

Cobblestone nights. **Above:** The Chicago Theatre on State Street near Lake Street. "How sad, to leave Chicago," wrote John Vachon to his wife in 1941. "I have had a wonderful week, and such dandy fun, and seeing so much going on—cab drivers looking at maps of Russia, and arguing about the war, one guy points and says that's where his old man is from. And all the snotty dames on Michigan Ave. that I want you to emulate." **Right:** Looking east on Randolph Street from Clark Street near City Hall. Once a thriving theater district, only the Oriental Theatre remains on that block. The Apollo closed in 1949, the Garrick in 1960, and the United Artists in 1987. Streetcars stopped running in 1958.

Next spread: A contact sheet of Richard Nickel's images of moviegoers leaving the State-Lake Theater after a showing of *The Robe*. Nickel focused on faces. "In a sense, I believe, I was unconsciously trying to know people," he said, "to find something strong and universal about them."

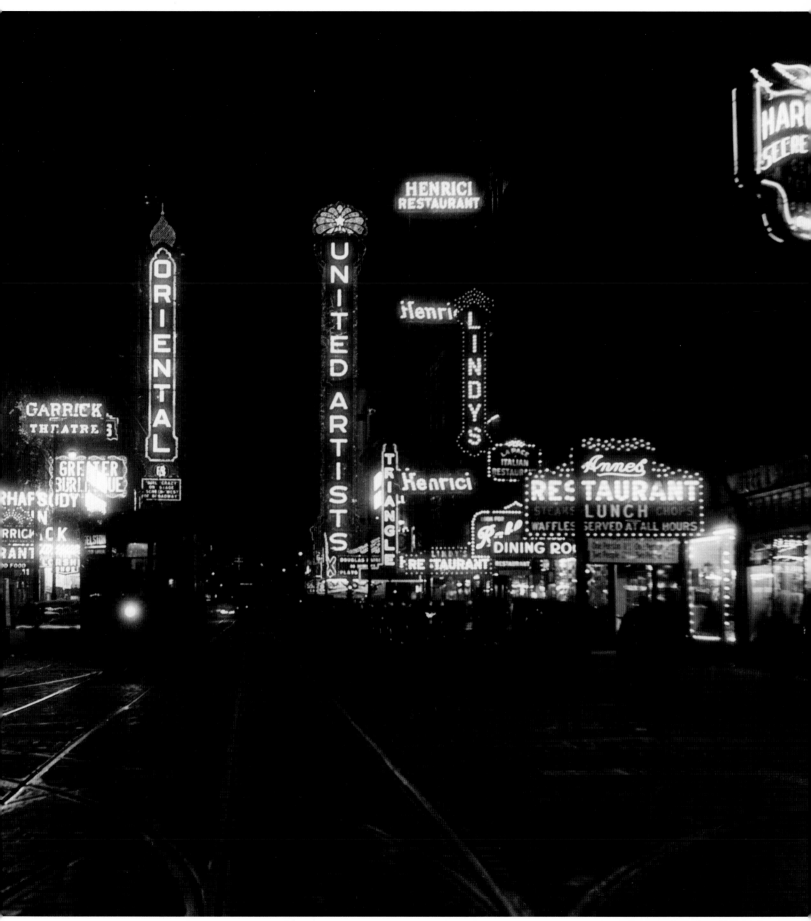

Chicago Surface Lines Photo 1931

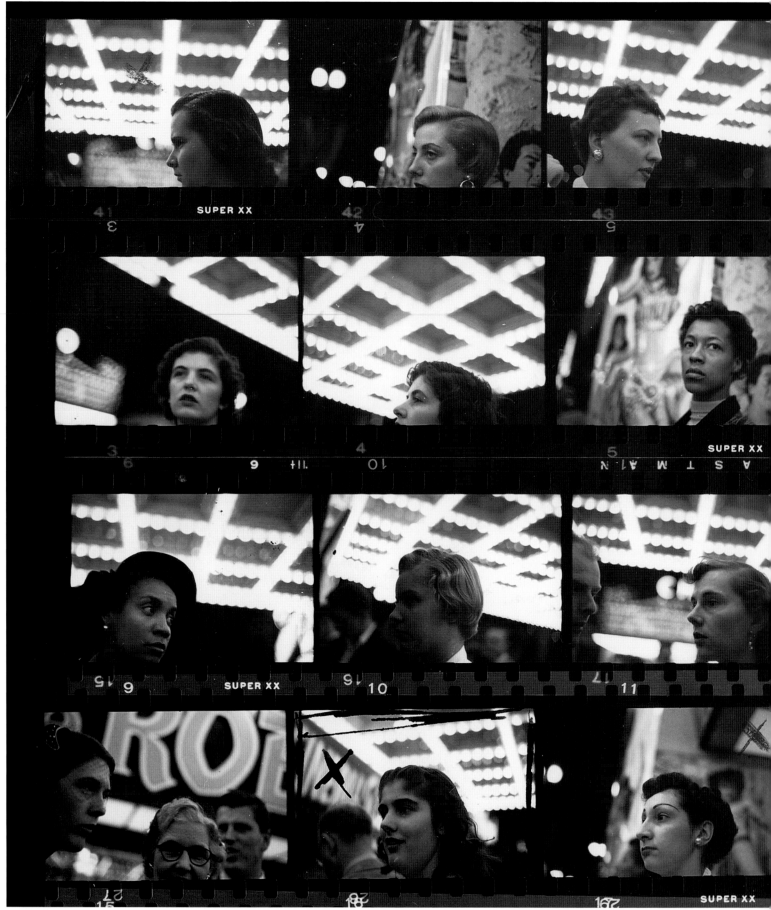

Richard Nickel 1953

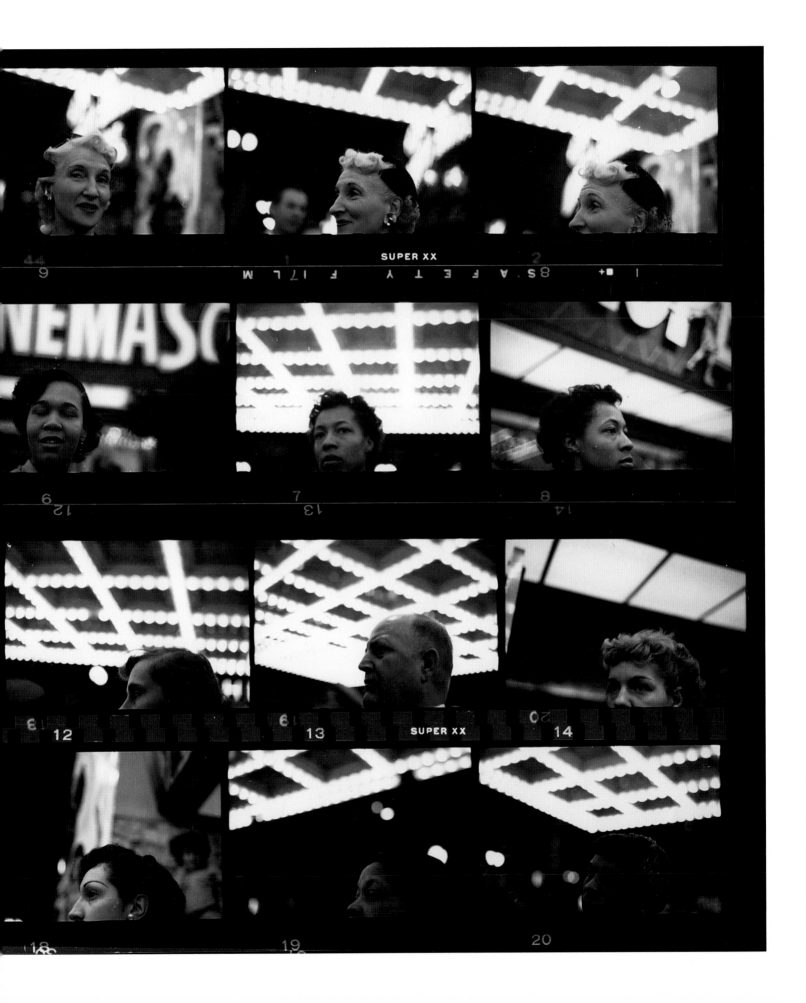

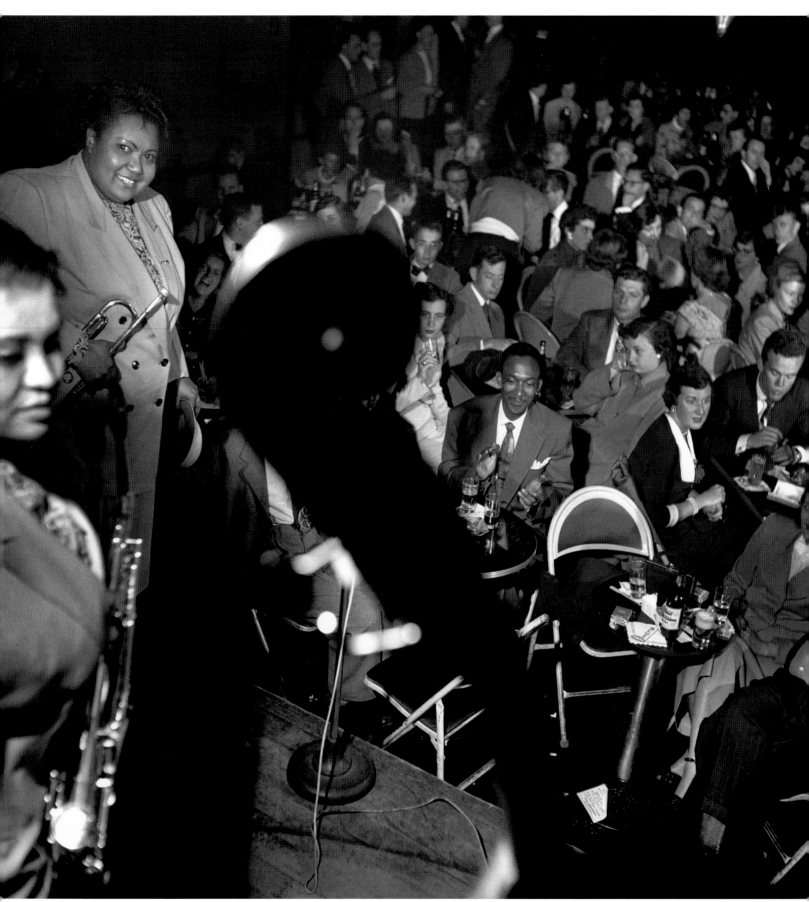

Robert Natkin Early 1950s

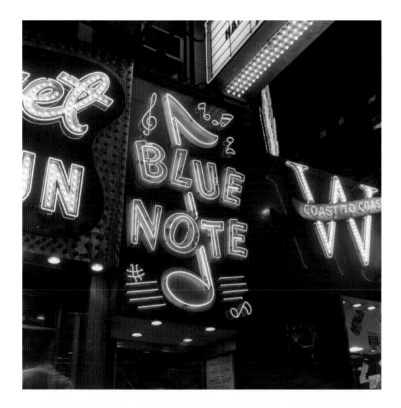

Don Bronstein 1950s

Jazzy nights at the Blue Note. **Above** (clockwise from top right): Billy Taylor's fingers, Ahmad Jamal's feet, Earl May's hands, and the jazz club's neon sign. With two locations near Clark and Madison Streets, the Blue Note was the venue for big-name jazz artists from 1947 to 1960. Don Bronstein (1927–1968) was all over the Chicago entertainment scene during those years. **Opposite:** Ernestine "Tiny" Davis, known as the female Louis Armstrong, at the Blue Note.

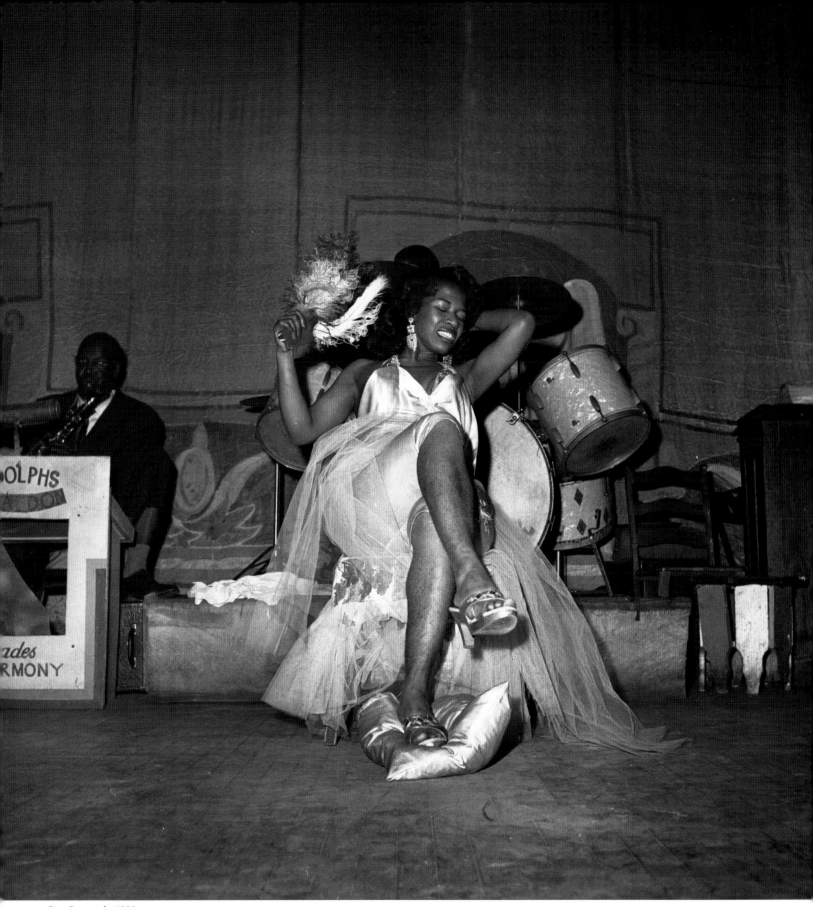

Don Bronstein 1950s

The Indiana Theater, on Forty-Third Street near Indiana Avenue, advertised "Loop Vaudeville at One-Half Loop Prices!" Don Bronstein was the house photographer for Chess Records and the first staff photographer for *Playboy* magazine. His photos of the Indiana are some of the only photos of South Side vaudeville houses. He spent a year documenting the city for his 1967 book *Chicago, I Will.*

Marc PoKempner 1979

Sammy Lawhorn (left) and John Primer share the stage at Theresa's Lounge, a basement bar at Forty-Eighth Street and Indiana Avenue that closed in 1983. "Whatever else it may be, blues is about the communication of emotion," wrote Marc PoKempner (born 1948) in his 2000 book *Down at Theresa's: Chicago Blues.* "When Sammy Lawhorn's broken fingers bend his guitar strings so the notes pour down like a perfectly rhythmical sweet spring storm and his feelings rush out in clear full chords that wash my soul clean, I'd like to turn the world on to his music."

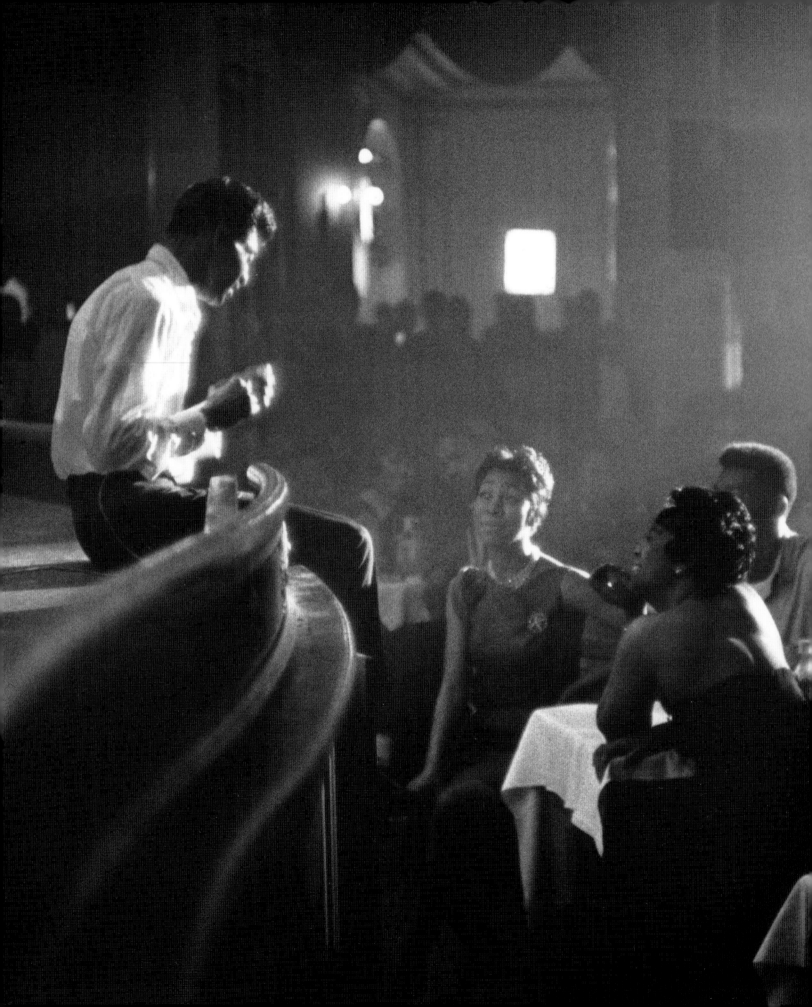

The rhythm-and-blues artist Al "TNT" Braggs at the Trianon Ballroom, at Cottage Grove Avenue and Sixty-Second Street. "The Trianon Ballroom caught me by surprise," wrote Raeburn Flerlage (1915–2002) in his 2000 book *Chicago Blues as Seen from the Inside.* "Spectacularly ornate, with vast reaches extending into high balconies and multiple stage settings, it was unlike anything I'd ever seen, certainly not like the little blues clubs that dotted the Southside." Flerlage moved to the South Side in 1944 and photographed entertainers at clubs several nights a week from about 1959 until 1971. "Chicago blues in the '60s was an event that needed to be documented," he wrote.

Raeburn Flerlage 1964

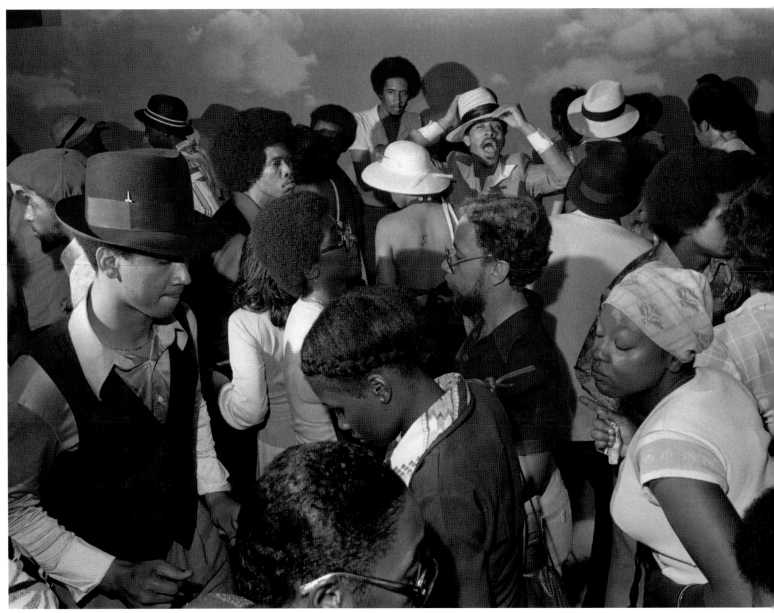

Michael Abramson Early 1970s

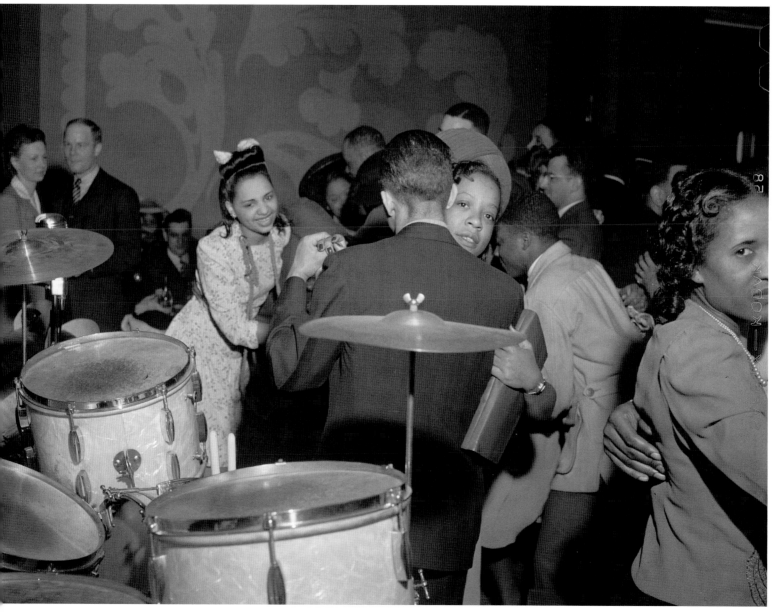

Jack Delano 1942

The beat goes on. **Above:** Dancing at the Club DeLisa, a "black-and-tan," or integrated, twenty-four-hour nightclub at 5521 South State Street. It was open from 1934 to 1958. The drums belonged to Red Saunders's house band. **Opposite:** Three decades later, dancing at Perv's House, at 914 East Seventy-Ninth Street. Michael Abramson (1948–2011) spent more than two years documenting African American dance clubs. Perv's, he noted in his 2009 book *Light: On the South Side,* was the Cadillac of clubs, a Playboy Club for the South Side. "I enjoy the fantasy that separates whimsical nightlife from the programmed pace of the daytime," he wrote.

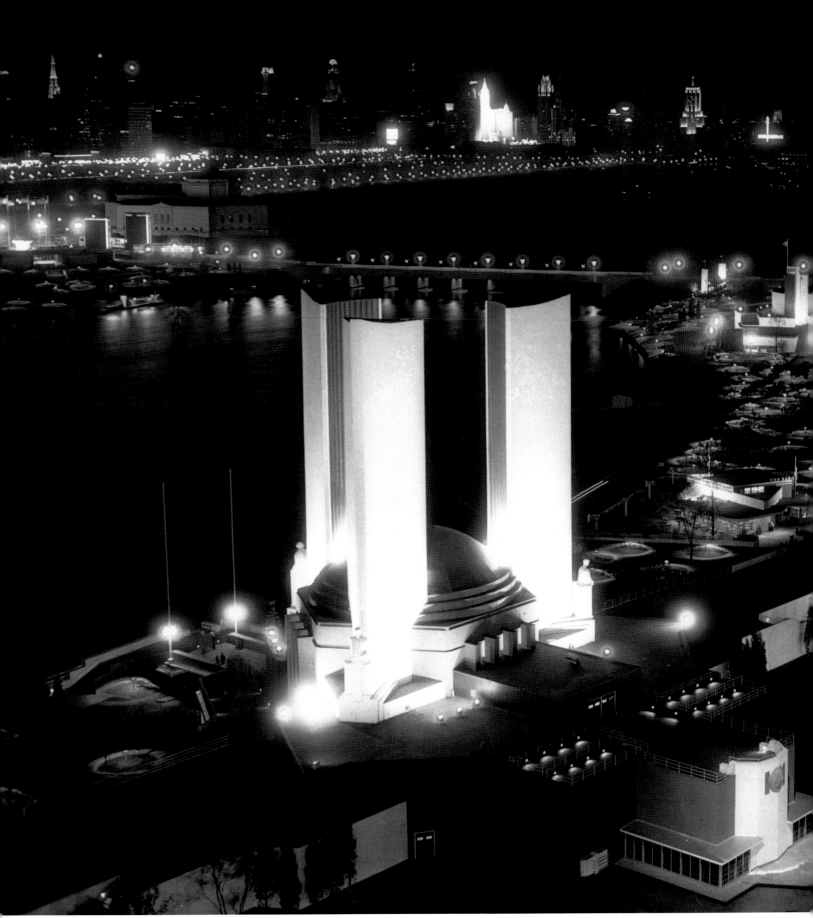

Unknown Photographer 1933

The illuminated Federal Building at the Century of Progress. The towers represented the three branches of government. In the background was the Twelfth Street Bridge, which connected the man-made Northerly Island, where the World's Fair was held during the summers of 1933 and 1934, to the Shedd Aquarium. The Wrigley Building, Tribune Tower, and Palmolive Building can be seen in the distance.

Steve Lasker/Chicago's American 1965

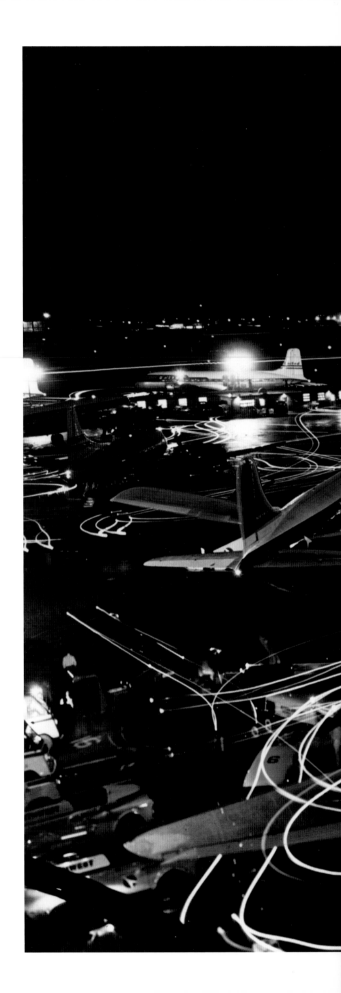

Night flights. **Above:** Northerly Island became Meigs Field more than a decade after the fair closed. Meigs was one of the nation's busiest single-strip airports until Mayor Richard M. Daley bulldozed it in 2003. The Main Terminal Building is now a Chicago Park District field house, part of Northerly Island Park. Steve Lasker (born 1930) photographed it often during his years with the *Chicago's American*. Lasker, the first photographer to arrive at the catastrophic crash of a Green Hornet streetcar in 1950 and at the fire at Our Lady of the Angels School in 1958, took memorable pictures of both. **Right:** A long exposure shows the streaks of light created by planes at O'Hare Airport in 1958, the year runways were extended to accommodate jets.

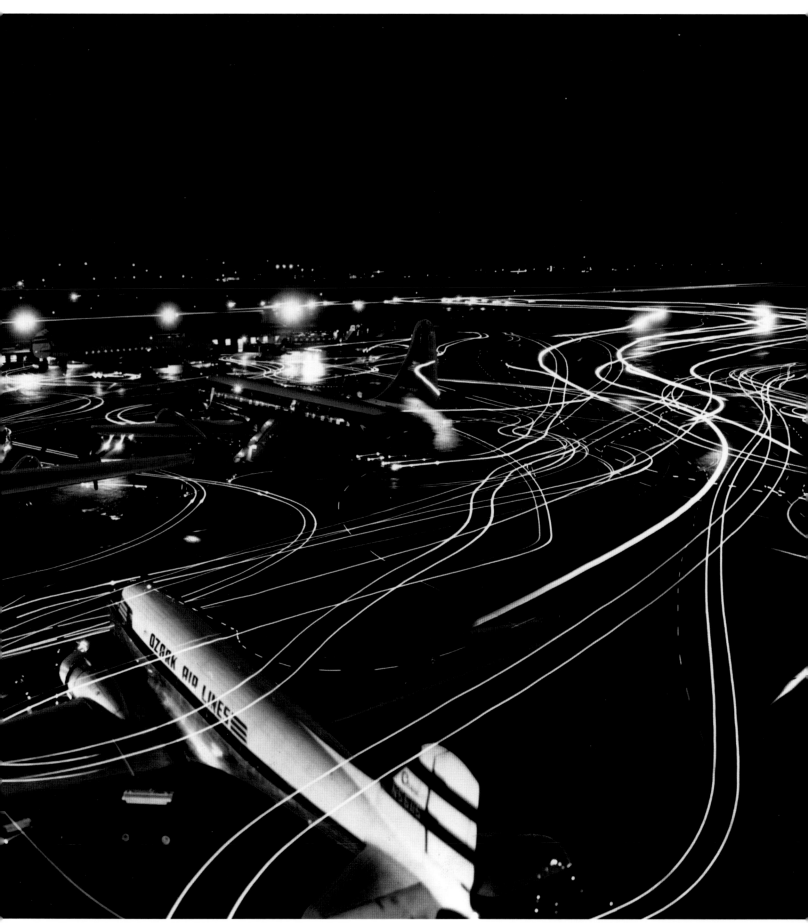

Unknown Photographer/Chicago Sun-Times 1958

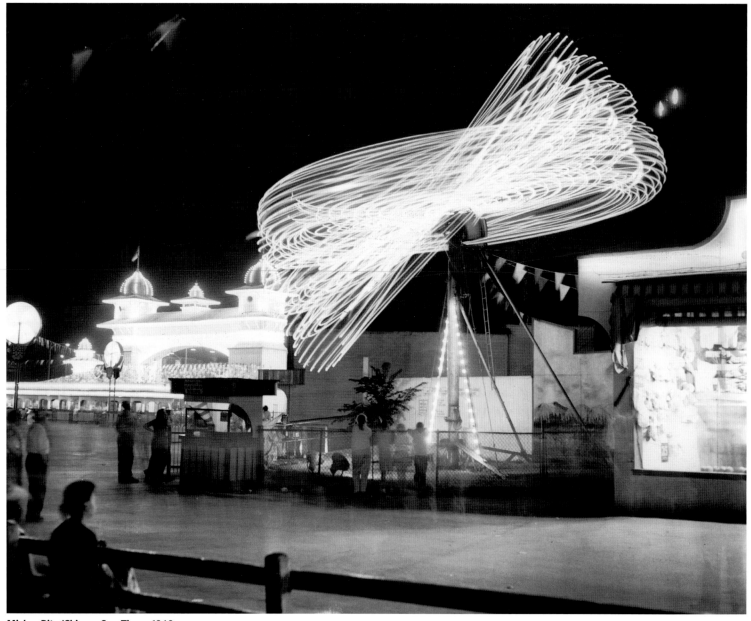

Mickey Rito/Chicago Sun-Times 1960

Beloved Riverview Park. **Above:** Mickey Rito (1913–1979) photographed the Roll-O-Plane near the amusement park's main entrance on Western Avenue north of Belmont Avenue. **Opposite:** A couple in front of the merry-go-round. Riverview was a perfect venue for a street photographer. "It was where all the action was," said Jay King. "Plenty of people. Things were happening." In the far background is the shoot-the-chutes. The park closed in 1967.

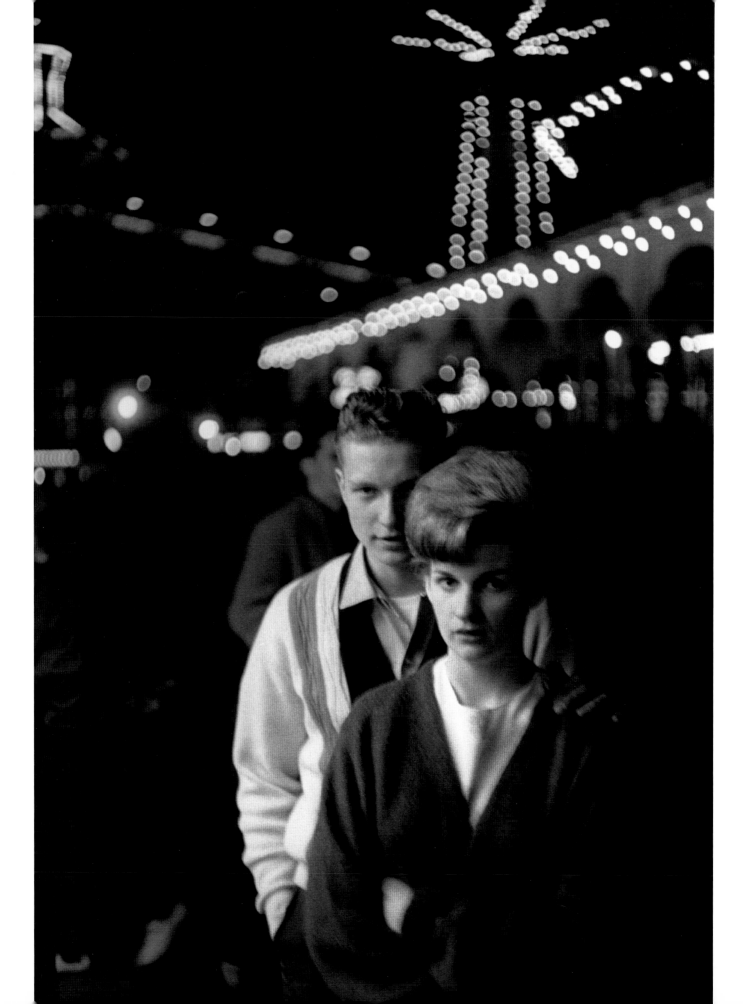

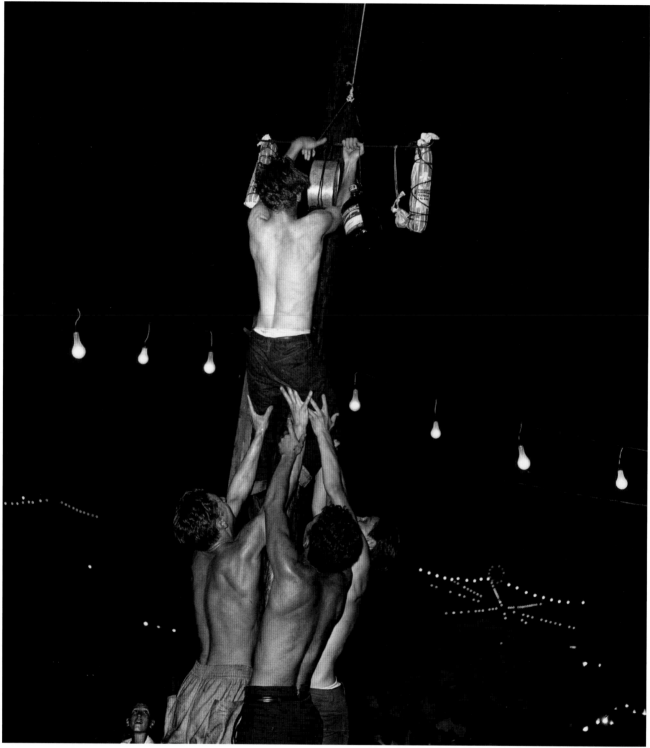

Louis Giampa/Chicago Sun-Times 1953

Summer carnivals. **Above:** Boys climb for sausages at an Italian festival at Chicago Avenue and Pulaski Road. Louis Giampa (1918–1970) ran an Italian restaurant on the side during his years as a photographer with the *Chicago Sun-Times*. **Opposite:** A thirteen-year-old girl breaks a piñata at a San Juan's Day celebration at the Chicago Avenue Armory. Bob Kotalik (1925–2013) began work at the *Sun-Times* taking care of its pigeons, which were used to carry film from sporting events back to paper's downtown offices. He must have done well, because he soon became a photographer and later served as photo chief.

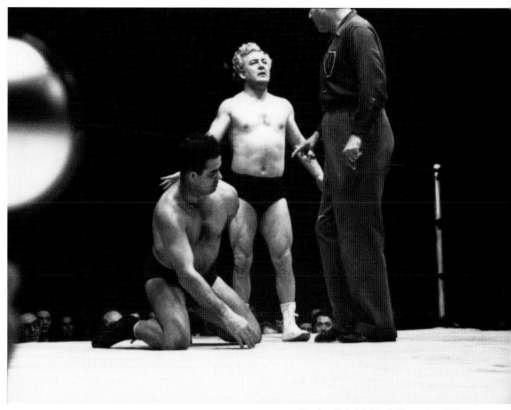

Stanley Kubrick/Look Magazine 1949

Rings of glory. **Above:** Gorgeous George defeats Ralph Garibaldi before a full house at the International Amphitheater, at Forty-Second and Halsted Streets. Stanley Kubrick (1928–1999) took the photograph of the wrestling exhibition prior to his career as a director, producer, screenwriter, and cinematographer. Kubrick became a staff photographer for *Look* at seventeen and worked at the magazine through the late 1940s. His pictures were used in its 1949 photo essay "Chicago: City of Extremes." **Left:** Boxing night at the Chicago Stadium. Known as the Madhouse on Madison, the stadium was the site of many major boxing matches. It was torn down in 1995.

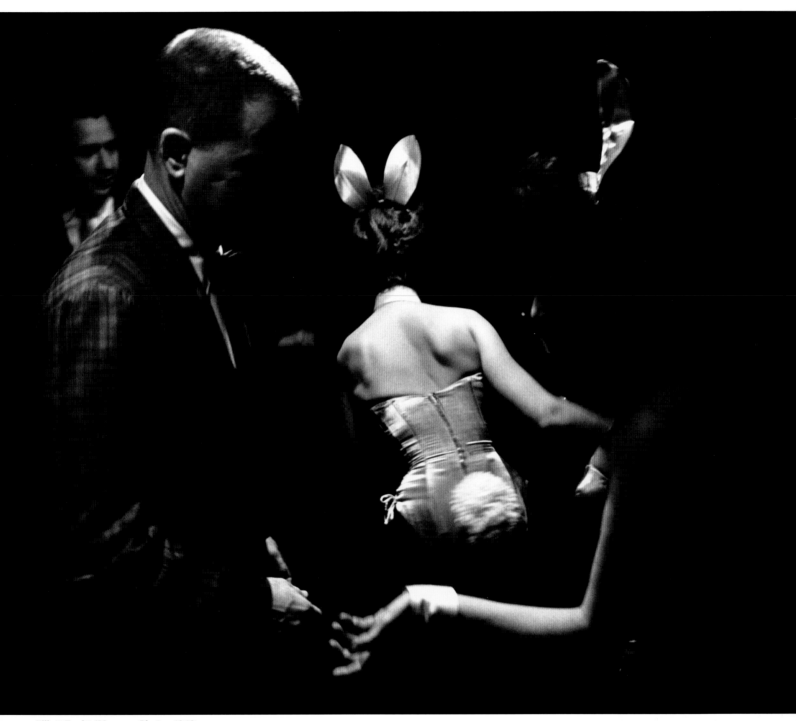

Elliott Erwitt/Magnum Photos 1962

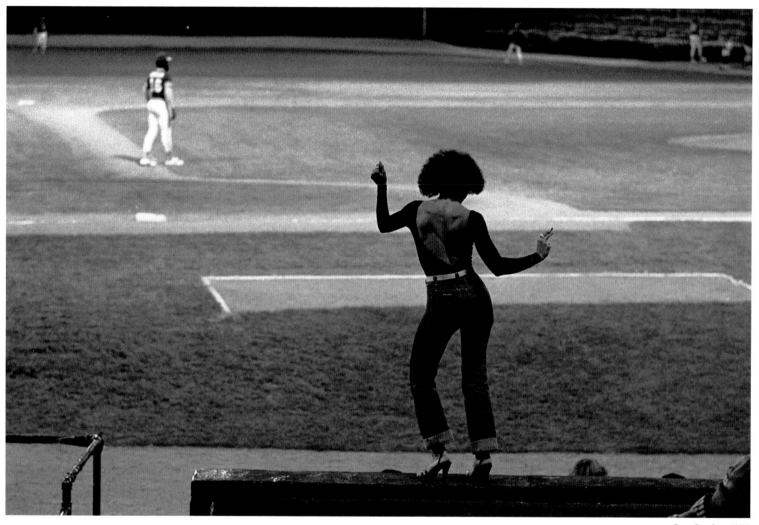

Ron Gordon 1978

Chicago samba. **Above:** Dancing atop the dugout at Comiskey Park toward the end of Bill Veeck's ownership of the White Sox. Ron Gordon (born 1942) sold peanuts at the park as a boy. Years later, he returned with a press pass. **Opposite:** At the Playboy Club, which opened in Chicago in 1960. An internationally known photographer, Elliott Erwitt (born 1928) started working for the photo agency Magnum in 1953. He rarely staged pictures, waiting instead for the moment when the scene before his camera resolved. "Photography is pretty simple stuff," he said. "You just react to what you see, and take many, many pictures."

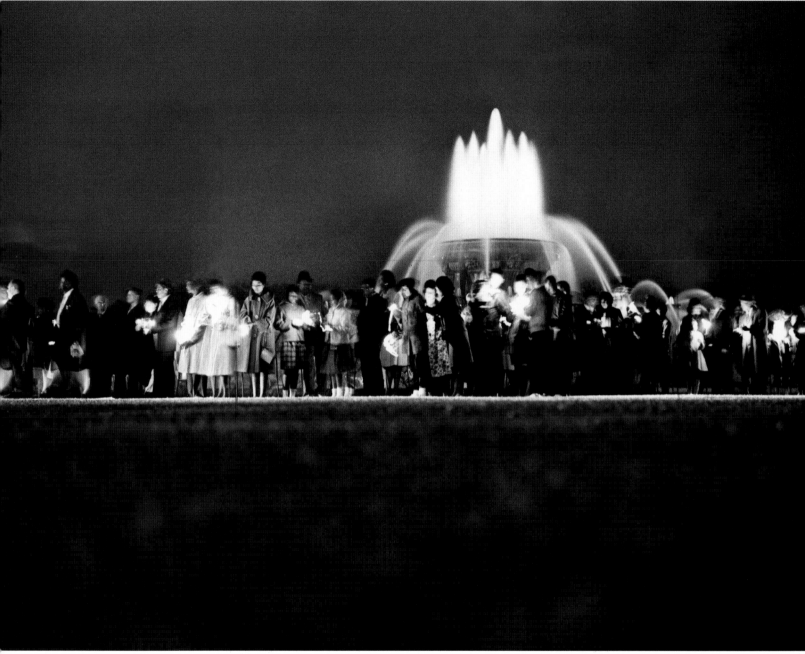

Larry Nocerino/Chicago Sun-Times 1963

The city that spouts. **Above:** In 1963, more than a thousand Chicagoans gathered for a vigil at Buckingham Fountain in Grant Park for the four girls who died in the Sixteenth Street Baptist Church bombing in Birmingham, Alabama. Larry Nocerino (1914–1974) worked as a newspaper photographer for thirty years, but it took a toll. A year after retiring, he wrote to his old colleagues that he now enjoyed "thinking nothing about storms, tornados, floods, cold nights, noise, pollution, riots, shootings, fires, two-hour editions, rush-hour traffic, gangs and dogs." **Opposite:** Crown Fountain in Millennium Park replaced Buckingham as the city's favorite. Ron Seymour (born 1936) photographed it soon after it opened.

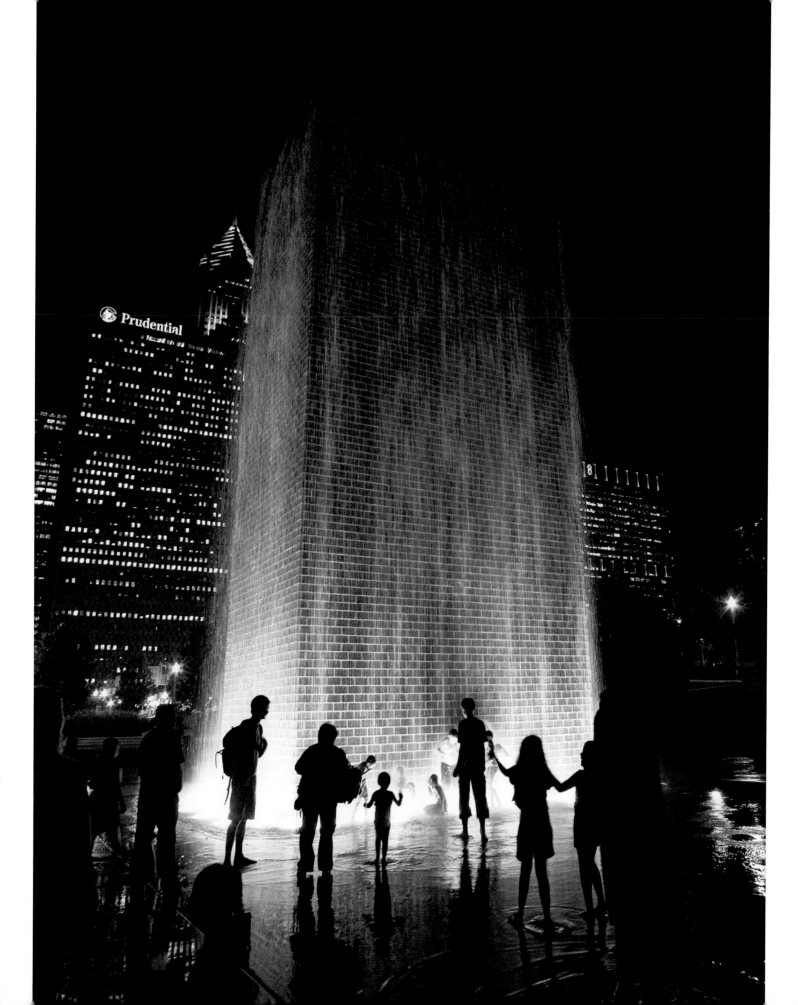

5

ON A DAY LIKE THIS

Every city has its downtown. Only one has Michigan Avenue. It's postcard Chicago, the city's front yard, where Chicago takes on the slightly sophisticated air of New York or even Paris. Here is a land of lions and drawbridges, of castellated water towers and skyscraper cliffs. Michigan Avenue is a grand boulevard—but it can be laid-back, too.

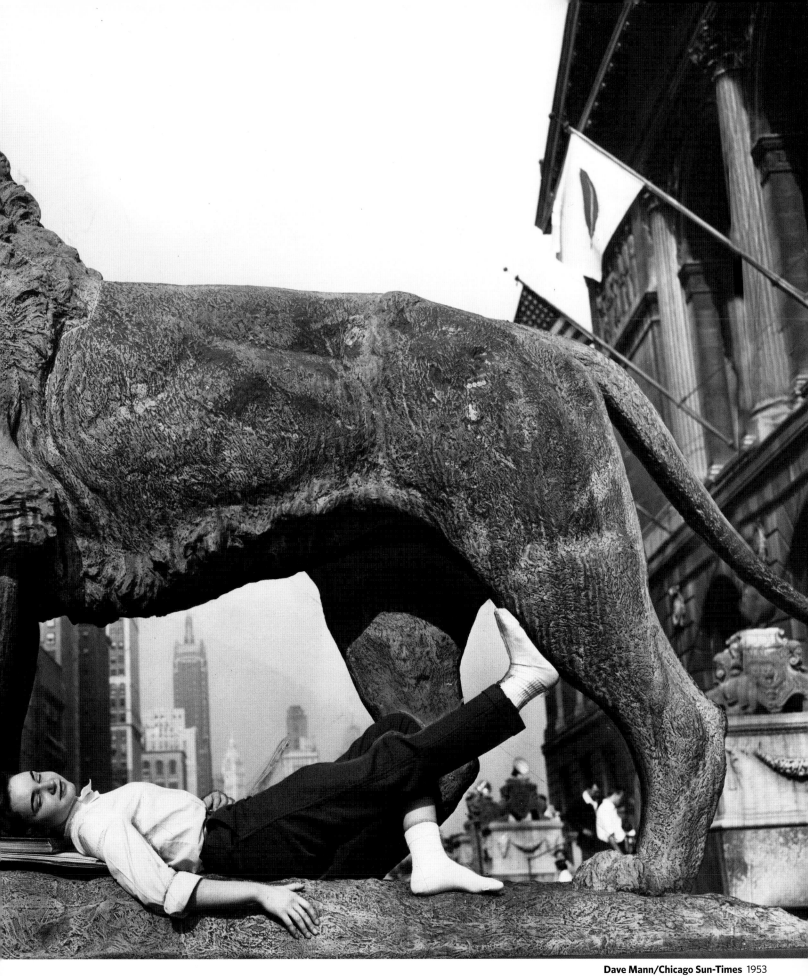

Dave Mann/Chicago Sun-Times 1953

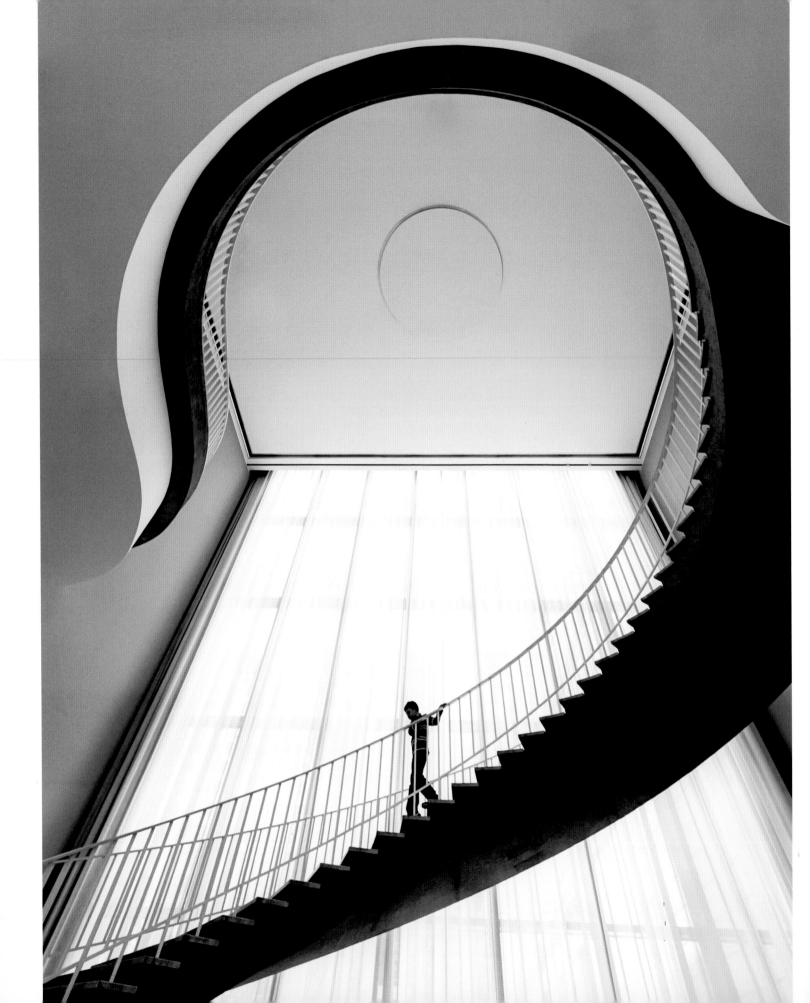

James Iska 2000

A garden of curiosity. **Above:** Crab apple trees grow in Grant Park just east of Michigan Avenue. **Opposite:** A boy descends the Art Institute's spiral staircase off the South Garden. "I was sitting on a bench waiting when I saw a boy and his mom walk down the steps," said architectural photographer Angie McMonigal (born 1977). "The mom walked in front of him, out of the scene, which was perfect. It's probably the only shot I've ever made where I said, 'That's going to be good.'"

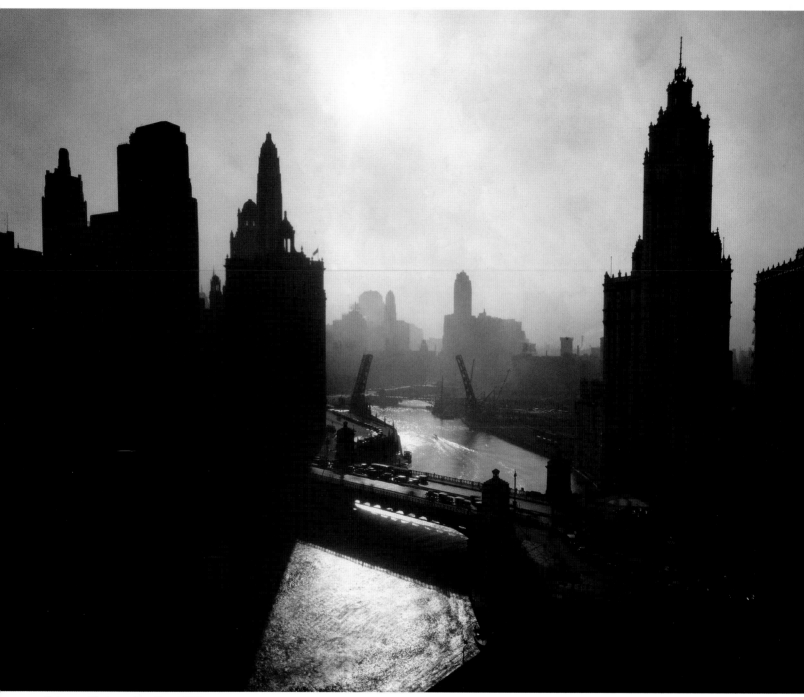

Unknown Photographer About 1935

The Michigan Avenue Bridge. **Above:** Looking west toward the bridge and the river beyond. **Opposite:** Fred Korth (1902–1982), an immigrant from Germany, spent decades working on *The Chicago Book,* his 1949 tribute to the city. He was a photo craftsman. "Often the best pictures appear to be spontaneous and lucky snapshots," he wrote. "This should fool nobody. Indeed, a good photograph very rarely is achieved by accident."

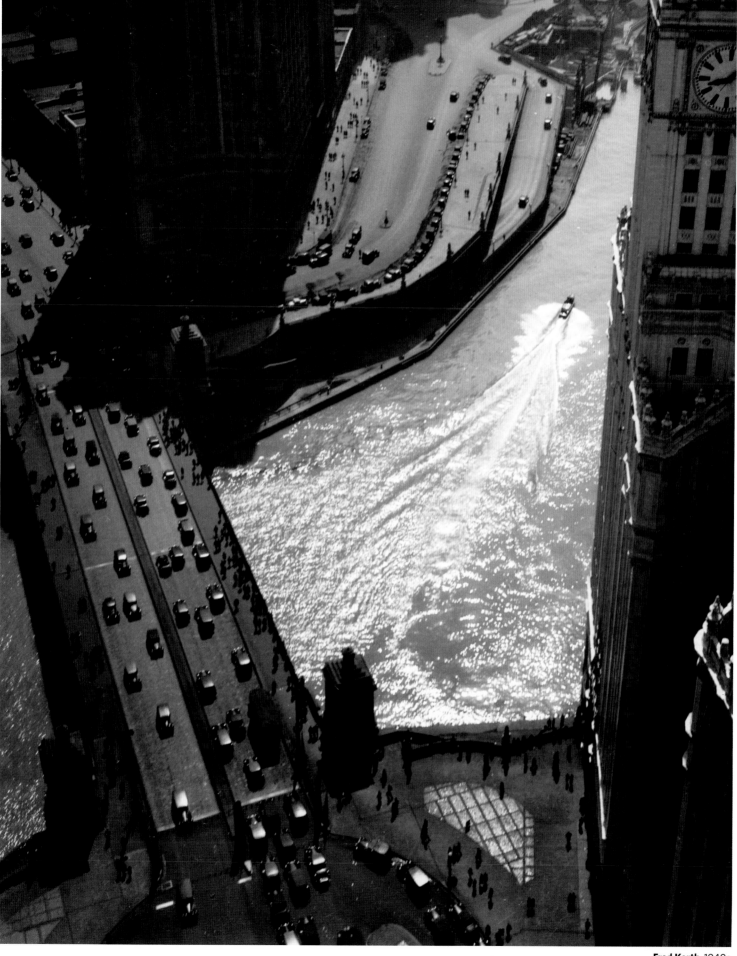

Fred Korth 1940s

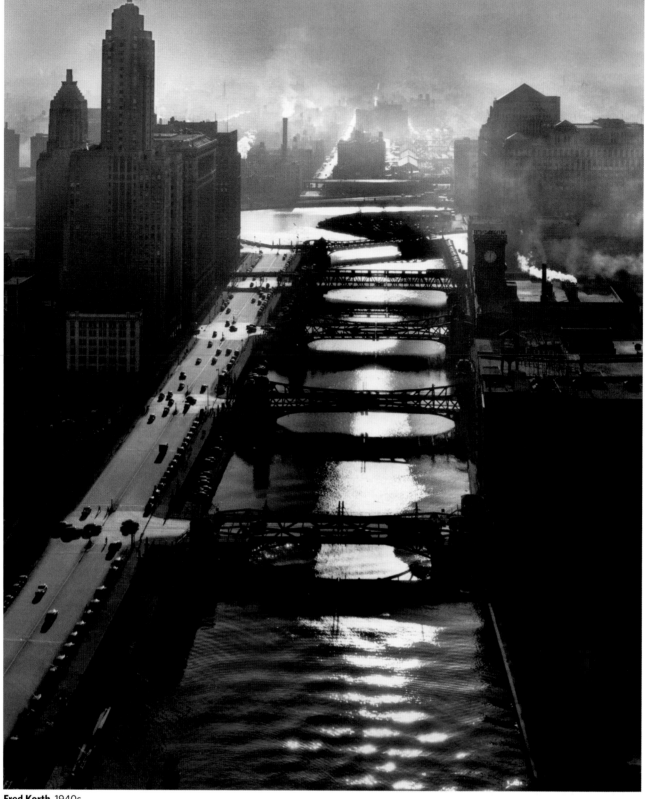

Fred Korth 1940s

A river runs through it. **Above:** Looking west at the main stem of the Chicago River as it heads toward Wolf Point. **Opposite:** Looking east at the Dearborn Street Bridge. Dave Jordano (born 1948) spent the major part of his career as a commercial photographer but returned to documentary work in 2000. "I didn't know if I could do it," he said. His first project was to document Chicago's bridges. "They are so iconic," said Jordano, who sees bridges as paths. "I believe in some way they are visual metaphors that helped me reconnect my past love for photography."

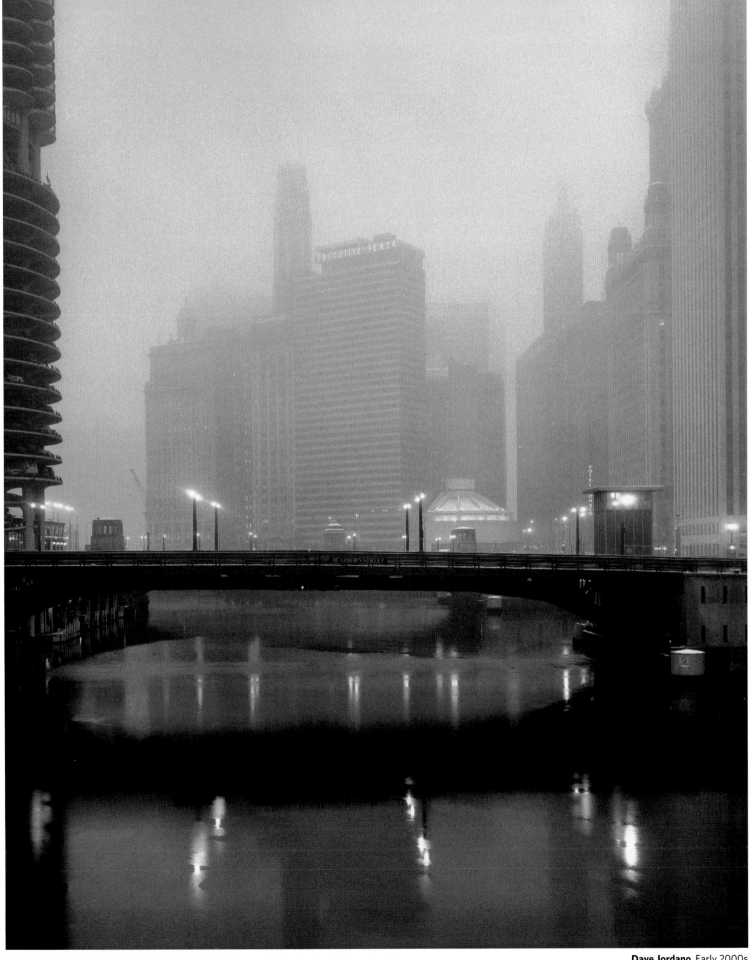

Dave Jordano Early 2000s

Virginia Lockrow/Chicago History Museum Early 1950s

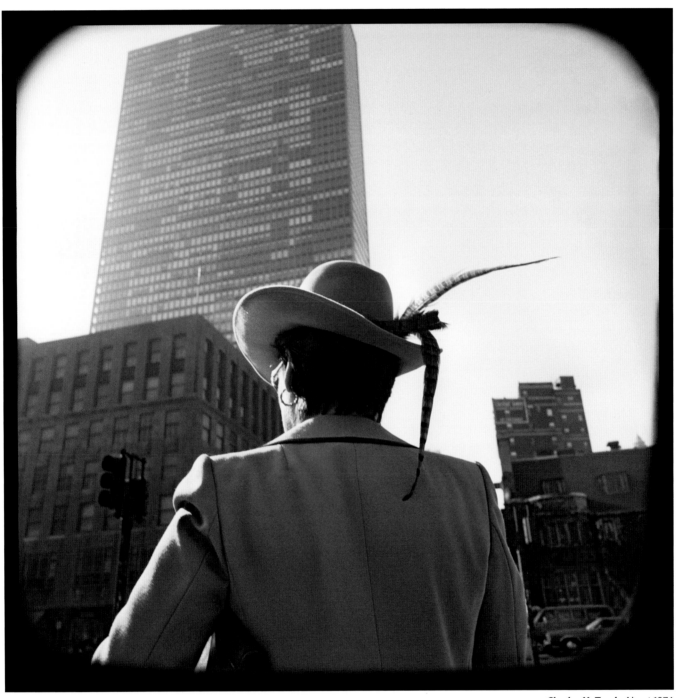

Charles H. Traub About 1974

Boul Mich. **Above:** For his "Street" series, Charles H. Traub (born 1945) shot from the hip. He got close to his subjects to get the feel of urban life. "My concerns at the time were really with how people displayed themselves," wrote Traub, an Institute of Design graduate. "The artifacts they wore or didn't wear that expressed their personalities, and roles."
Opposite: A chauffeur waits for his "lady" in front of Bonwit Teller on Michigan Avenue at Pearson Street. Virginia Lockrow (1921–1986), an Institute of Design student, documented high life along Michigan Avenue.

A tourist family takes every precaution in the big city. "I saw the kid on a leash, took one shot, and walked away," said Jay King, who did not ask their names. The picture, taken at the northwest corner of the Michigan Avenue Bridge, has appeared frequently in books and exhibits. "I'm surprised nobody has ever come up to me and identified the family," said King. "The little boy must be in his midfifties. I often wonder what becomes of my subjects."

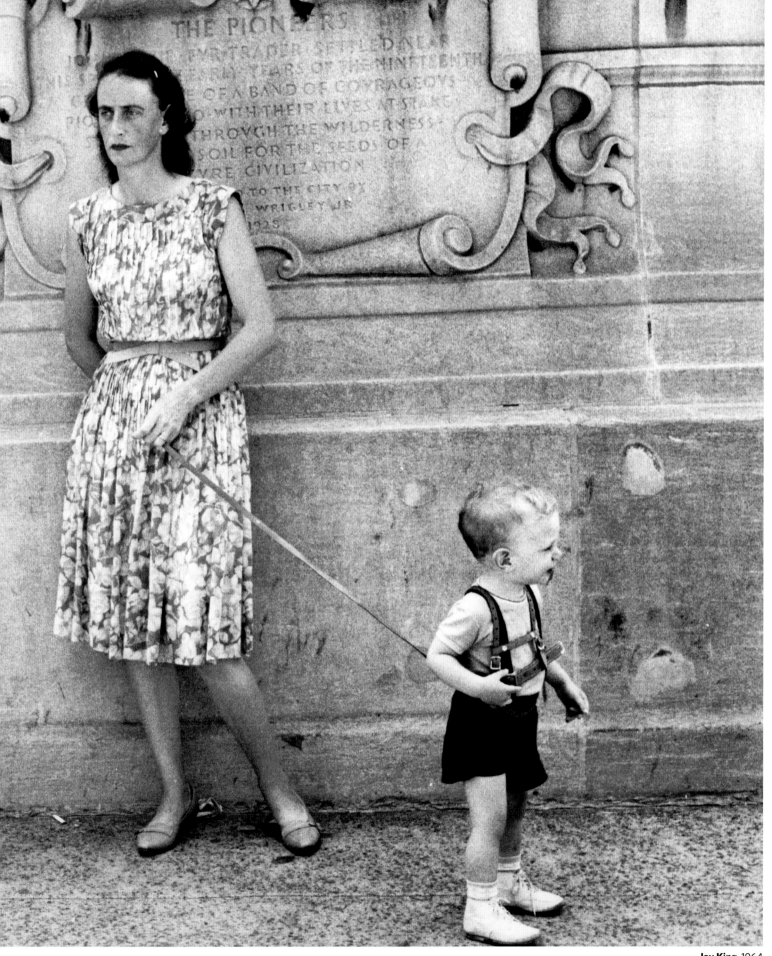

Jay King 1964

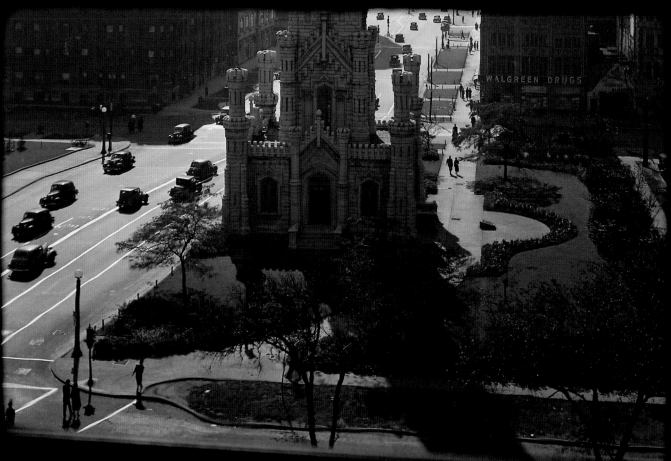

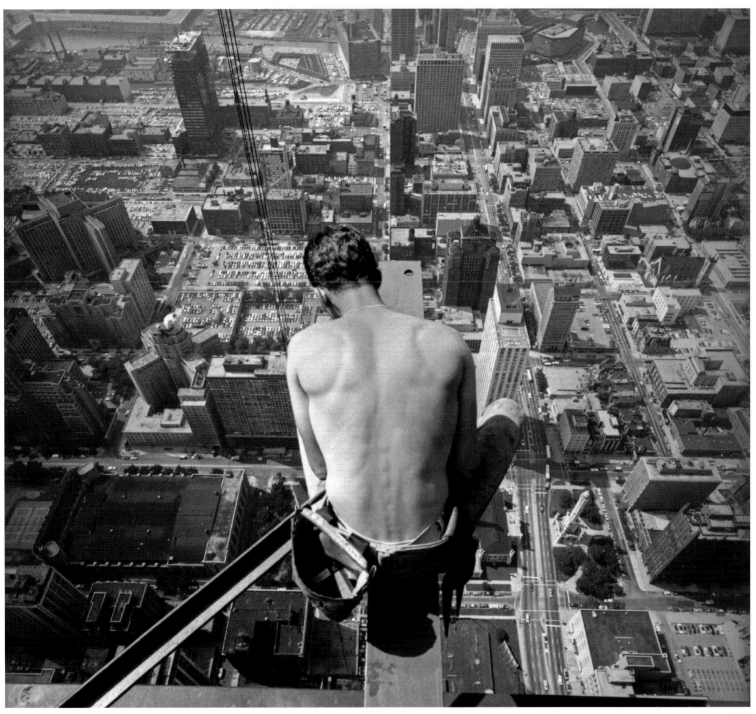

Jonas Dovydenas 1969

Points of view. **Above:** Jonas Dovydenas spent half a year documenting the installation of the antenna atop the John Hancock Center. Hunched on a beam more than a thousand feet above the city was George Moone, an apprentice ironworker. Dovydenas took this view looking south down Michigan Avenue toward the Loop. **Opposite:** The same scene, but across Michigan Avenue and from a much lower level.

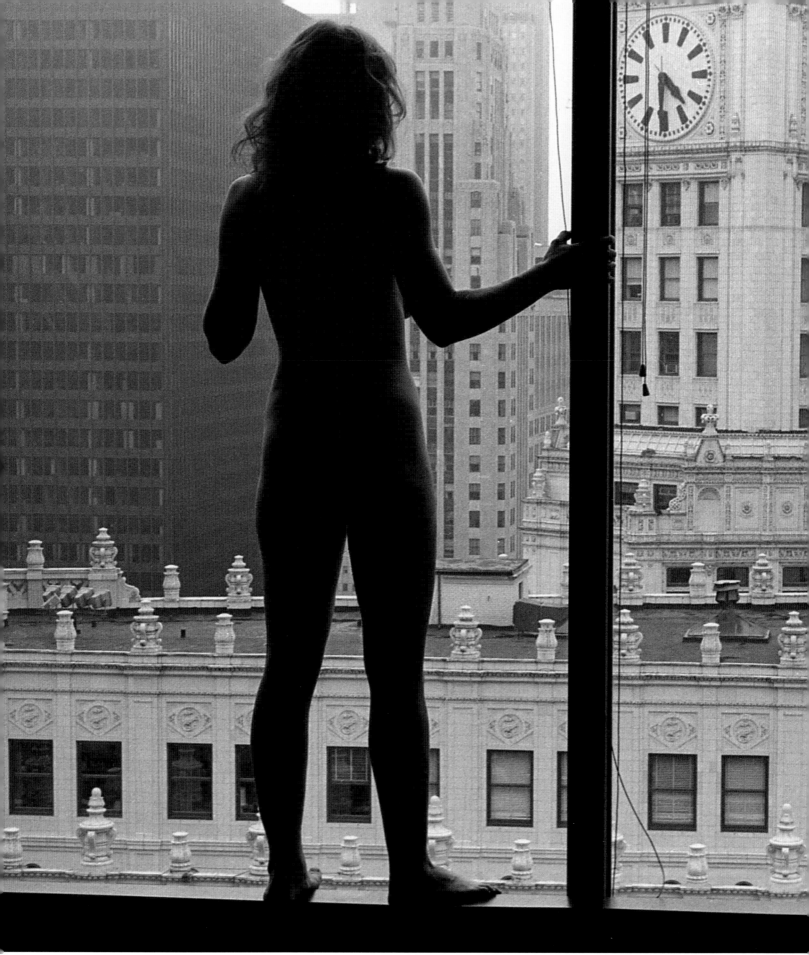

Diane Joy Schmidt and Michele Fitzsimmons 1980

Diane Joy Schmidt (born 1953) collaborated with Michele Fitzsimmons (1949–2015) to create a book and exhibit called *The Chicago Exhibition.* Schmidt photographed Fitzsimmons posing without clothes around the city. "Some people thought it was a publicity stunt. To us it was an art project," said Schmidt. This photo was taken in a hallway in the National Association of Realtors Building, at 430 North Michigan Avenue, on a Sunday. The pair made photographs at more than fifty locations over five years. Schmidt usually shot at least one roll of film at each. "At the time I was very disturbed by fashion photographs," Schmidt said. "Art nudes had no face, no personality. I wanted to show the human being in this technological, masculine architectural city." They were seldom noticed as they worked.

Next spread: Night slowly approaches. Ron Gordon, who documented Chicago for more than four decades, photographed the Wrigley Building from a nearby apartment tower. "No matter what happens, that clock keeps moving," he said.

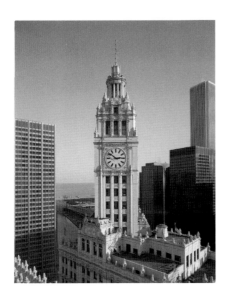
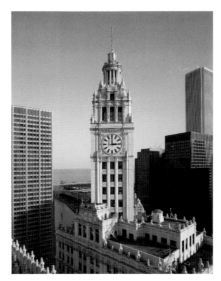
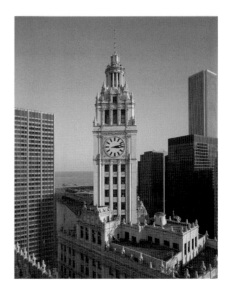
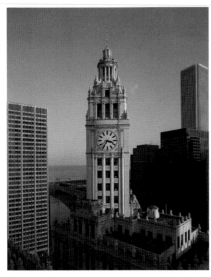

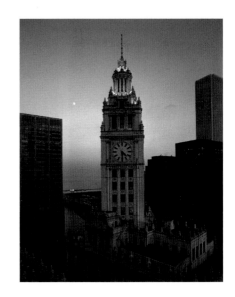

Ron Gordon 1980

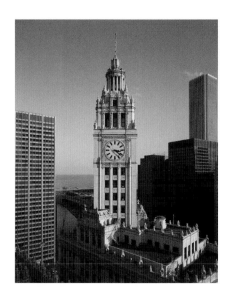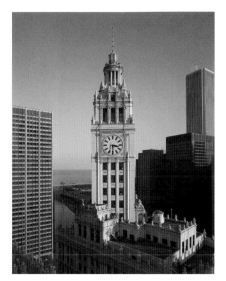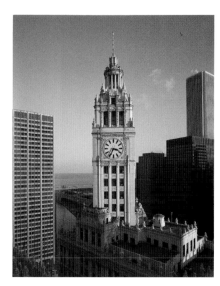
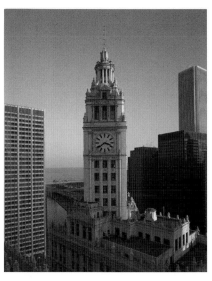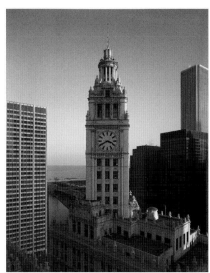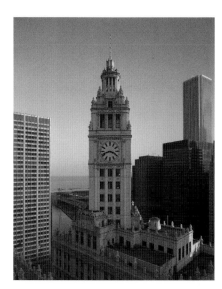
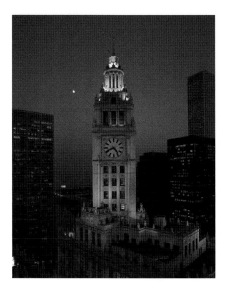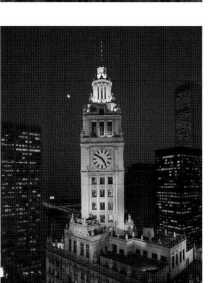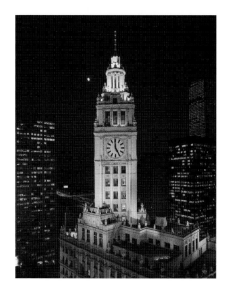

6

WATERFRONT FANCIES

The city's beaches are where Chicagoans shed their clothes— and their inhibitions. The lakefront is the city's natural boundary. It was here that Native Americans and then white pioneers found a way to connect the East to the Midwest and points beyond. That is what made Chicago. Centuries later, the lake endures. A spiritual home. A place unending and immense and as flat as the prairie itself.

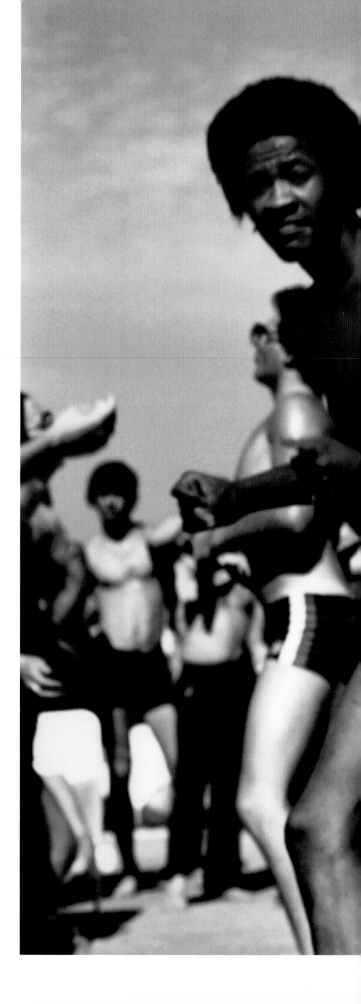

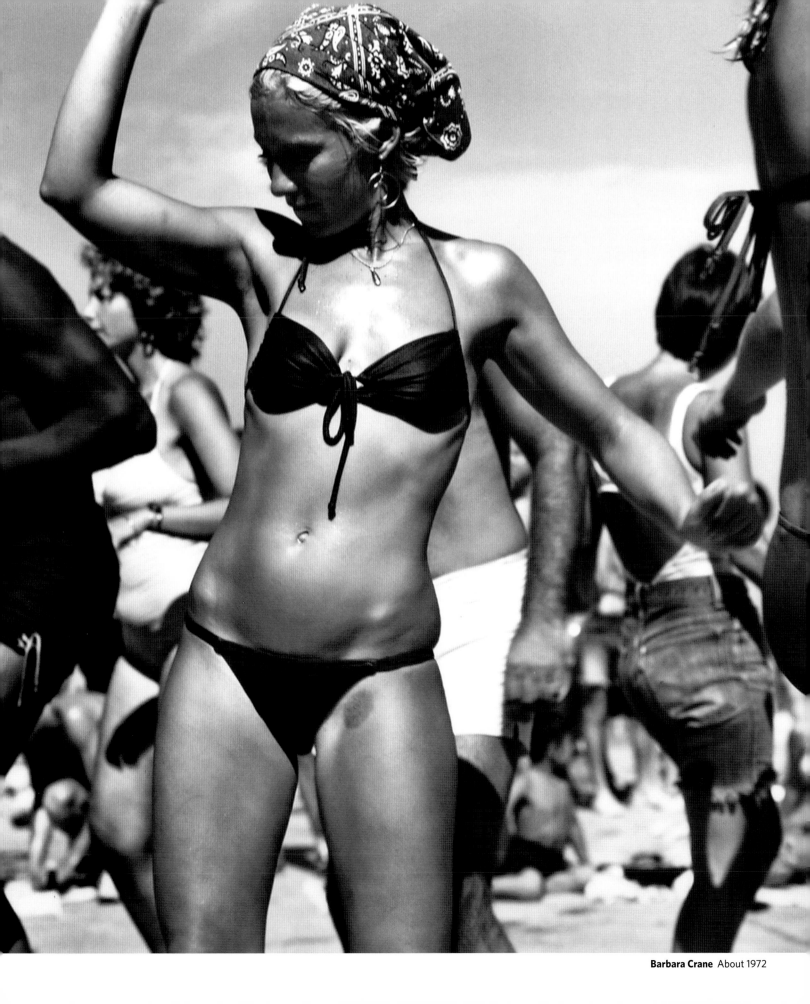

Barbara Crane About 1972

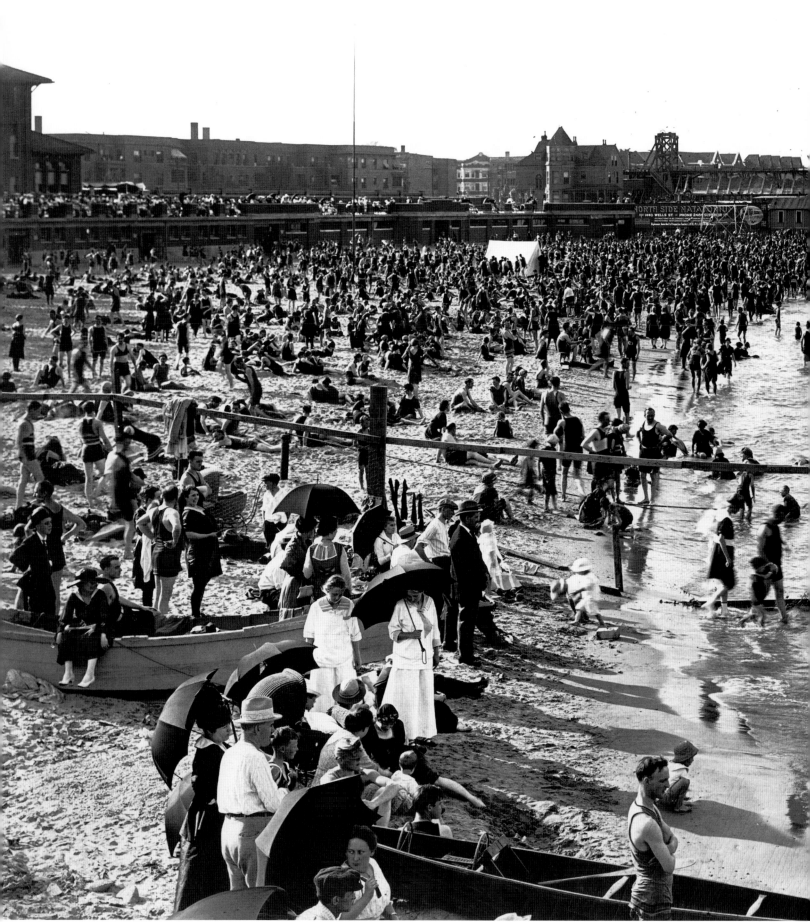

Unknown Photographer About 1920

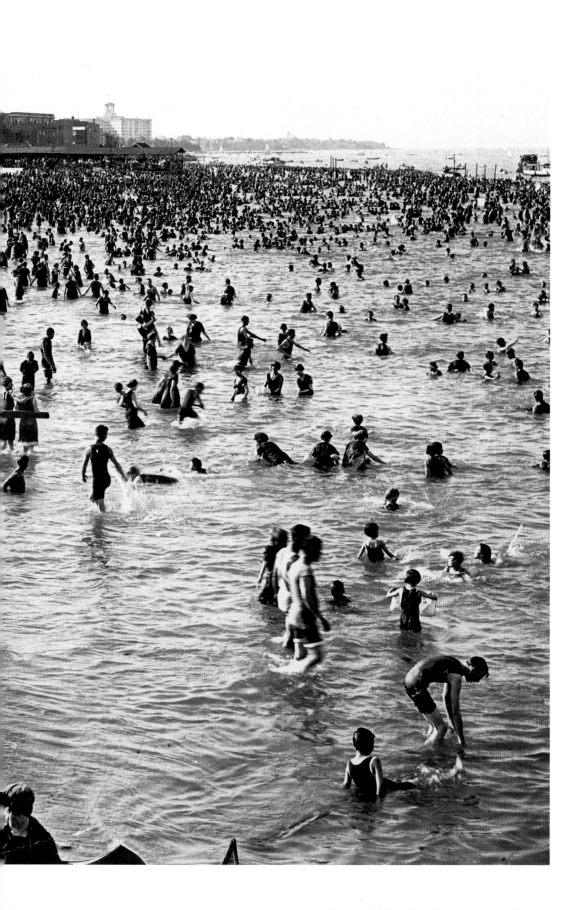

Bathers pack the Clarendon Municipal Beach, which opened in 1916 and accommodated 9,000 people. People seldom swam in Lake Michigan until the early part of the twentieth century—when the city stopped routinely routing its sewage into it. In the 1930s, the city used landfill to extend Lincoln Park northward and the Clarendon Beach was drydocked and eliminated. It was replaced by the Montrose Beach, the city's largest, between Montrose and Lawrence Avenues. The Clarendon Beach House, at 4501 North Clarendon Avenue, was later converted into a community center and field house. The original Edgewater Beach Hotel, seen in the far distance, opened in 1916.

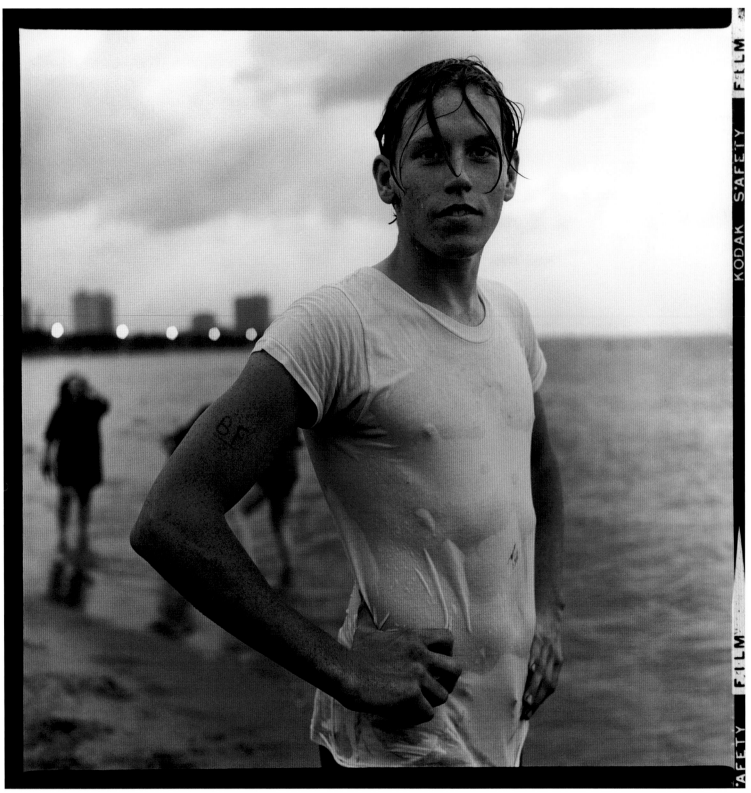

Marc Hauser 1966

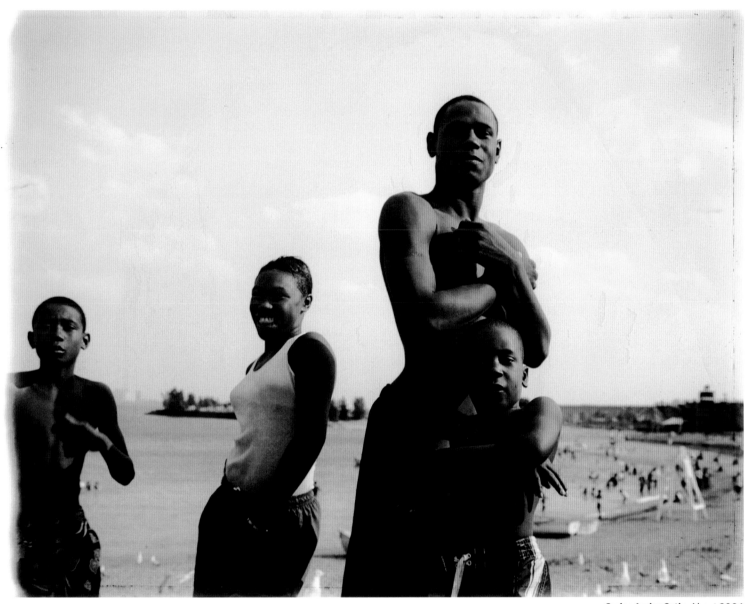

Carlos Javier Ortiz About 2006

Along the shore. **Above:** Carlos Javier Ortiz (born 1975) used a Polaroid camera to take this family portrait at the Twelfth Street Beach. "It is a monumental thing that we have this water resource," Ortiz said. "Many people, stuck in their neighborhoods, never even get to the beach." **Opposite:** Marc Hauser (born 1952) is one of the city's most prominent portrait photographers. He took this picture at the North Avenue Beach when he was thirteen. "I asked, 'Is it okay if I take your picture?' He posed. Looked cocky. I've tried to find him ever since. It's one of the first pictures I took and still a favorite."

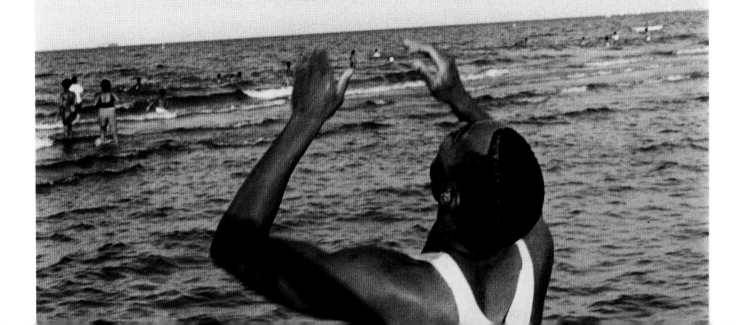

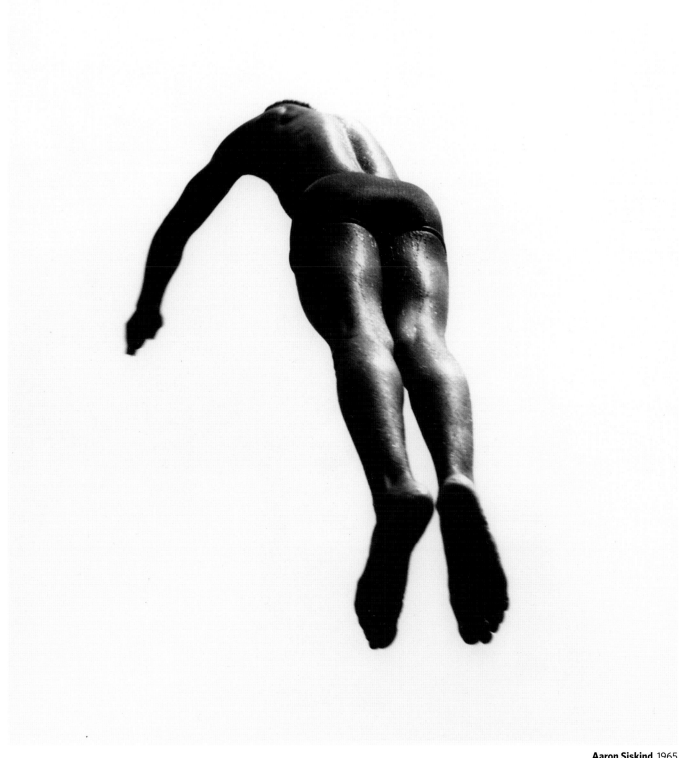

In the air. **Above:** Aaron Siskind (1903–1991) photographed young men diving into Lake Michigan many times during the 1950s and '60s for his "Terrors and Pleasures of Levitation" series. "When I make a photograph I want it to be an altogether new object, complete and self-contained, whose basic condition is order," he wrote. **Opposite:** Stephen Marc was on the last frame of his last roll of film when he saw a man playing with his son at the Fifty-Seventh Street Beach. One shot. They were gone. "You have to be prepared to accept a gift," Marc said

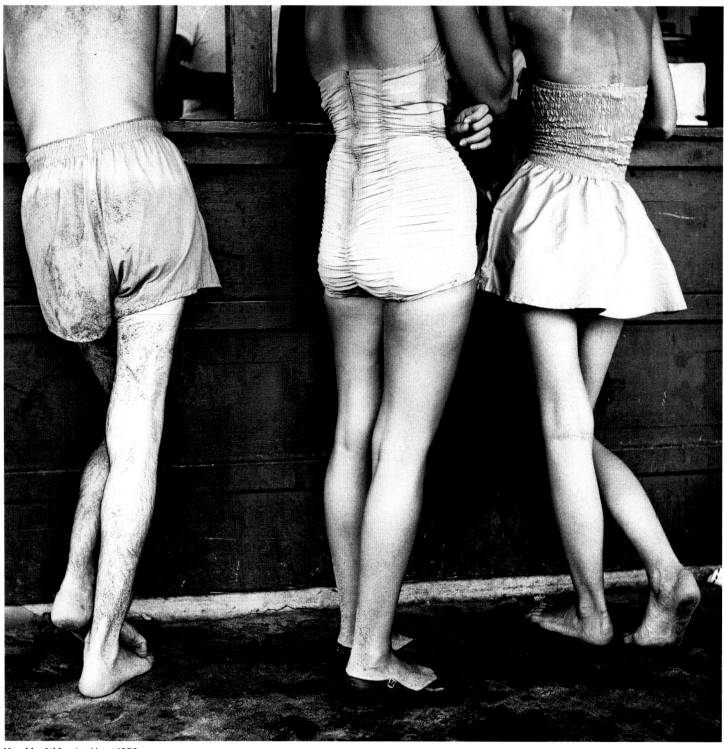

Yasuhiro Ishimoto About 1950

Beach scene. **Above:** Yasuhiro Ishimoto (1921–2012) was born in San Francisco and spent World War II in a detention center for Japanese Americans. After the war, he moved to Chicago to study architecture at Northwestern University and then photography at the Institute of Design. He lived in Japan much of his later life but published *Chicago, Chicago*, a portfolio of the city, in 1969. **Opposite:** Art Sinsabaugh (1924–1983), another Institute of Design student, was known for his panoramic views of Chicago. Both of these photographs were taken at the North Avenue Beach House.

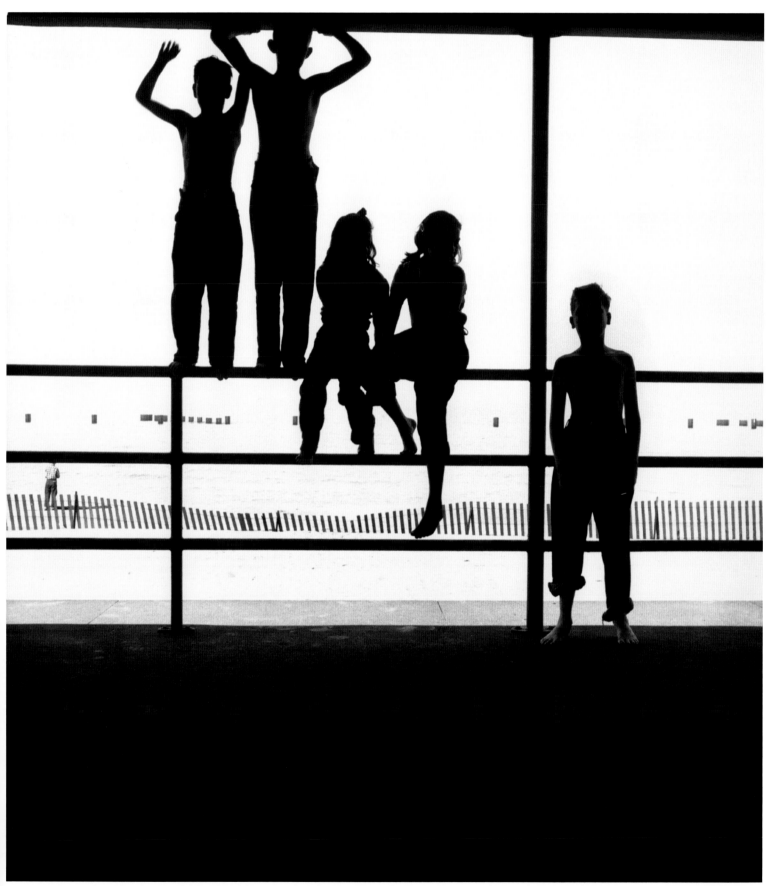

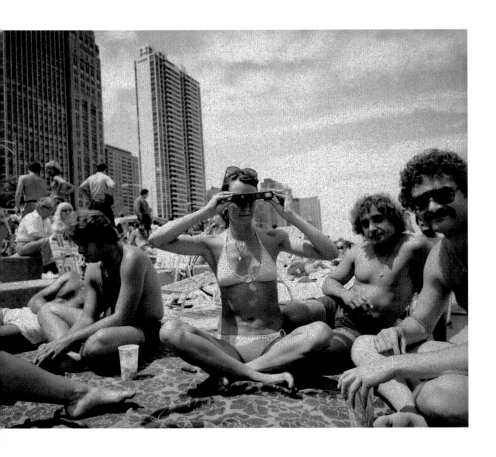

Barbara Crane (born 1928) documented Chicago's beaches and parks between 1972 and 1978. "Travel was not easy and Chicago was always there," said Crane, who has used the city as her subject for sixty years. Each park and beach had its own personality, she said. Crane worked with a large press camera, which gave her legitimacy. "People thought I was working for the city," she said. "I was small and harmless. They were busy playing." Crane has tried and mastered many photographic techniques and formats—from abstract to representational and from platinum palladium prints to Polaroids. "Photography is my adventure."

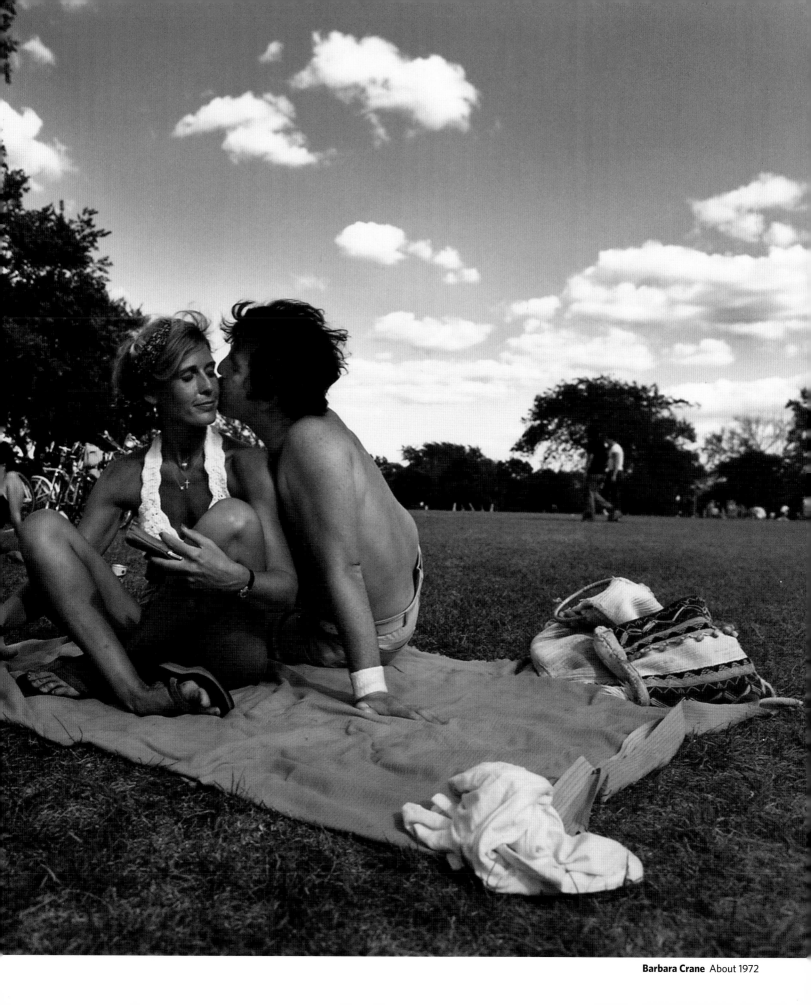

Barbara Crane About 1972

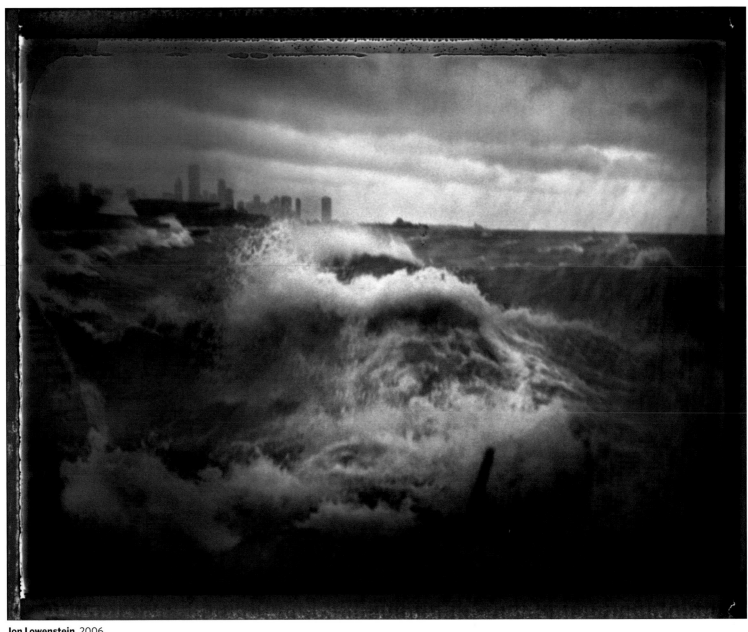

Jon Lowenstein 2006

The churning waves. **Above:** Jon Lowenstein remembers the day he took this shot at a South Side beach, part of his "South Side" series: "The waves hit me, soaked me, and destroyed my camera." **Opposite:** In 1939, the *Chicago Tribune* covered the baptism at dawn of a woman named Hazel Taylor at the Fifty-Seventh Street Beach by the Reverend Archie Johnson and his wife. Johnson was pastor of the nearby Erion's St. Jude Christian Church. Members of the congregation watched from the shore in the thirty-five-degree chill.

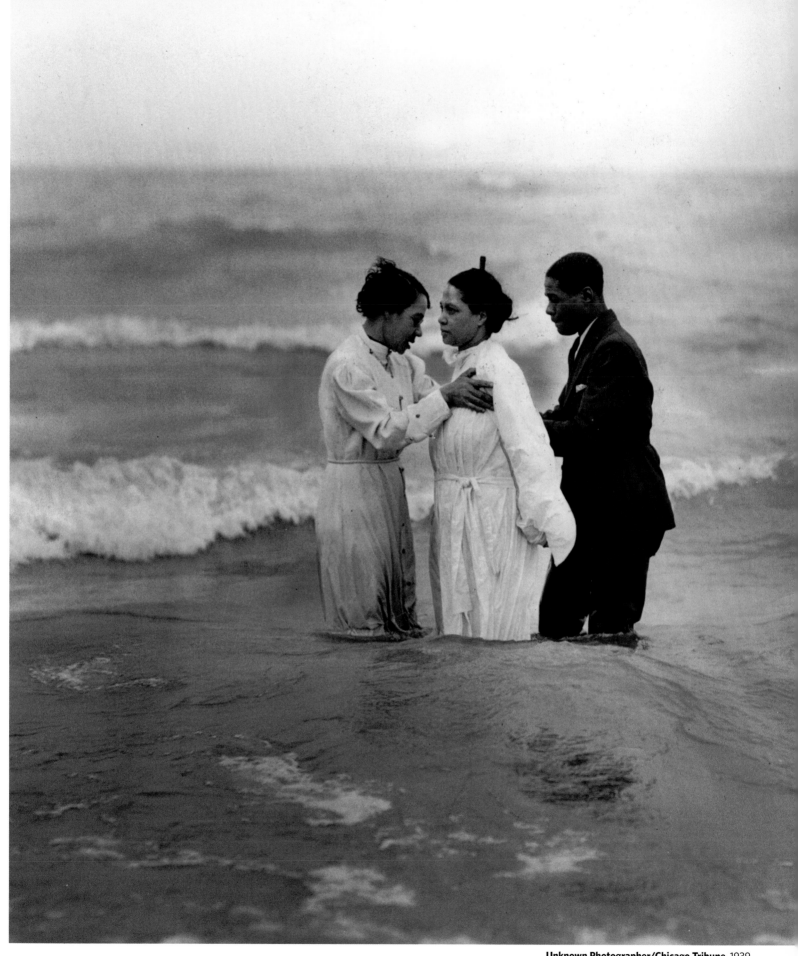

Unknown Photographer/Chicago Tribune 1939

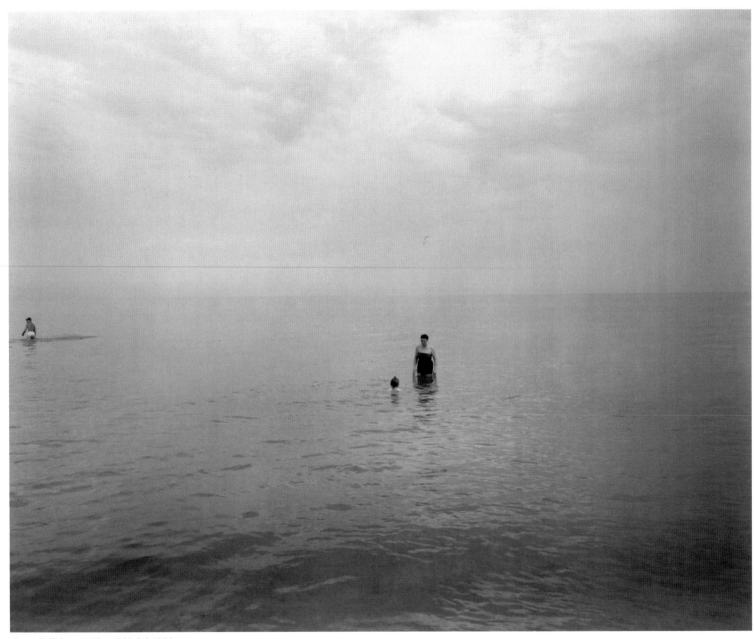

Harry Callahan 1953 and (right) 1950

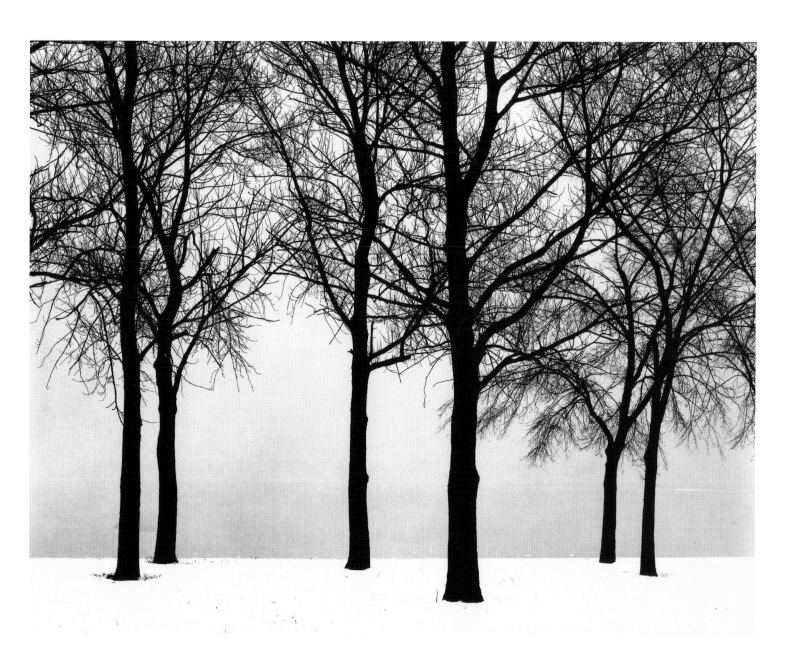

Harry Callahan (1912–1999), who moved to Chicago from Detroit in 1946 to teach at the Institute of Design, was one of the city's most influential photographers. **Above:** Callahan's celebrated photo of trees near Lake Michigan. "I have always lived in simple places," Callahan said. "There is nothing extraordinary about these places, but somehow I find them beautiful."
Opposite: Callahan's wife, Eleanor, and daughter, Barbara, in Lake Michigan. Callahan called these pictures "8 x 10 snapshots" because he used a large-format camera to make straightforward photographs. "He just liked to take the pictures of me," said Eleanor. "In every pose. Rain or shine. And whatever I was doing. If I was doing the dishes or if I was half asleep. And he knew that I never, never said no."

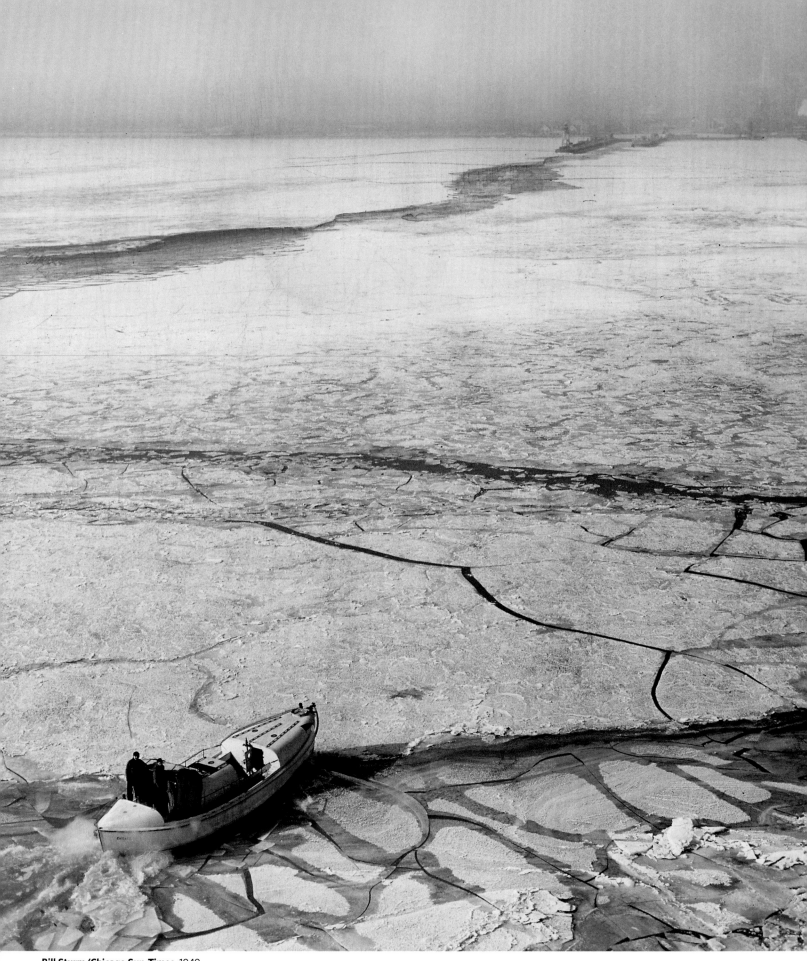

Bill Sturm/Chicago Sun-Times 1949

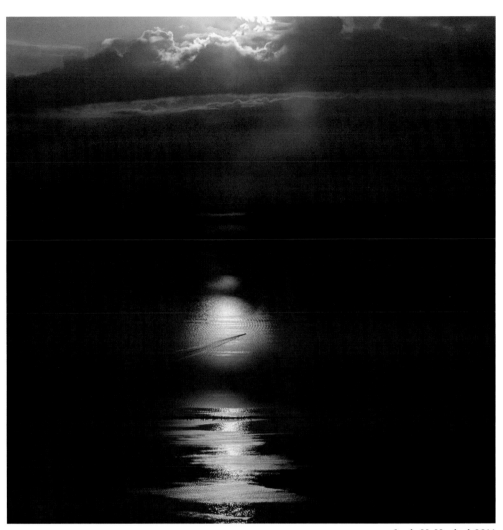

Angie McMonigal 2016

In all weather. **Above:** Angie McMonigal had spent much of the early morning focusing on cityscapes as she photographed from the Willis Tower's Skydeck. Then she turned her camera toward the lake. "No architecture, just this lone boat sailing through a stream of light into the unknown," she said. **Left:** Bill Sturm documented the Coast Guard's three-quarter-mile trip through icy Lake Michigan to the lighthouse off Randolph Street and back. The boat brought supplies and a fresh crew of workers. The photo essay that ran in the *Chicago Sun* was titled "You Can't Take a Streetcar to This Job!"

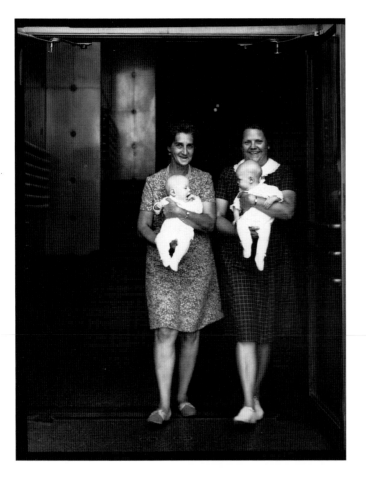
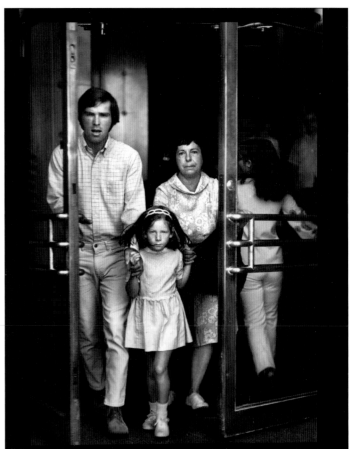
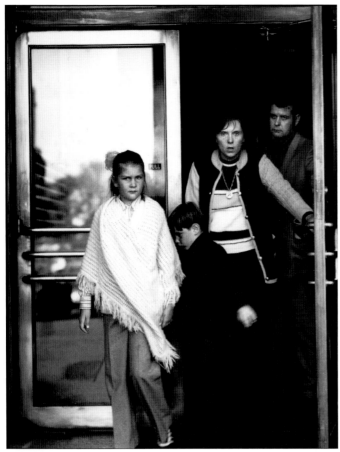
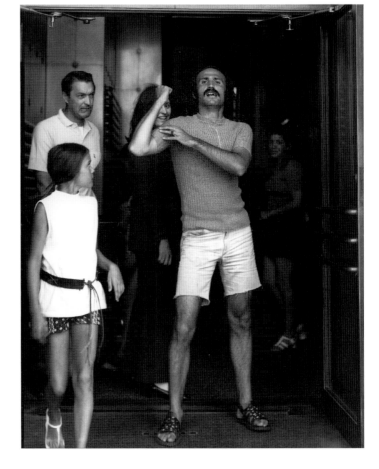

Barbara Crane About 1970

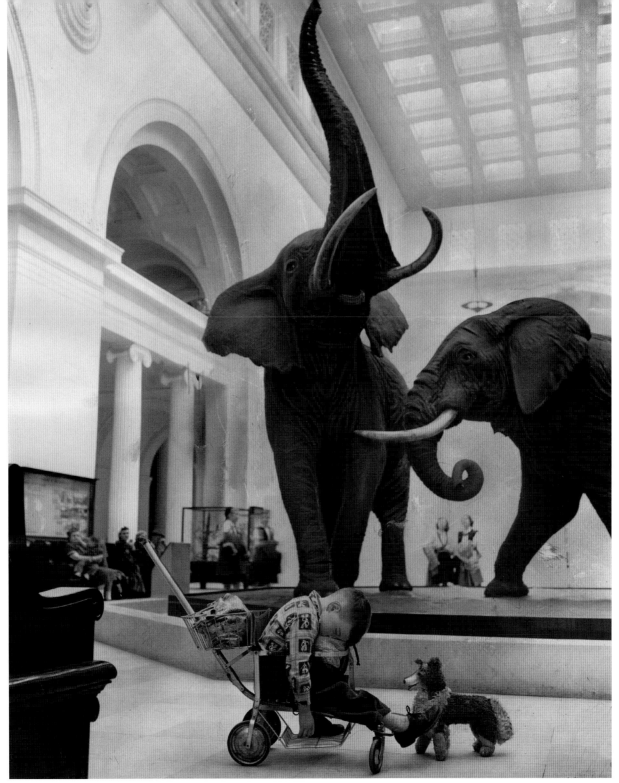

Ralph Walters/Chicago Sun-Times 1956

Treasures along the lake. **Above:** A four-year-old sleeps at the Chicago Natural History Museum, now known as the Field Museum. Ralph Walters (1914–1997) wrote: "All tuckered out, he naps in his stroller in front of a trumpeting elephant." **Opposite:** Barbara Crane's "People of the North Portal" series shows visitors leaving the Museum of Science and Industry. "Chance extends the boundaries of my imagination," she said. "I try to set up a framework to allow this to happen. I choose where I stand. I determine the tonalities. I select the spacing—such as people at the outer edges of the picture or a couple holding a baby in the center. Then I look for the right light, and I give chance a little room to perform for me."

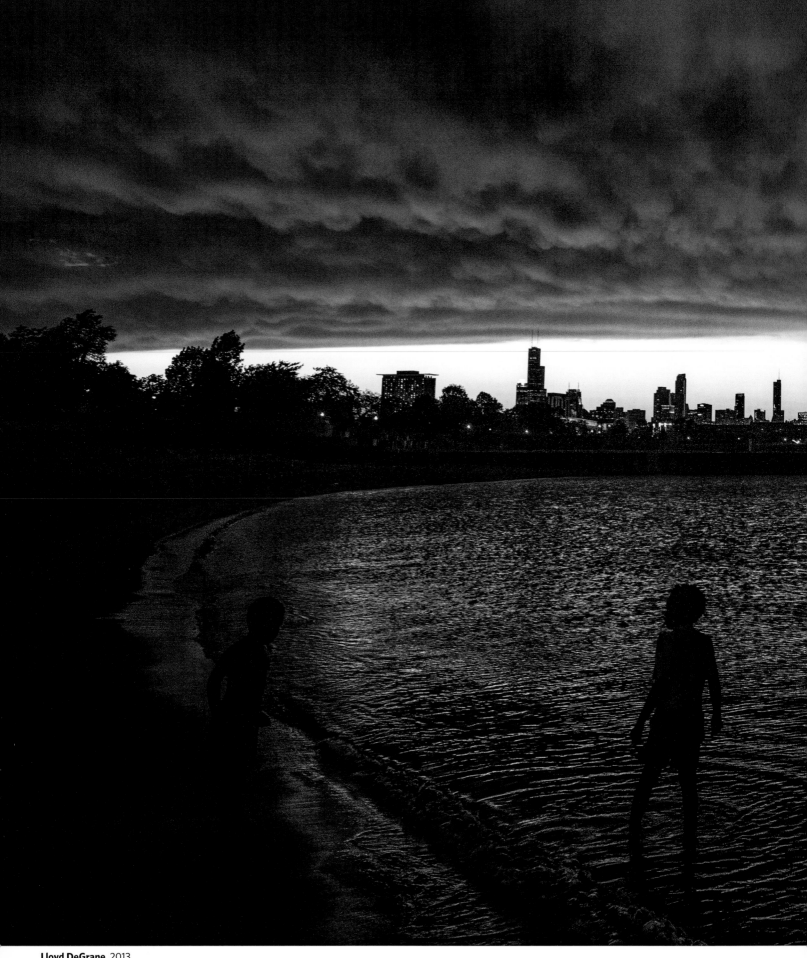

Lloyd DeGrane 2013

Lloyd DeGrane (born 1948) raced from his nearby home during a thunderstorm to arrive at the lake as the clouds blew in from the west. "In a way, I try to plan for it," he said. "You've got to be ready for a spontaneous natural event." Do Chicagoans appreciate the lake? "Some do," he said. "Many others take it for granted. They don't understand its true essence. They pass by it biking or hiking and they dip their toes in it, but they don't have a sense of its immense size, its geography, or its importance in the world." Since the early 2000s, DeGrane has been documenting the human impact on all five Great Lakes.

7

TEN-CENT WEDDING RINGS

The original Maxwell Street Market is gone. The giant flea market held on for more than a century. Here was working-class Chicago, where you could buy hot dogs and hubcaps, suits and shoes, and where pullers proclaimed, "We cheat you fair." It was unpredictable, dangerous, and real. A victim of time and development, it officially closed in 1994. But it was memorialized by the scores of photographers attracted by its bluesmen and preachers and the chance to score a bargain too good to be true.

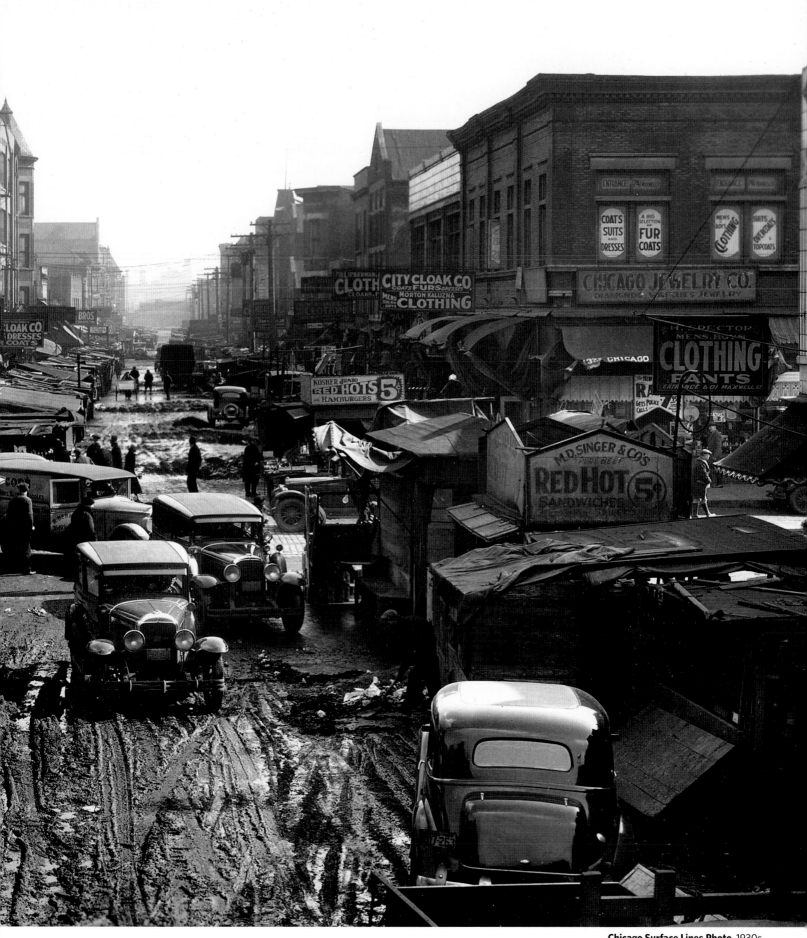

Chicago Surface Lines Photo 1930s

Nathan Lerner 1936

The grand bazaar that was Maxwell Street. **Above:** Nathan Lerner (1913–1997), who was in the first class of László Moholy-Nagy's New Bauhaus, photographed the market for three years. He called this photo "Uncommon Man." **Opposite:** Russell Hamm (1897–1975) worked for Chicago newspapers for four decades. Though he covered the St. Valentine's Day Massacre and called himself a "fire horse" photographer because most of his work involved rushing to news events, he wrote: "For every bit of pain I put on film, I offset it with a little bit of beauty, something wonderful, alive."

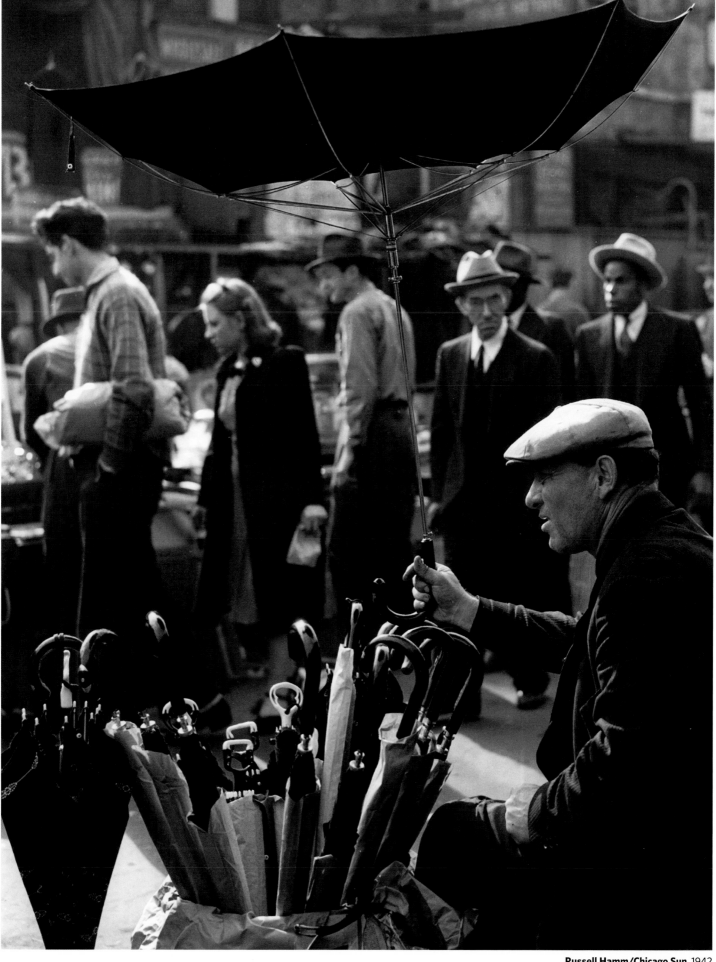

Russell Hamm/Chicago Sun 1942

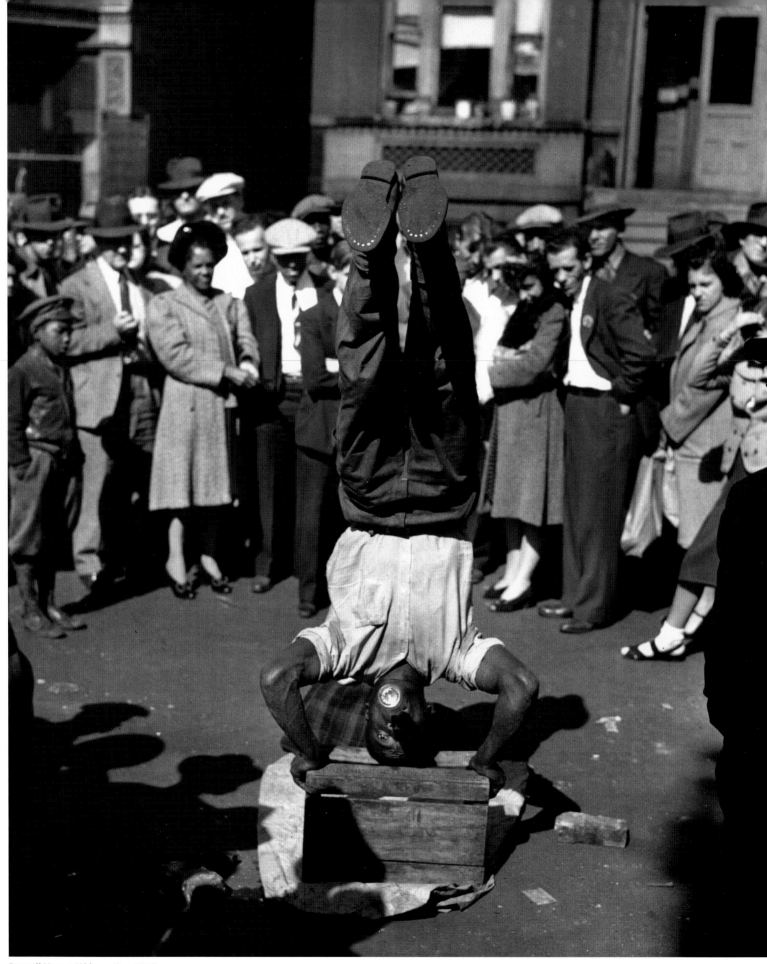

Russell Hamm/Chicago Sun 1942

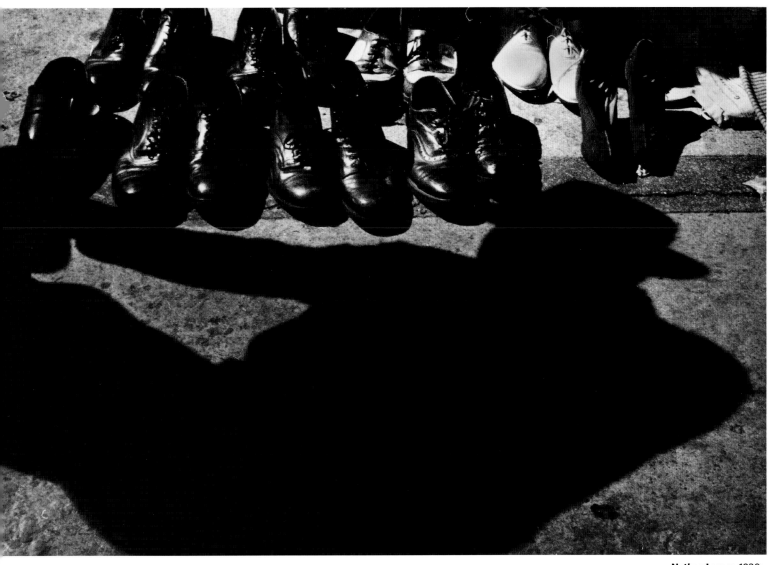

Nathan Lerner 1930s

Soul of the city. **Above:** Nathan Lerner started taking photographs to help him perfect his compositions as a painter. He soon saw that the camera could also help him witness and record life in the poorest immigrant neighborhoods of Chicago. "Showing society what it looks like is not a gift the artist bestows on society," he wrote. "It is an obligation he fulfills."
Opposite: Russell Hamm captures a Maxwell Street show. Performers were a key draw to the city's open-air market.

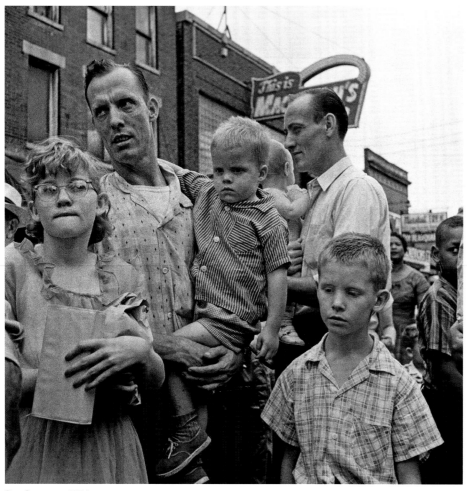

Ron Seymour 1954

Maxwell Street blues. **Above:** Ron Seymour was taken to Maxwell Street a few times as a child. In 1954, he was asked by a friend to help out an uncle who sold toys there. In his free time, Seymour wandered the street with his first "real" camera (a twin-lens reflex). "I have about ten photos that I really love," he said, "all taken over one weekend." **Right:** By 2000, Maxwell Street was a different place. The market was closed and surrounding buildings were being torn down. Yvette Marie Dostatni photographed a man who lived in his car smoking a wax-paper-wrapped cigarette in front of a soon-to-be-demolished building. "This was the last remnant of Maxwell Street before the neighborhood was rebuilt to look like the suburbs," she said.

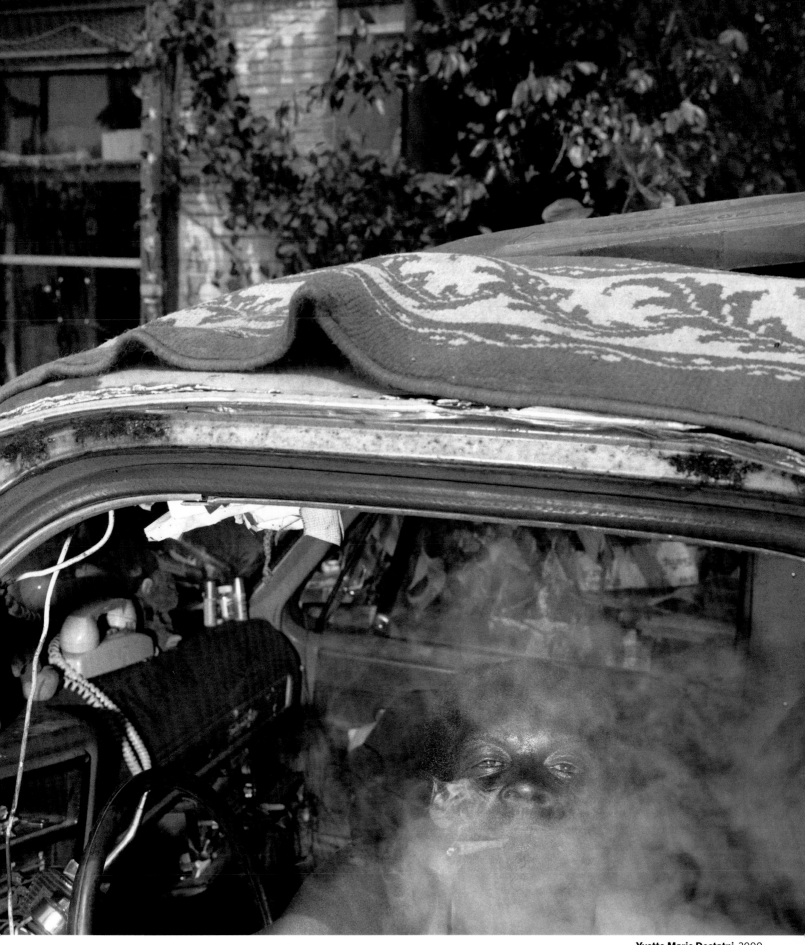

Yvette Marie Dostatni 2000

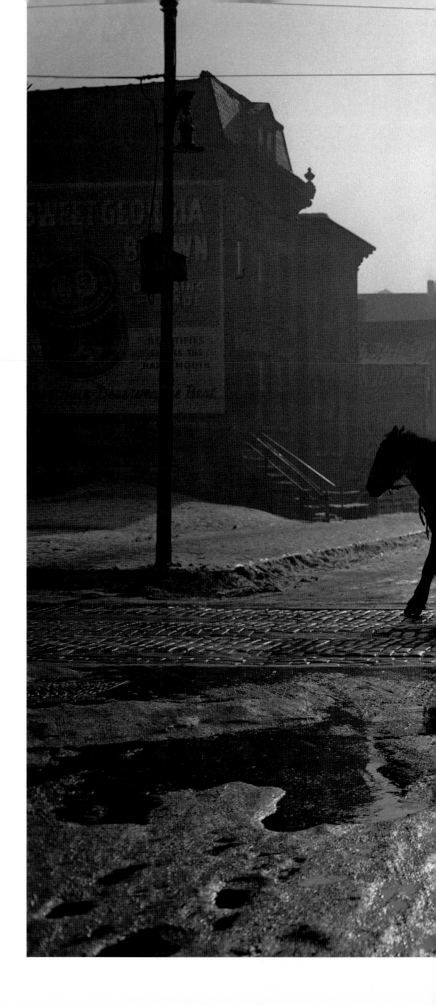

Bill Sturm took "To Work at Dawn" at Thirteenth Street and Newberry Avenue. The intersection, just west of the old Maxwell Street Market, is now adjacent to the University of Illinois at Chicago's sports fields. Sturm was known among his fellow press photographers for his artistic imagery and his serious demeanor. "He never played cards with us," recalled Steve Lasker, who broke into the business in the late 1940s.

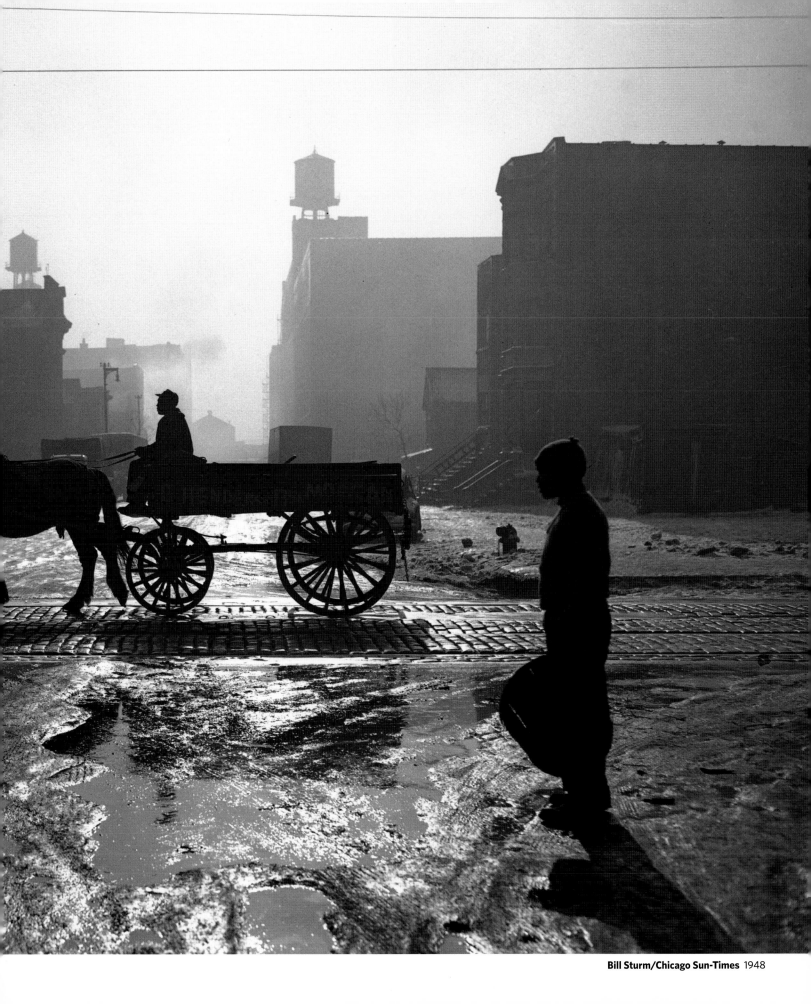

Bill Sturm/Chicago Sun-Times 1948

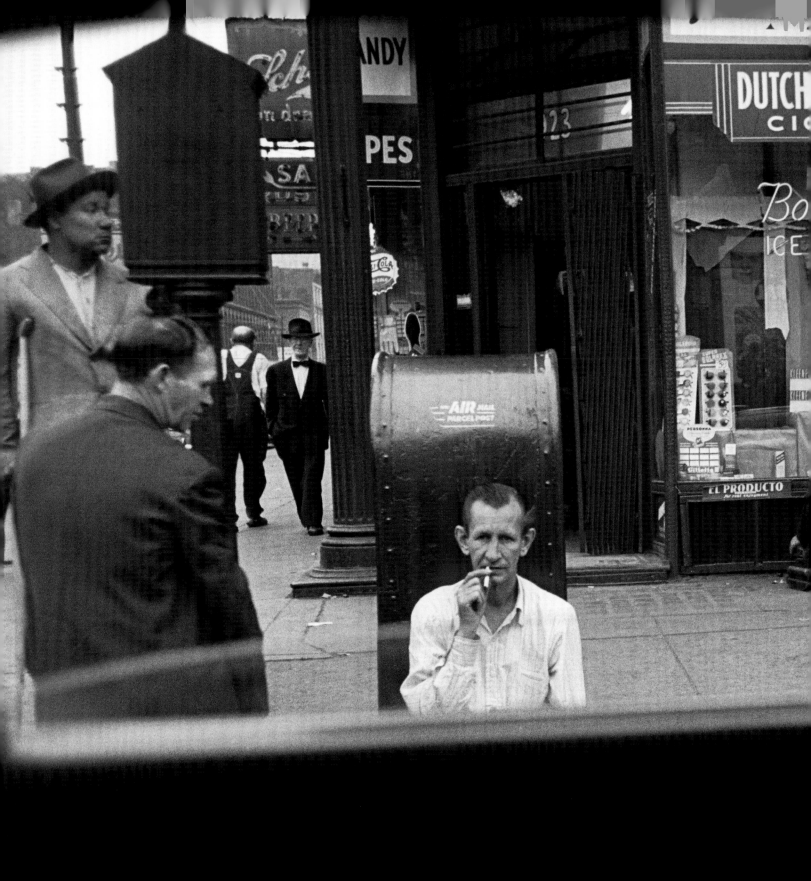

Art Shay 1950

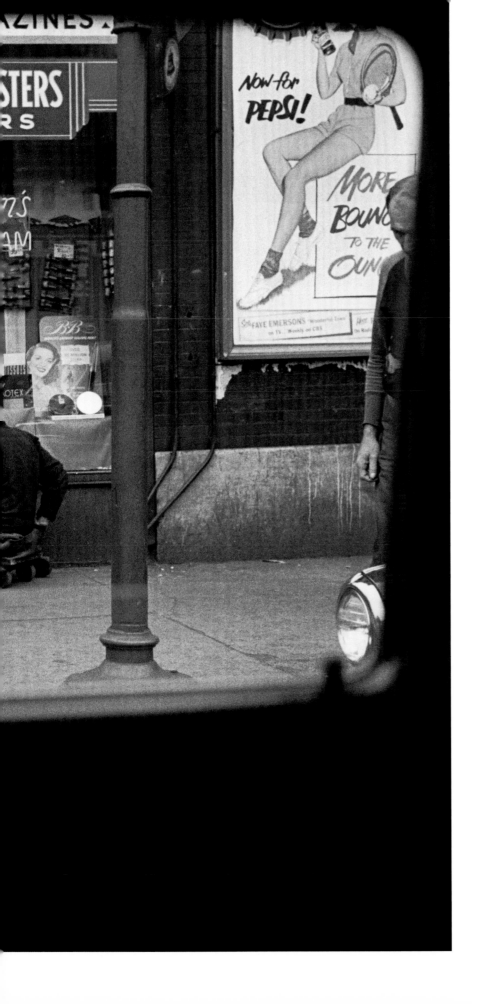

8
NOTES FOR
A TRAGEDY

"Sunday Morning on Madison Street" was taken from inside a car in the heart of what was known as Skid Row. The stretch, just west of the Loop, was as bleak as its name. It was the home of men (and a few women) who could not break their drinking or drug addictions. They congregated in a neighborhood of transient hotels, cheap bars, and dirty streets. *Time* magazine called it the Land of the Living Dead. But it really was a place to die.

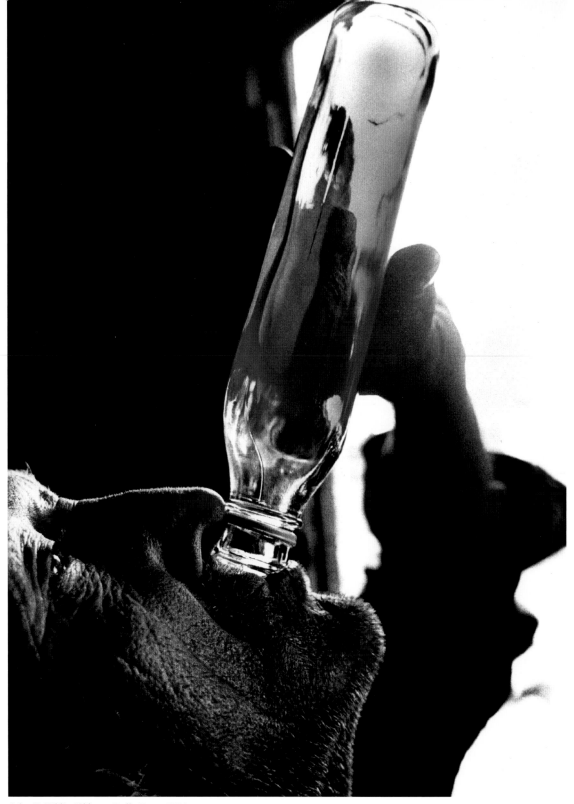

John H. White/Chicago Daily News 1974

Dark times. **Above:** From the "Faces of Skid Row" series by John H. White (born 1945). "Chicago had the second largest Skid Row at the time. I was just trying to help the poor, the needy, those with weak hope," said White, who later won a Pulitzer Prize for feature photography. **Opposite:** Bill Sturm's "Morning Hangover."

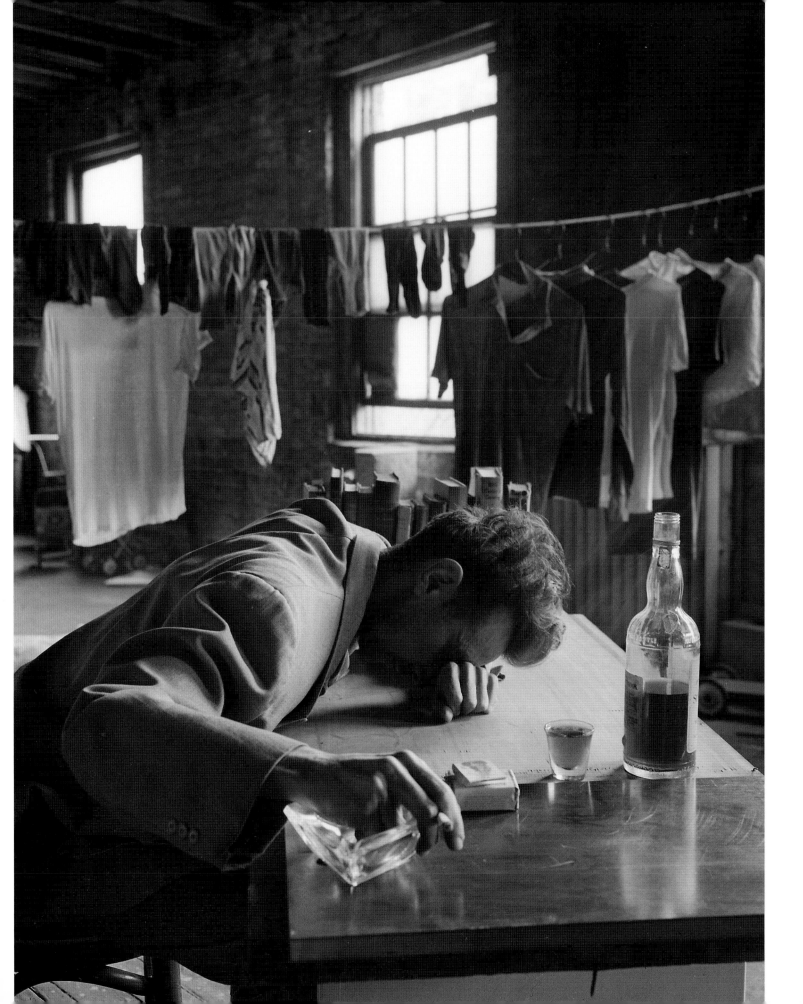

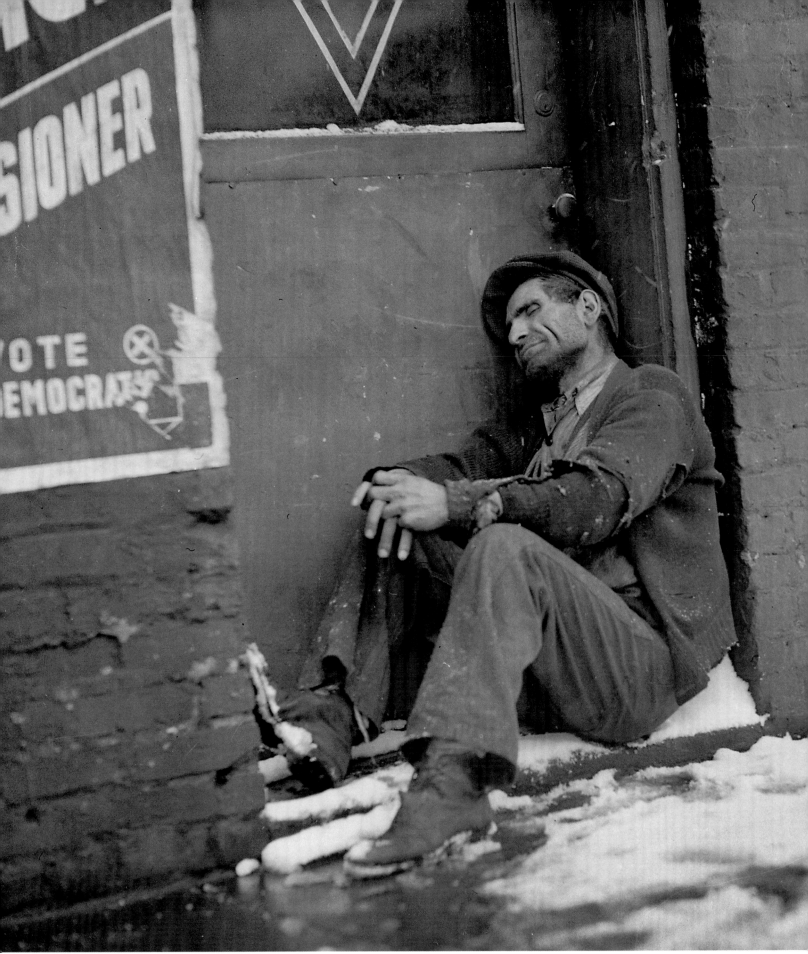

Al Mosse/Chicago Sun 1943

The *Chicago Sun* sent the photographer Al Mosse (1905–1978) and reporter Eddie Doherty to show how Skid Row was changing. During the war, some men found jobs at munitions plants, and others were drafted by the army. But many remained—some to pass away on the streets. Wrote Doherty: "A man drinks. He gets a sort of paralysis in his legs. He reels, or is carried to his 25-cent room. Maybe he carries a bottle with him. Maybe his friends, if he has any, bring him a bottle. He dies. And nobody cares very much."

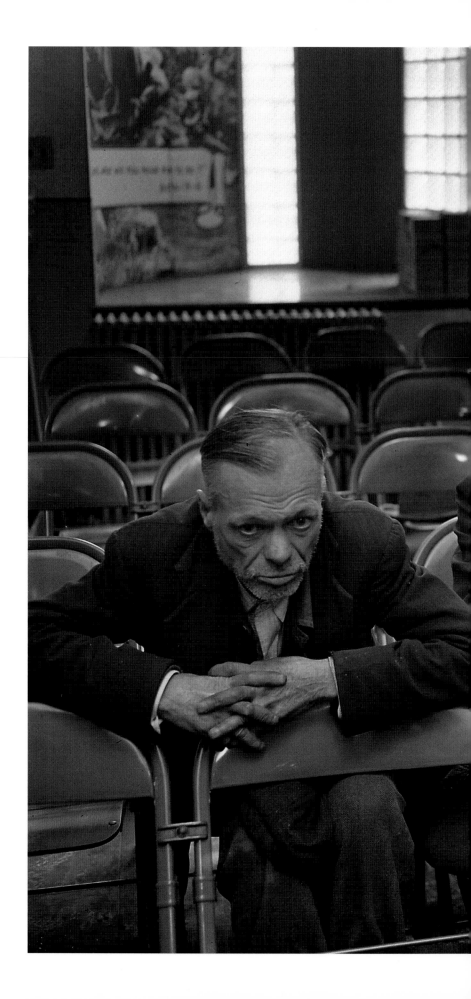

Bill Sturm photographed a Salvation Army mission on West Madison Street on New Year's Day 1947. "These men contemplated the years gone by and the years to come," Sturm wrote. Skid Row swelled after the war. The *Daily News* estimated that more than twelve thousand people lived in forty-six flophouses in the late 1940s. "Skid Row is an open jail for men whose only crime may be poverty or loneliness," wrote William J. Slocum in *Collier's* in 1949. Much of Chicago's Skid Row was torn down in the 1990s for residential developments. The problems remain.

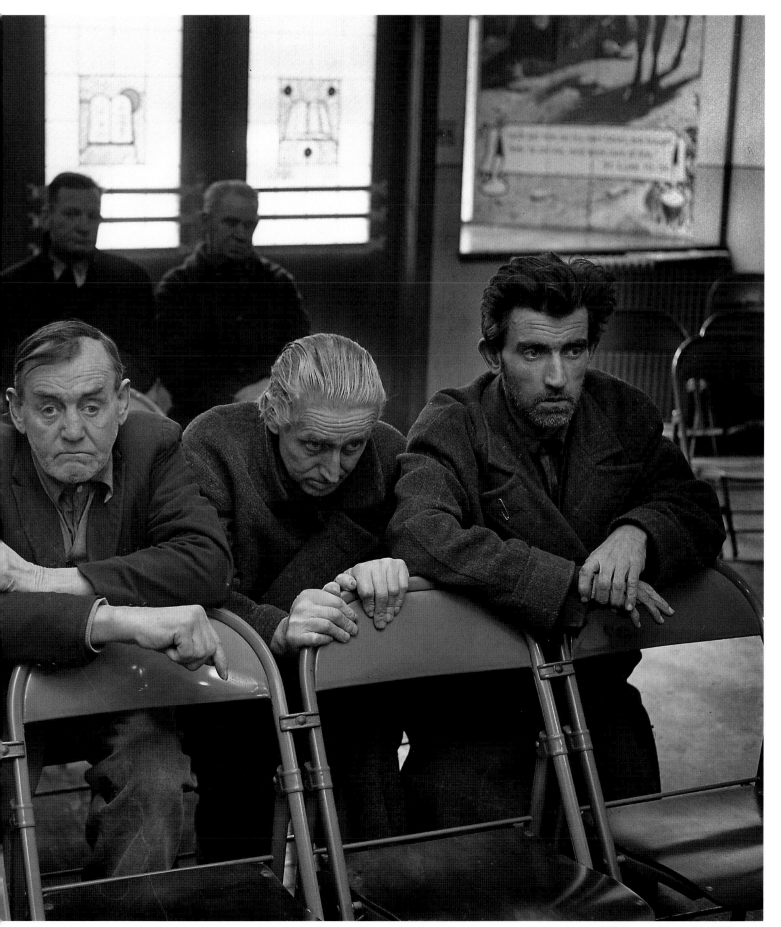

Bill Sturm/ Chicago Sun 1947

9 FANTASTIC LOLLYPOPS

The father of modern photography in Chicago was László Moholy-Nagy, the Hungarian-born artist who brought avant-garde ideas here in 1937. Moholy-Nagy experimented with such things as photograms and photomontages and saw straight photography as only one way to use the camera. "The enemy of photography is the convention, the fixed rules of 'how to do,'" he said. "The salvation of photography comes from the experiment." For Moholy-Nagy's admirers and disciples—Frank Sokolik (1910–1984) among them—Chicago became a kaleidoscope.

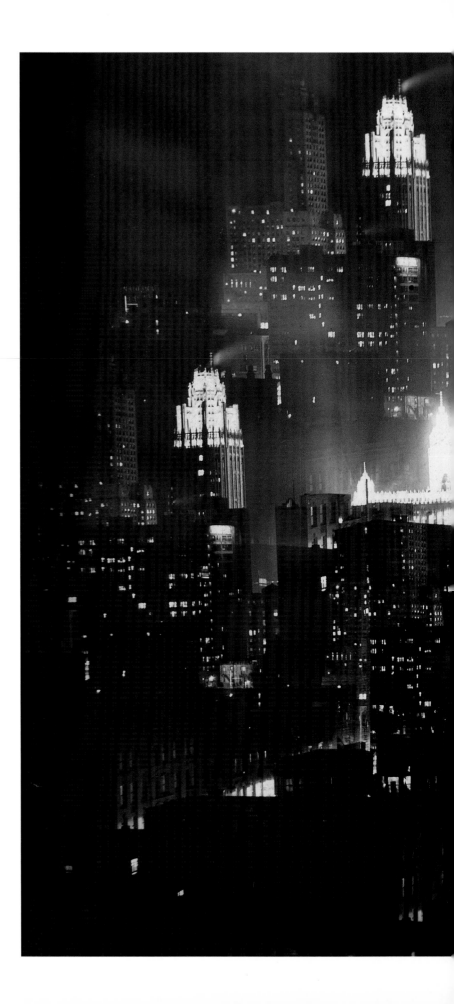

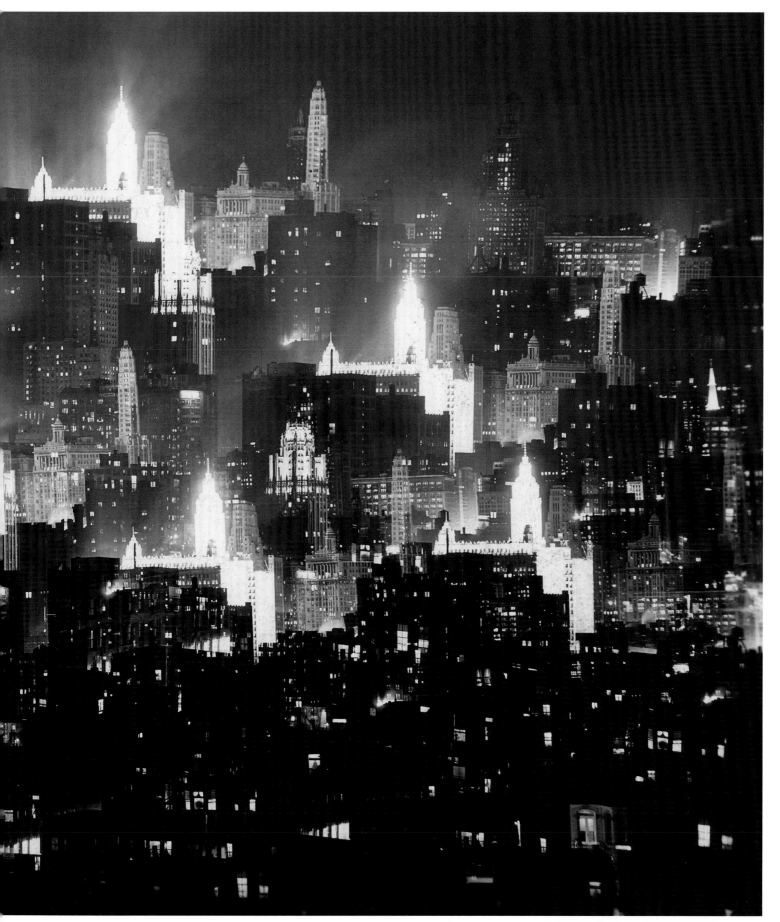

Frank Sokolik/The Art Institute of Chicago 1940s

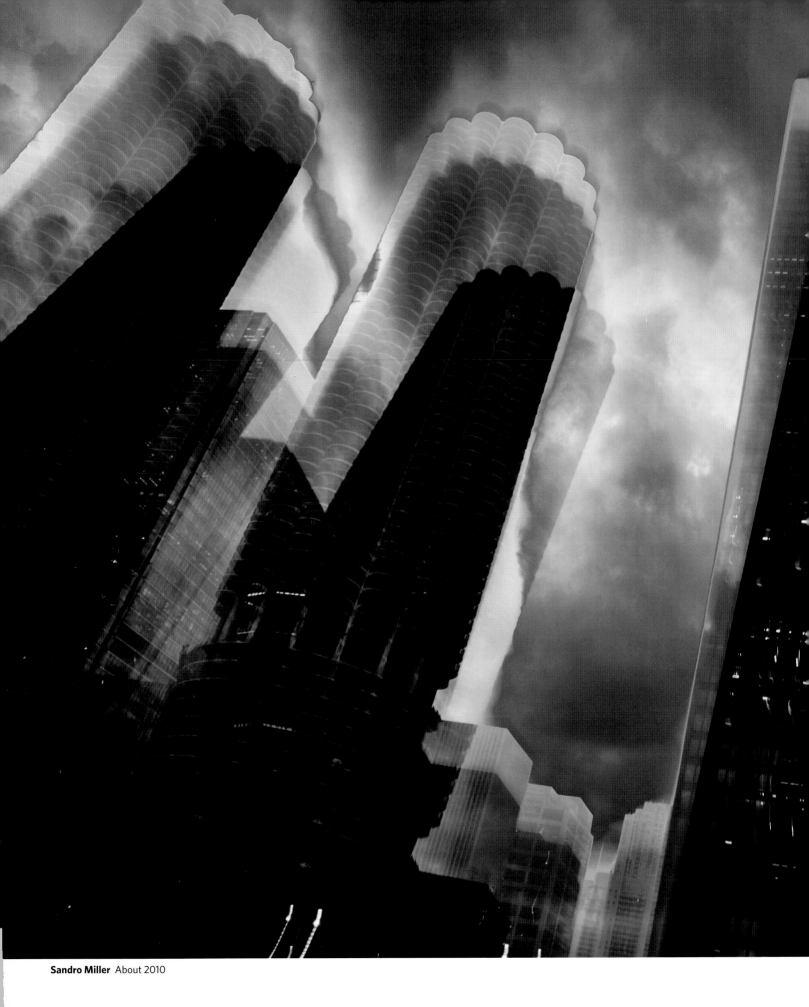

Sandro Miller About 2010

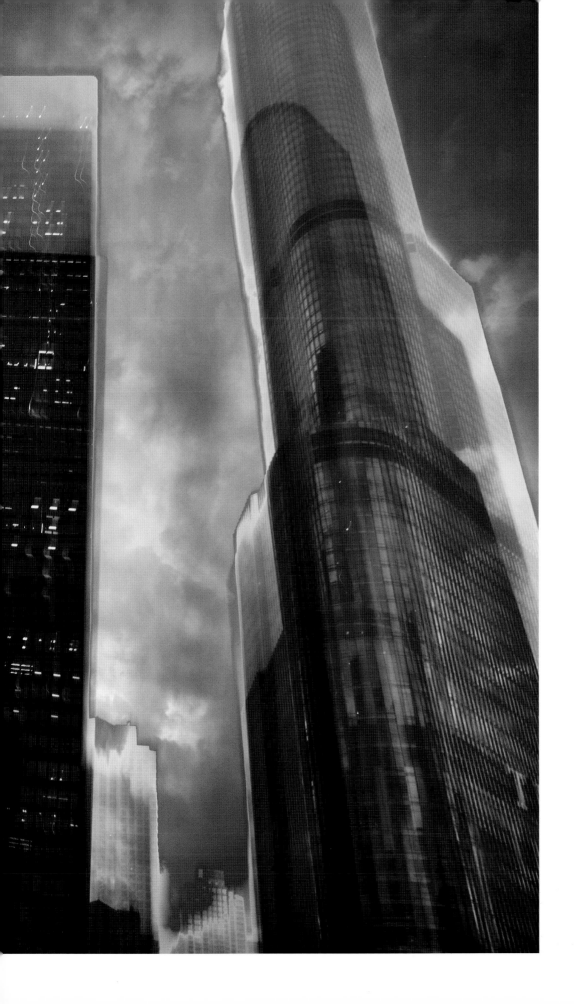

Sandro Miller (born 1958) photographed the skyscrapers just north of the Chicago River—Marina City, the AMA Plaza (formerly One IBM Plaza), and Trump Tower—with a handheld camera. "I use the camera to record the energy of the city," Miller said. "I used a long exposure, found the correct exposure to match, and then moved the camera by hand to adjust to a feeling." Miller works as an advertising and fine art photographer. Born in Elgin, he's lived in Chicago for twenty years—and believes he is following in the Chicago photo tradition started by Harry Callahan, Aaron Siskind, and others. Many successful advertising photographers move to New York or Los Angeles. "I have everything I need right here," he said.

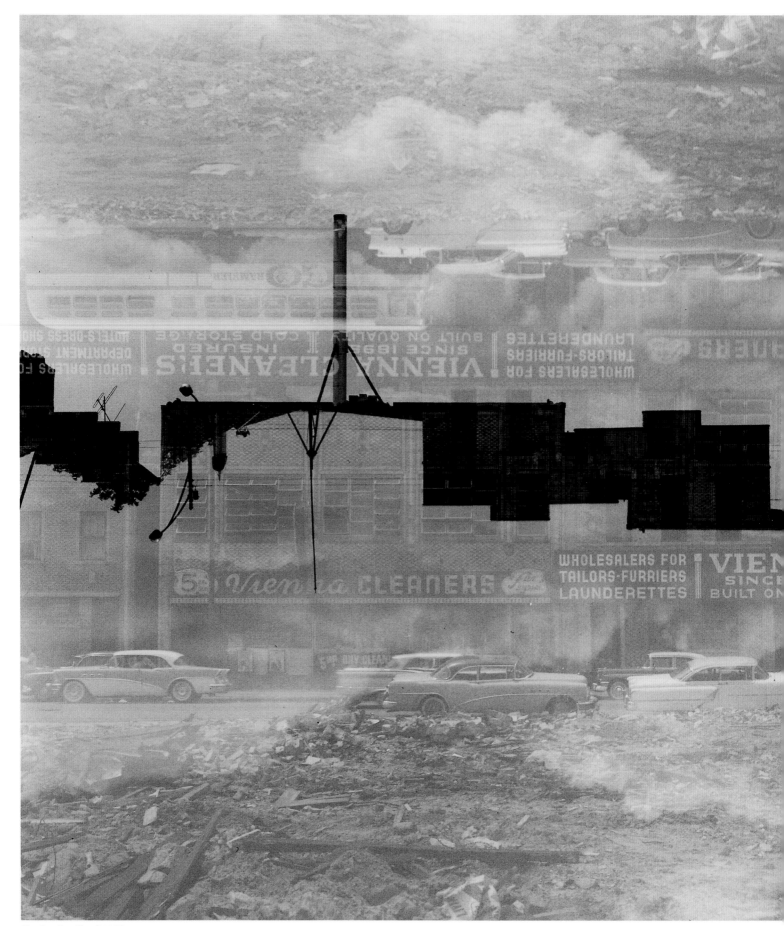

Charles Swedlund 1950s

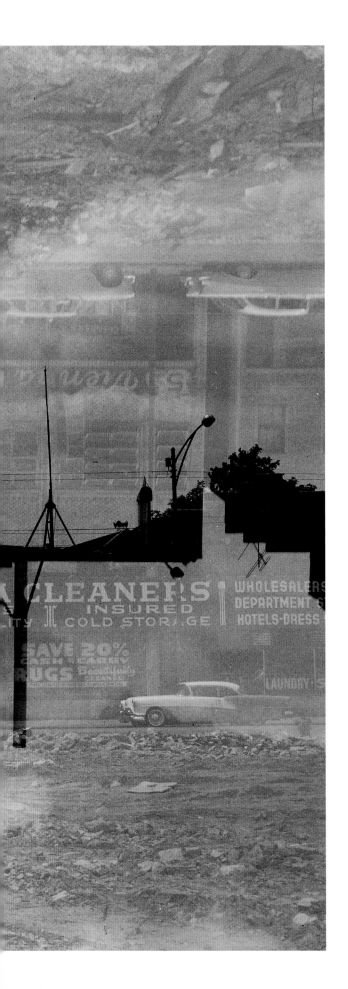

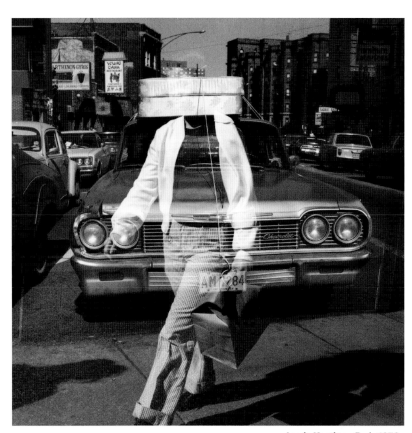

Lewis Kostiner Early 1970s

Happy accidents. **Above:** Studying with Harry Callahan and Aaron Siskind in the early 1970s, Lewis Kostiner (born 1950) learned to imitate those masters. After his first critique at the Institute of Design, he was told, "Now put all these pictures back in the box—we never want to see them again." Kostiner began experimenting with the hope of developing a style. "We were trying to learn about the world," he said. "We never thought about photography being a solution to anything. It was simply a journey." **Left:** Charles Swedlund (born 1935) produced layered photographs—including this one of Vienna Cleaners, at 3036 South Wentworth Avenue—in the camera. "I like and foster the associations produced by mistakes or vaguely controlled situations rather than the ones consciously constructed."

Charles Swedlund 1950s

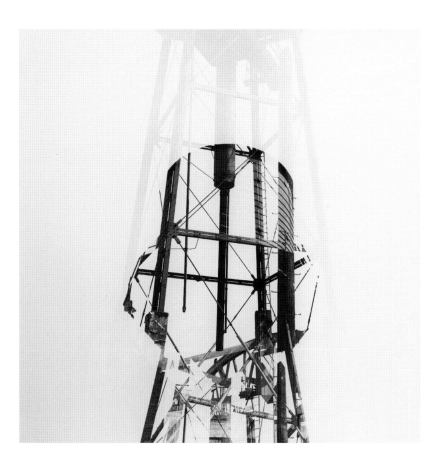

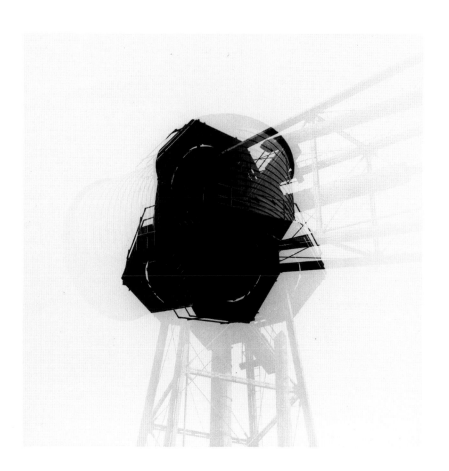

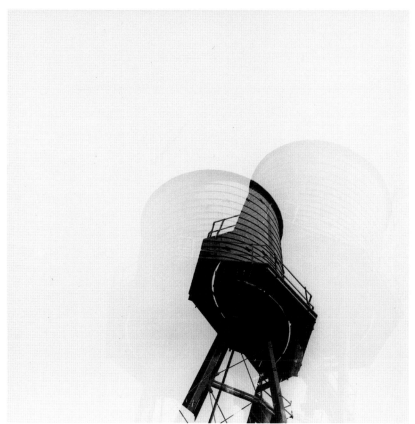

Water tanks atop buildings were part of the Chicago landscape when Charles Swedlund, who grew up in the city, started photographing in the 1950s. Swedlund was known for his desire to expand traditional photography at the Institute of Design. "'Experimental' is not a bad word," he said. "I think of it as a serious and positive term. It's just what discovery is all about." The use of multiple exposures was hit-and-miss at the time, Swedlund said. "There were no Polaroids, no previsualization. We used our intuition."

Gordon Coster 1932

Bill Sosin About 2008

Night and day. **Above:** Bill Sosin (born 1947) photographed rain and snow for four years—often through his windshield. He shot with a shallow focus and short depth of field to get a painterly, impressionist look. "It was usually dark and people couldn't see me shooting," he said. "I hoped my presence with a camera would not interfere with the natural flow of people on the street." Sosin admits that many of his photographs—like this one in the Jefferson Park neighborhood— were taken as he drove or was stopped in traffic. "I would try to have the framing, lens choice, and focus set as I moved so the potential subjects would naturally come into the frame." **Opposite:** Gordon Coster called this view of the city from above "Chicago—Impression at Night."

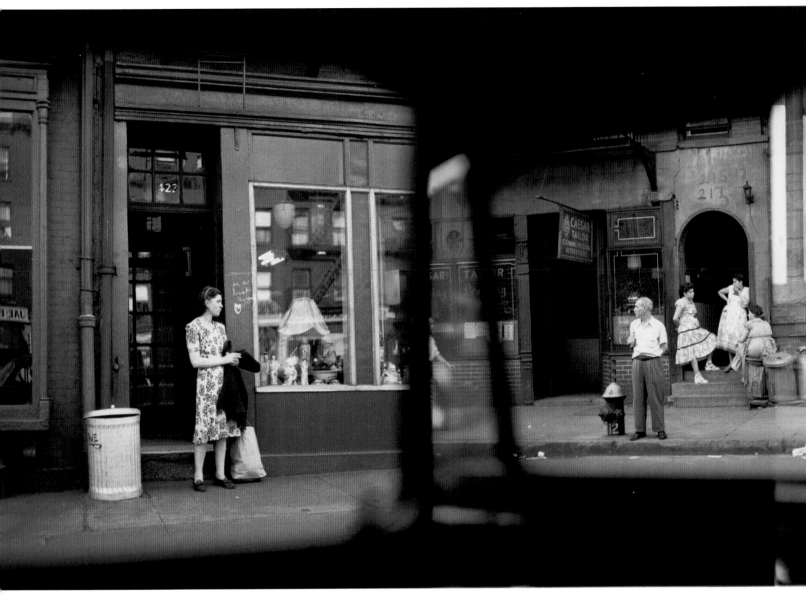

Art Shay Early 1950s

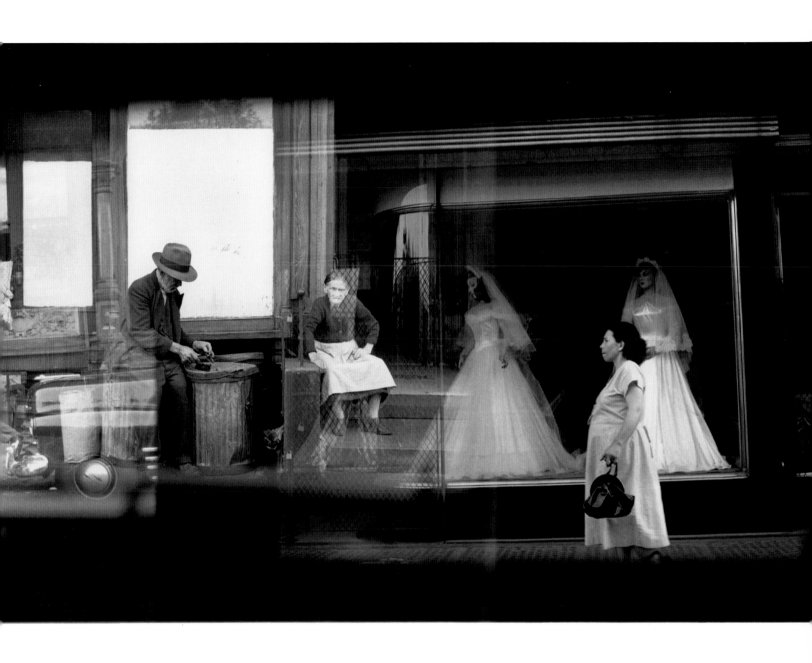

"It's a lovely accident, created when I mis-wound my medium-format film while shooting out my 1949 Pontiac car window," said Art Shay of this Southwest Side street montage. The reflection is from a pane of glass that two glaziers had briefly placed in a narrow street before installing it. The mime Marcel Marceau bought the picture because it reminded him of how a woman matures. Shay's original title: "The Three, Possibly Four Ages of Women."

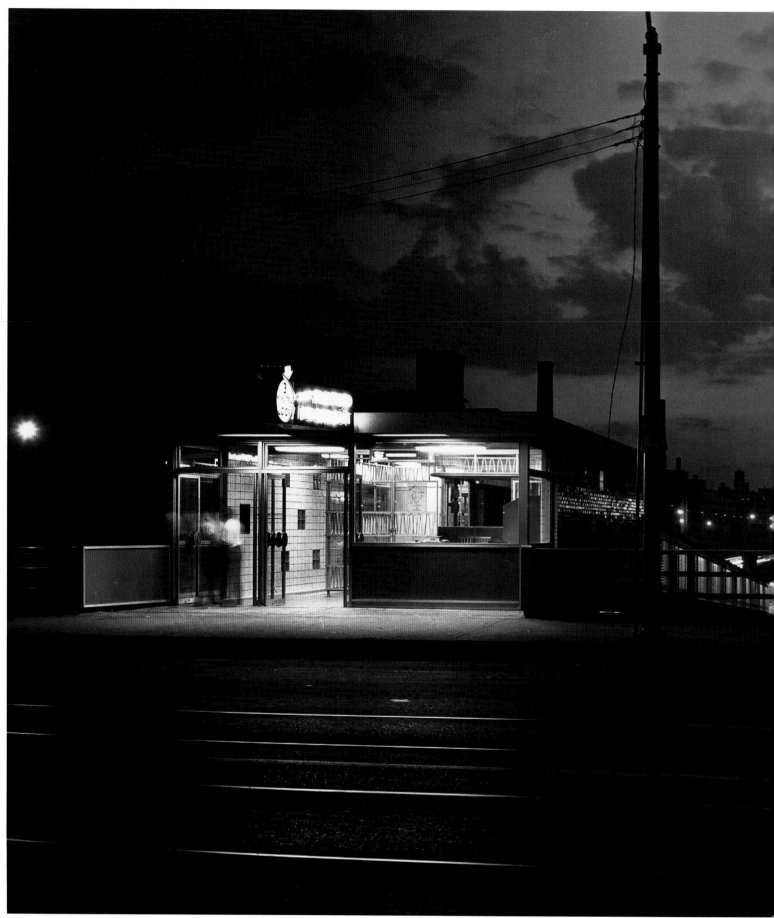

Ed Evenson/CTA 1958

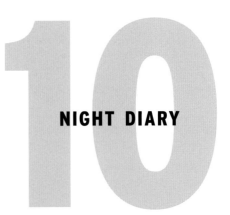

10

NIGHT DIARY

When the hog butchers for the world, the tool makers, and the stackers of wheat head home, Chicago takes on a distinctive look. Streetlamps, window light, and the silhouetted skyline create a noir city. Capturing Chicago at night is a challenge. As the city slows and solitary figures come out, it displays a nuanced mood. Shadows disappear and reflections heighten. The end of the day is near.

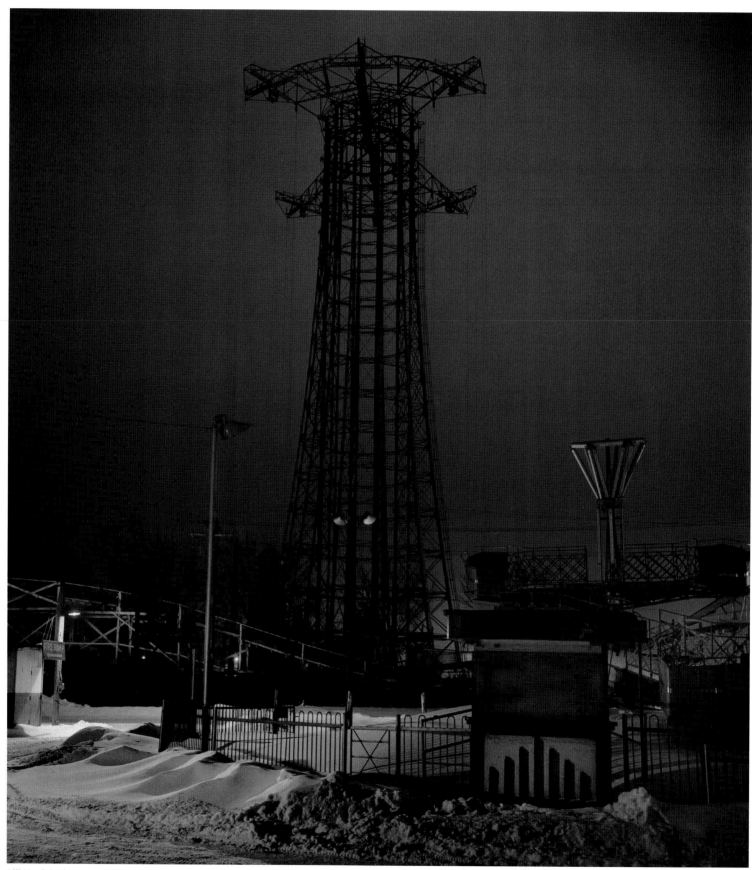

Bill Knefel/Chicago Sun-Times 1959

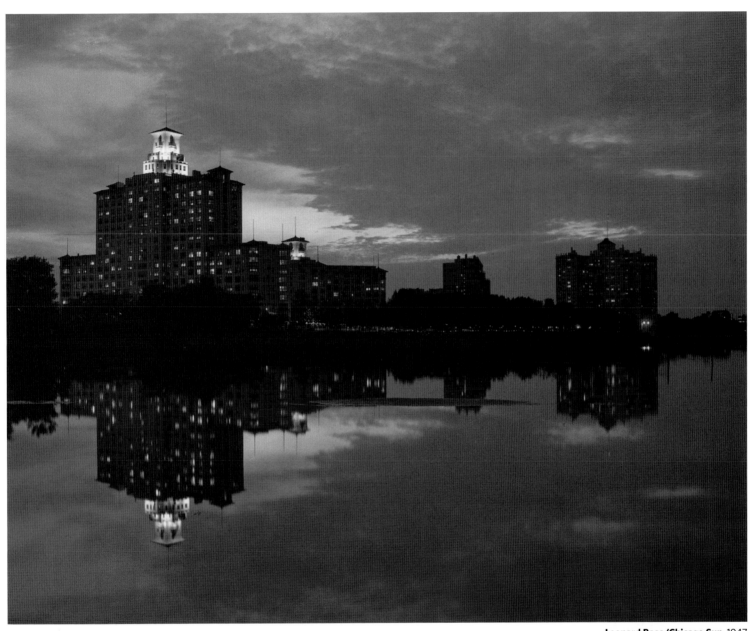

Leonard Bass/Chicago Sun 1947

The hush of evening. **Above:** Leonard Bass (1910–1998) called this "Shades of Evening." The *Chicago Sun* photographer took it from the Foster Avenue Beach at dusk looking toward the Edgewater Beach Hotel. At the time, Lake Shore Drive ended at Foster, but it was extended to Hollywood Avenue in 1957. **Opposite:** Riverview Park's Pair-O-Chutes in the middle of winter— the one time of year the park seemed forlorn. Bill Knefel (1909–1960) worked for the *Chicago Herald-Examiner, Chicago American, Chicago Sun,* and *Chicago Sun-Times.*

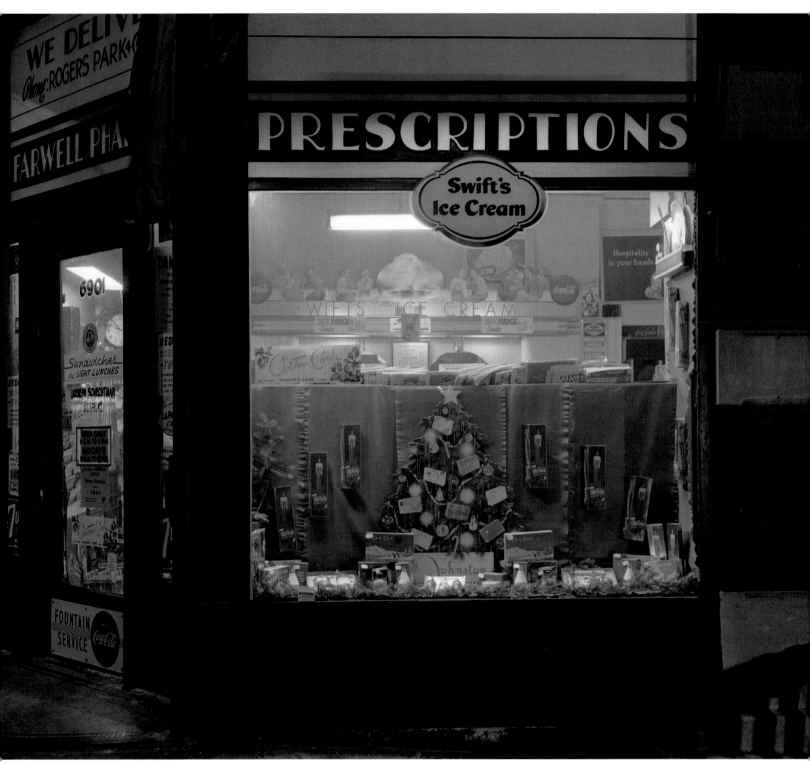

Willming Hugh 1950s

Last embers. **Above:** The corner drugstore. Willming Hugh (1930–2000) photographed the Farwell Pharmacy, at 6901 North Clark Street, during the holiday season. Hugh, a serious amateur who shot weddings and did commercial work, lived nearby in an apartment attached to the Adelphi Theater. **Opposite:** Police officers gather around a fire to keep warm during guard duty at the Trumbull Park Homes, a public housing project near 105th Street and Yates Avenue. Police provided around-the-clock protection for African American families who moved into the previously segregated housing project during the summer of 1953.

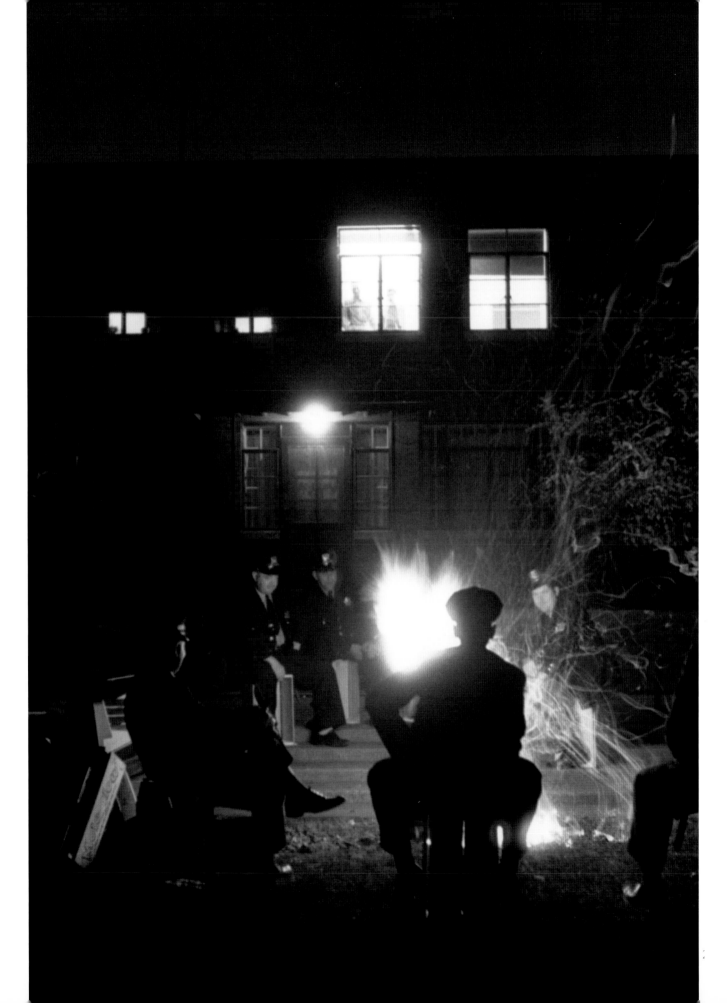

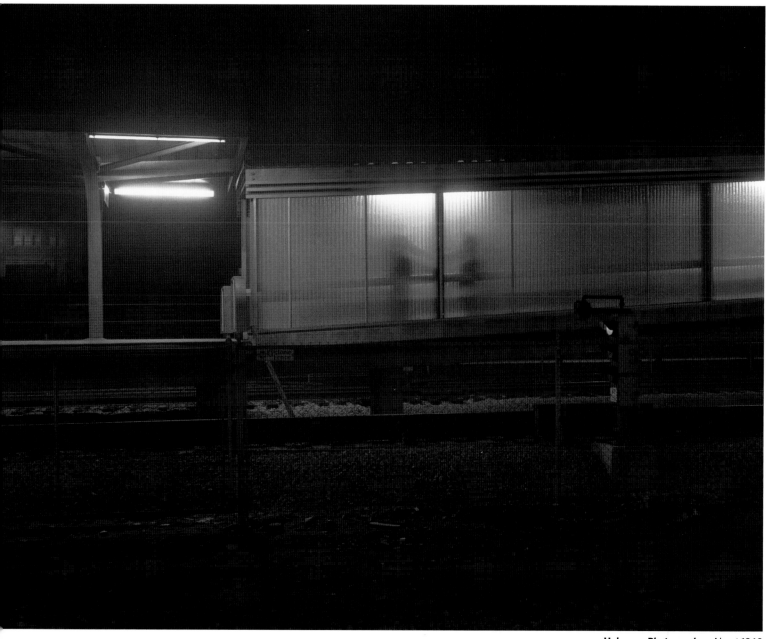

Unknown Photographer About 1960

Quiet nights. **Above:** A meeting on the new Congress Line. The "L" line, which was called the West Side Subway when it opened in 1958, ran down the median of the Congress Expressway. It's now called the Blue Line, and the expressway is now the Eisenhower. **Opposite:** Joseph D. Jachna split his time photographing Chicago, where he lived, and upper Wisconsin, where he loved to take pictures. "I feel God has given me the potential to be a little more than an obscure photographer," he wrote in 1965, "and I do feel photography is worthwhile if done at the level of art or poetry and not just a hobby." Jachna won a Guggenheim Fellowship in 1980.

◁ **Joseph D. Jachna** 1959

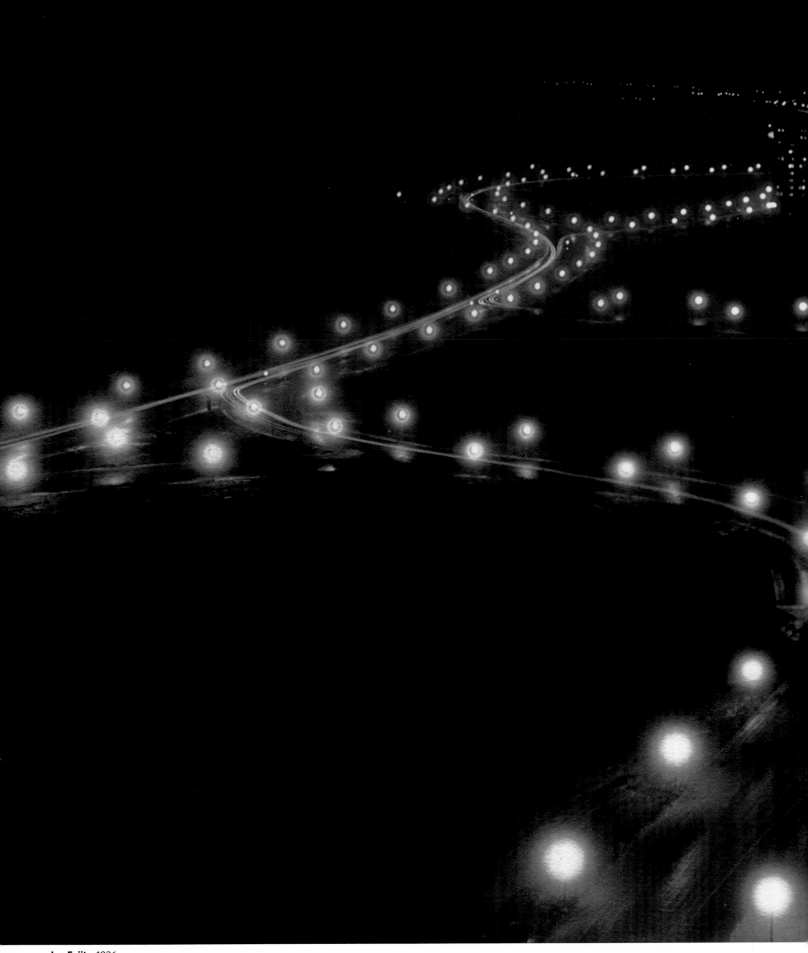

Jun Fujita 1936

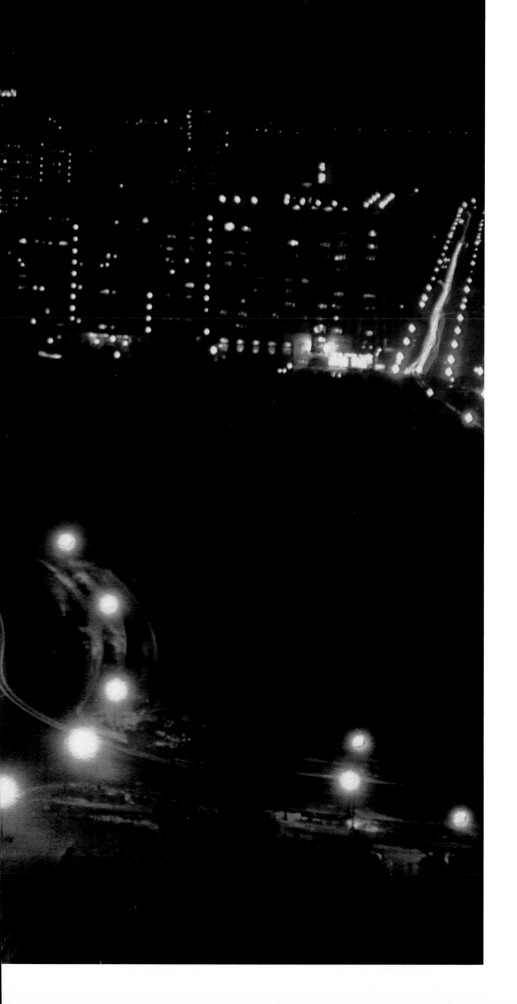

Jun Fujita (1888–1963) was one of Chicago's first celebrated photographers. As a photojournalist, he covered the *Eastland* disaster in 1915, the Chicago race riot of 1919, and the St. Valentine's Day Massacre in 1929. But he was also a pictorialist, using his camera to create visually poetic views of the city and of nature. Here, Fujita photographed South Shore Drive at Promontory Point. The building at the right is the Hotel Del Prado, at the corner of Fifty-Third Street and Hyde Park Boulevard.

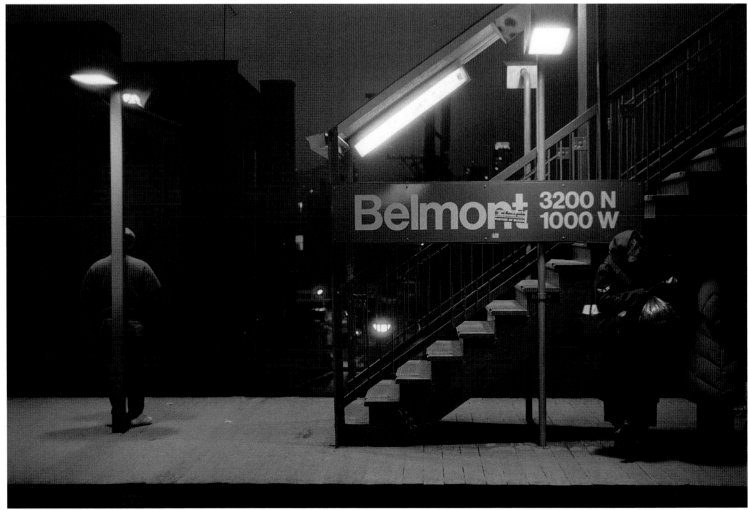

Jon Randolph 1991

Twenty-three feet above Chicago. **Above:** Jon Randolph (born 1946) photographed the "L" station at Belmont for a *Chicago Reader* story about transportation. "I was told to shoot the CTA with no other directions, so that's what I did," Randolph recalled. "I just remember it was a cold night in January." *Reader* photo assignments were often vague because editors depended on the creativity of photographers, he said, which spurred photographers to be creative. **Opposite:** Another view of the Belmont station, with people standing beneath the warming lights.

Jay King 1980

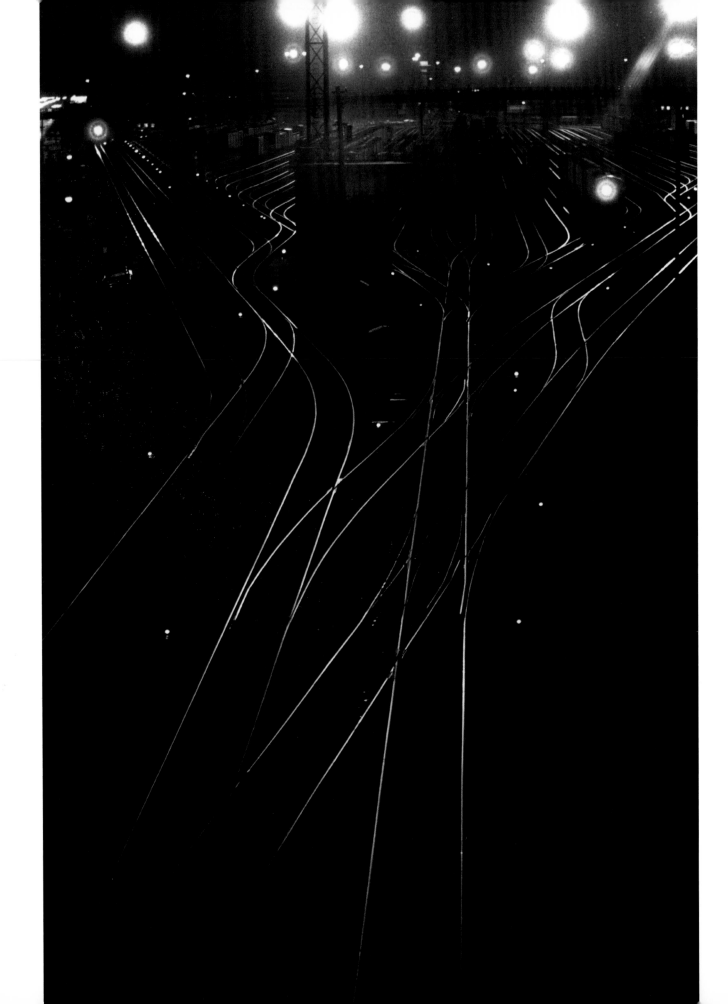

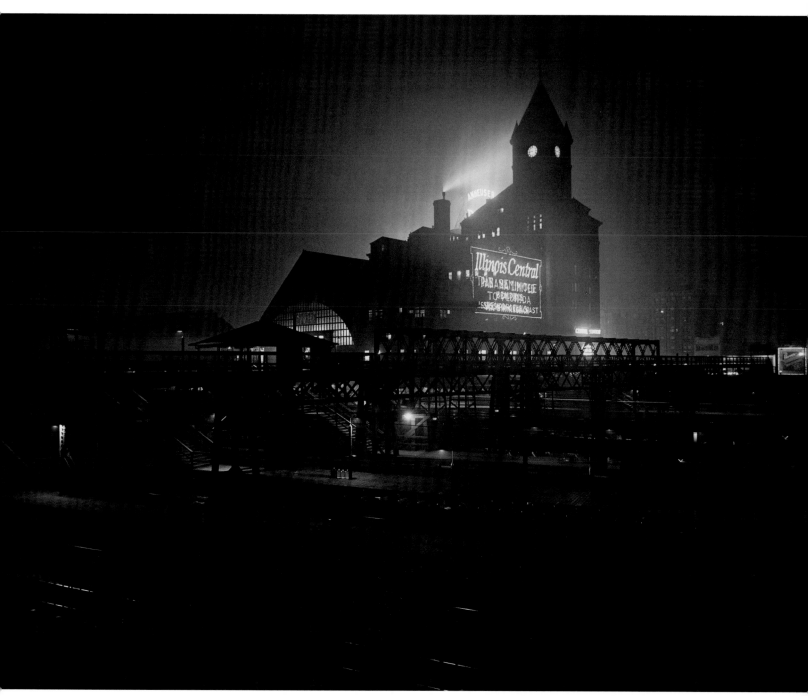

Raymond Trowbridge/Chicago History Museum About 1930

City tracks. **Above:** Raymond Trowbridge (1886–1936), one of the city's most prominent early architectural photographers, was first a practicing architect. The Illinois Central Railroad's Central Station, at Michigan Avenue and Roosevelt Road, was where African Americans arrived in Chicago from the South. **Opposite:** "I remember the blackness of the environment, how the light was glinting off the tracks," Kenneth Josephson said of the gritty freight yard on the Near West Side that he made look pristine. "I could not have designed it better if I drew it."

◁ **Kenneth Josephson** 1961

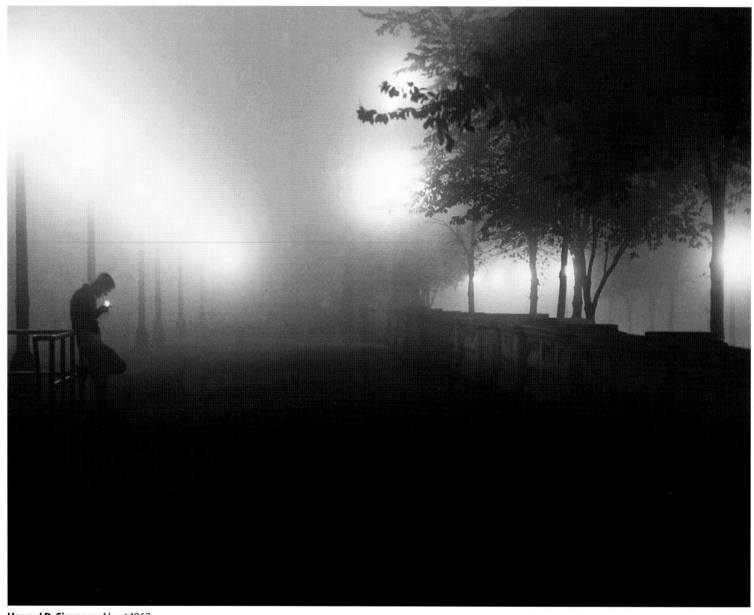

Howard D. Simmons About 1963

Under the glow. **Above:** Howard D. Simmons (born 1943) was teaching himself photography when he shot this Grant Park scene while on a weekend pass from the Chanute Air Force Base in Rantoul, Illinois. He later moved to Chicago to work for *Ebony* magazine and the *Chicago Sun-Times* before starting a commercial career. **Opposite:** Jack Delano's view of Chicago from freight tracks east of downtown. The Pabst sign, which included a clock, was near the South Water Street freight terminal.

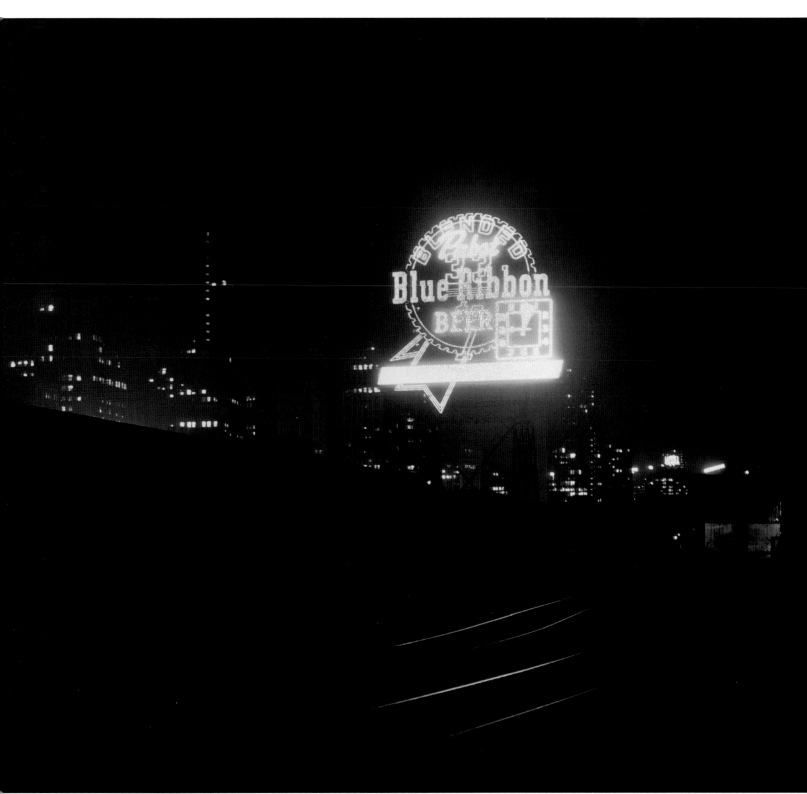

Jack Delano 1943

Allen Porter Late 1940s

Light matters. **Above:** Allen Porter (born 1926) took this photograph of steps leading to the Chicago River as a student at the Institute of Design. "The ID influenced me the rest of my life," said Porter, who became a graphic and industrial designer in Los Angeles. **Opposite:** Gordon Coster's photo of fireworks over Buckingham Fountain was included in a 1931 show at the London Salon of Photography called *The Marvels of Photography.*

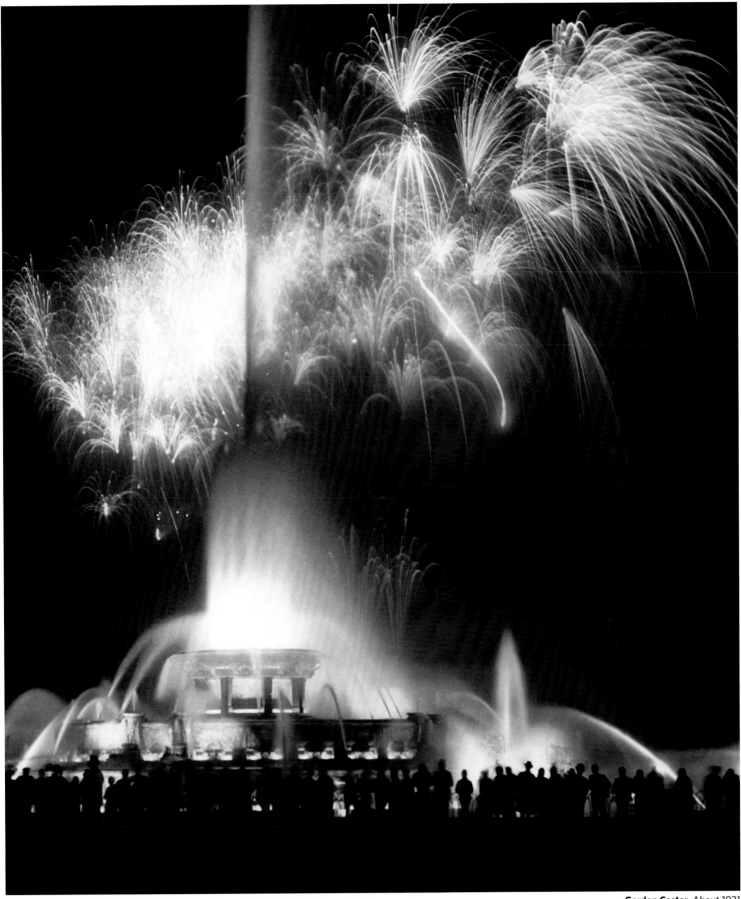

Gordon Coster About 1931

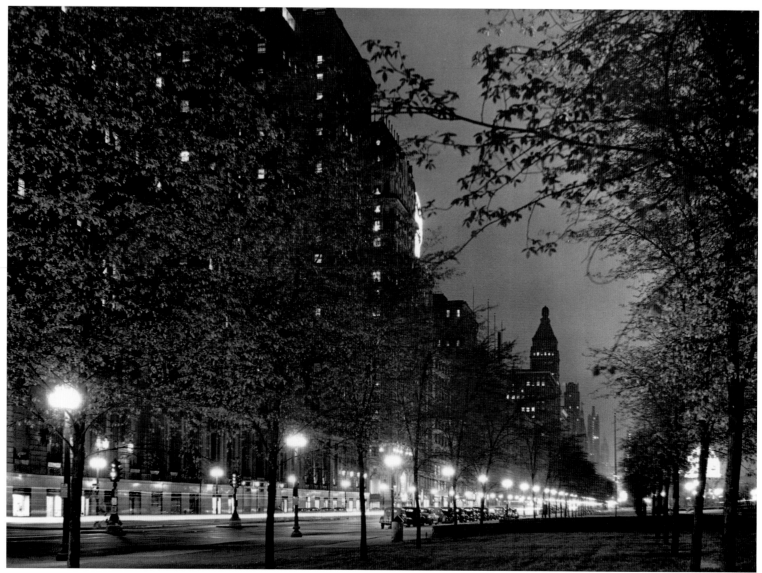

Gordon Coster About 1940

Great streets. **Above:** Gordon Coster's view of Michigan Avenue. The Conrad Hilton (known first as the Stevens Hotel) is in the foreground. **Opposite:** The Palmolive Building rises above Michigan Avenue. This view is looking east from Walton Street. Raymond Trowbridge sold his photographic archive to the architectural photography firm Hedrich-Blessing when he retired.

Raymond Trowbridge/Chicago History Museum About 1930 ▷

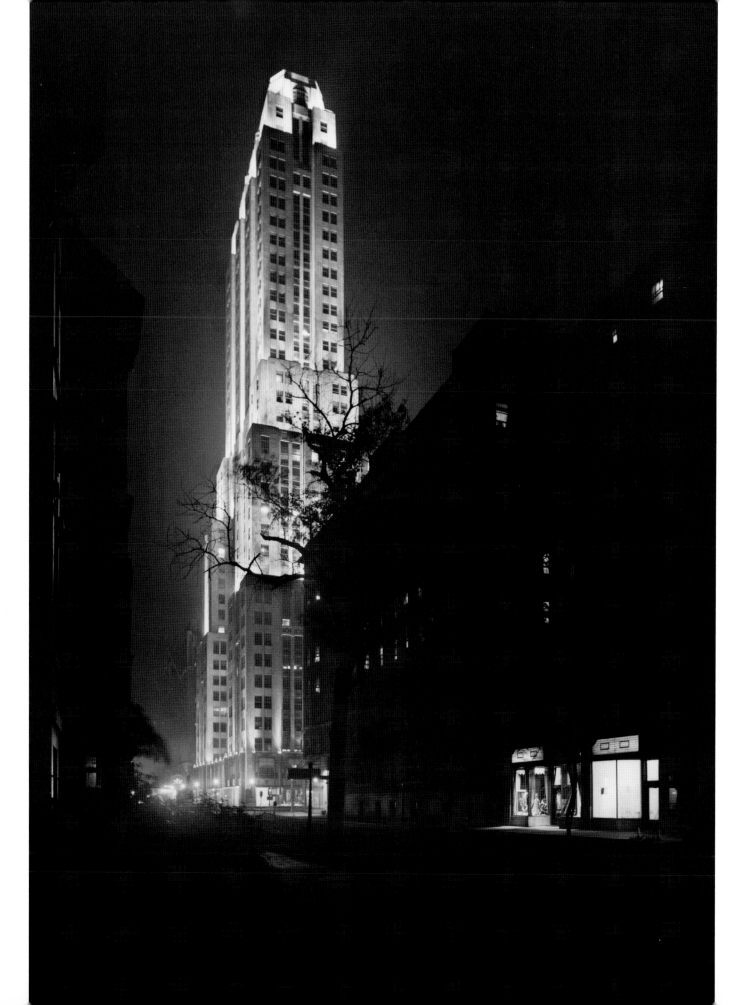

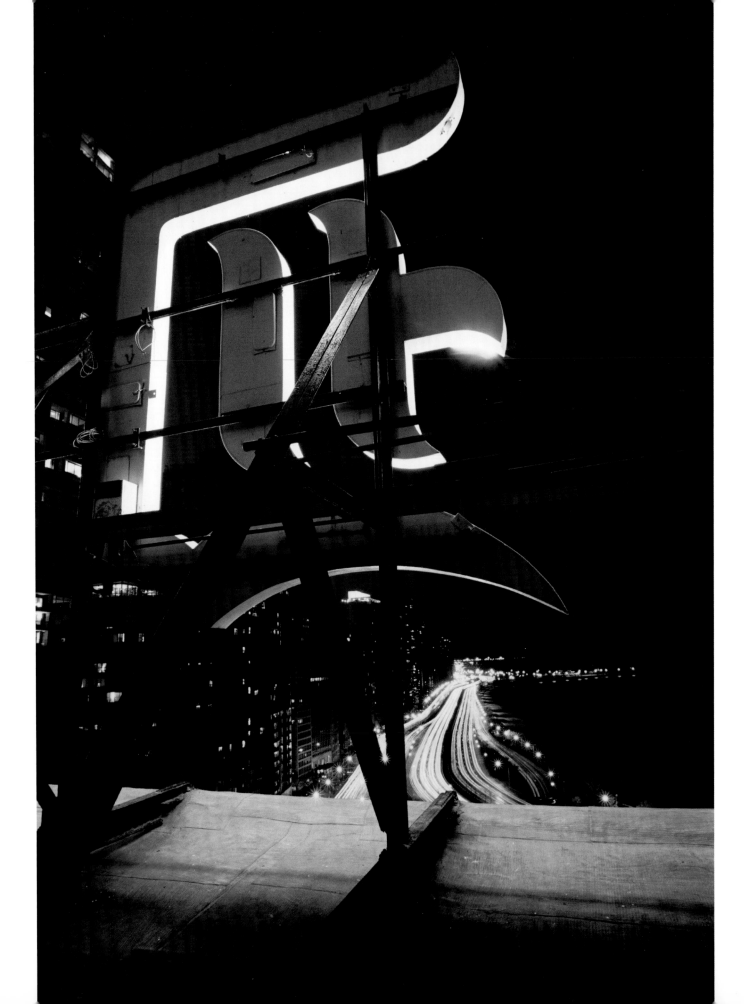

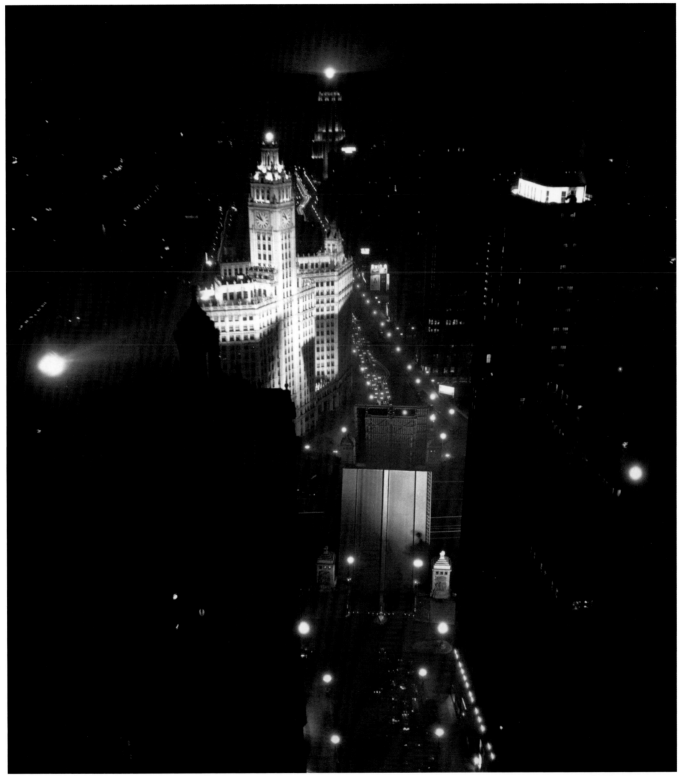

Gordon Coster 1932

A last look. **Above:** The Michigan Avenue Bridge rises over the Chicago River. Illuminated in the background are the Wrigley Building and the Lindbergh Beacon of the Palmolive Building. **Opposite:** Behind the Drake Hotel sign above Lake Shore Drive, part of a series of rooftop views by Robert Murphy (born 1963), who also works as an architect. "I was trying to come up with a different way of seeing the city."

PHOTO CREDITS

Endsheets Ralph Frost/Chicago Sun-Times
1-9 Howard Lyon/Chicago Sun-Times
10-11 Unknown Photographer/CityFiles Press Archive
12 James P. Blair/Edgewater Gallery
13 Richard Nickel/Richard Nickel Archive, Ryerson and Burnham Archives, The Art Institute of Chicago
14-15 John Vachon/Farm Security Administration - Office of War Information Photograph
16-17 John Vachon/Farm Security Administration - Office of War Information Photograph
18 John Vachon/Farm Security Administration - Office of War Information Photograph
19 Marvin E. Newman/Stephen Daiter Gallery
20 Kenneth Josephson/Stephen Daiter Gallery
21 Scott Strazzante
22 Hedrich-Blessing Collection/Chicago History Museum/HB-02137-A2
23 Eric Futran
24 and 25 Marco Lorenzetti/Financial Canyon, 2000, 8x10 gelatin silver contact print, c. Marco Lorenzetti
26-27 Gordon Coster
28 Richard Nickel/Richard Nickel Archive, Ryerson and Burnham Archives, The Art Institute of Chicago
29 Walker Evans/The Metropolitan Museum of Art. The Horace W. Goldsmith Foundation Gift, through Joyce and Robert Menschel, 1990
30 and 31 Richard Nickel/Richard Nickel Archive, Ryerson and Burnham Archives, The Art Institute of Chicago
32-33 Jonas Dovydenas
34 Kathy Richland
35 Art Shay
36 John Vachon/Farm Security Administration - Office of War Information Photograph
37 Art Shay
38 Vaughn Shoemaker/Chicago Sun-Times
39 Dorothea Lange/Farm Security Administration - Office of War Information Photograph
40 John Vachon/Farm Security Administration - Office of War Information Photograph
41 Henry Simon/Norbert Simon/Paul Berlinga Fine Art
42-43 Joe Kordick/Chicago Sun-Times
44-45 Bill Sturm/Chicago Sun-Times
45 Richard Nickel/Richard Nickel Archive, Ryerson and Burnham Archives, The Art Institute of Chicago
46 Ray Metzker/Laurence Miller Gallery
47 John Vachon/Farm Security Administration - Office of War Information Photograph
48-49 John Vachon/Farm Security Administration - Office of War Information Photograph
50 Kenneth Josephson/Stephen Daiter Gallery
51 Jay King/Stephen Daiter Gallery
52 and 53 Jay King/Stephen Daiter Gallery
54-55 Esther Bubley/Chicago, Burlington & Quincy Railroad Company Archives/Newberry Library
56 Robert C. Florian/Chicago History Museum/ICHi-92689
57 Robert C. Florian/ Chicago History Museum/ICHi-92688
58 Ralph Frost/Chicago Sun-Times
58-59 Unknown Photographer/CityFiles Press Archive
60 and 61 Harold Allen/The Harold Allen Study Collection/School of the Art Institute of Chicago
62-63 Detroit Photographic Company/Library of Congress
64 and 65 Jack Delano/Farm Security Administration - Office of War Information Photograph
66 and 67 Jack Delano/Farm Security Administration - Office of War Information Photograph
68 Esther Bubley/Chicago, Burlington & Quincy Railroad Company Archives/Newberry Library
69 Algimantas Kezys
70-71 Unknown Photographer/CityFiles Press Archive
72-73 Jay King/Stephen Daiter Gallery
74 and 75 Marvin E. Newman/Stephen Daiter Gallery
76 Stephen Marc/Museum of Contemporary Photography at Columbia College Chicago
76-77 Henri Cartier-Bresson/Magnum Photos
78 Mildred Mead/Chicago History Museum/ICHi-86536
79 Mildred Mead/Chicago History Museum/ICHi-86704
80 Wayne Miller/Magnum Photos
81 Robert Natkin/Paul Natkin
82 John Tweedle/Chicago Sun-Times
83 Bob Black/Chicago Sun-Times
84-85 Art Shay
86-87 Art Shay
88-89 Danny Lyon/Magnum Photos
90 Yvette Marie Dostatni
90-91 Antonio Perez/Museum of Contemporary Photography at Columbia College Chicago
92 Unknown Photographer/Chicago Tribune/TNS
93 Jon Lowenstein
99-95 Russell Lee/Farm Security Administration - Office of War Information Photograph
96 and 97 Robert Natkin/Paul Natkin
98-99 Robert Natkin/Paul Natkin
100 Stephen Deutch/Chicago History Museum/ICHi-40841
101 Art Shay
102 George Kufrin/Paul Berlinga Fine Art
103 James P. Blair/Edgewater Gallery
104-105 Russell Lee/Farm Security Administration - Office of War Information Photograph
106 Chicago Surface Lines Photo/CTA Archives
107 Kathy Richland
108-109 Tom Harney/Museum of Contemporary Photography at Columbia College Chicago
110-111 Jay King/Stephen Daiter Gallery
112 James Iska
113 Joseph D. Jachna/Heidi and Virginia Jachna
114 Gordon Coster/Peter Coster
115 Clarence John Laughlin/Chicago History Museum/ICHi-26061
116-117 Ralph Arvidson/Chicago Sun-Times
118-119 Gordon Coster/Peter Coster
120 John Vachon/Farm Security Administration - Office of War Information Photograph
120-121 Chicago Surface Lines Photo/CTA Archives
122-123 Richard Nickel/Richard Nickel Archive, Ryerson and Burnham Archives, The Art Institute of Chicago
124 Robert Natkin/Paul Natkin

125 Don Bronstein/Susan Hillman
126 and 127 Don Bronstein/Susan Hillman
128-129 Mark PoKempner
130-131 Raeburn Flerlage/Stephen Daiter Gallery
132 Michael Abrahamson/Midge Wilson
133 Jack Delano/Farm Security Administration - Office of War Information Photograph
134-135 Unknown Photographer/CityFiles Press Archive
136 Steve Lasker/ Chicago Tribune/ TNS
136-137 Unknown Photographer/Chicago Sun-Times
138 Mickey Rito/Chicago Sun-Times
139 Jay King/Stephen Daiter Gallery
140 Louis Giampa/Chicago Sun-Times
141 Bob Kotalik/Chicago Sun-Times
142-143 Unknown Photographer/Chicago Sun-Times
143 Stanley Kubrick/Look magazine/Library of Congress
144 Elliott Erwitt/Magnum Photos
145 Ron Gordon/Paul Berlinga Fine Art
146 Larry Nocerino/Chicago Sun-Times
147 Ron Seymour
148-149 Dave Mann/Chicago Sun-Times
150 Angie McMonigal
151 James Iska
152 Unknown Photographer
153 Fred Korth/Paul Berlinga Fine Art
154 Fred Korth/Paul Berlinga Fine Art
155 Dave Jordano
156 Virginia Lockrow/Chicago History Museum/ICHi-92687
157 Charles H. Traub
158-159 Jay King/Stephen Daiter Gallery
160 Hedrich-Blessing Collection/Chicago History Museum/HB-03631
161 Jonas Dovydenas
162-163 Diane Joy Schmidt and Michele Fitzsimmons
164 and 165 Ron Gordon/Paul Berlinga Fine Art
166-167 Barbara Crane/Stephen Daiter Gallery
168-169 Unknown Photographer/CityFiles Press Archive
170 Marc Hauser
171 Carlos Javier Ortiz
172 Stephen Marc/Museum of Contemporary Photography at Columbia College Chicago
173 Aaron Siskind/Aaron Siskind Foundation
174 Yasuhiro Ishimoto/Kochi Prefecture, Ishimoto Yasuhiro Photo Center
175 Art Sinsaugh/Art Sinsaugh Archive, Eskenazi Museum of Art, Indiana University
176 and 177 Barbara Crane/Stephen Daiter Gallery
178 Jon Lowenstein
179 Unknown Photographer/Chicago Tribune/TNS
180 and 181 Harry Callahan/ © The Estate of Harry Callahan; courtesy Pace/MacGill Gallery
182-183 Bill Sturm/Chicago Sun-Times
183 Angie McMonigal
184 Barbara Crane/Stephen Daiter Gallery
185 Ralph Walters/Chicago Sun-Times
186-187 Lloyd DeGrane
188-189 Chicago Surface Lines Photo/CTA Archives
190 Nathan Lerner /Kiyoko Lerner/Shashi Caudill
191 Russell Hamm/Chicago Sun-Times
192 Russell Hamm/Chicago Sun-Times
193 Nathan Lerner/Kiyoko Lerner/Shashi Caudill
194 Ron Seymour
194-195 Yvette Marie Dostatni
196-197 Bill Sturm/Chicago Sun-Times
198-199 Art Shay
200 John H. White/Chicago Sun-Times
201 Bill Sturm/Chicago Sun-Times
202-203 Al Mosse/Chicago Sun-Times
204-205 Bill Sturm/Chicago Sun-Times
206-207 Frank Sokolik/The Art Institute of Chicago
208-209 Sandro Miller
210-211 Charles Swedlund/Stephen Daiter Gallery
211 Lewis Kostiner
212 and 213 Charles Swedlund/Stephen Daiter Gallery
214 Gordon Coster/Peter Coster
215 Bill Sosin
216-217 Art Shay
218-219 Ed Evenson/CTA Archives
220 Bill Knefel/Chicago Sun-Times
221 Leonard Bass/ Chicago Sun-Times
222 Willming Hugh /CityFiles Press Archive
223 Art Shay
224 Joseph D. Jachna/Heidi and Virginia Jachna
225 Unknown Photographer/CityFiles Press Archive
226-227 Jun Fujita/Graham Lee
228 Jon Randolph
229 Jay King/Stephen Daiter Gallery
230 Kenneth Josephson/Stephen Daiter Gallery
231 Raymond Trowbridge/Chicago History Museum/ ICHi-81150
232 Howard D. Simmons
233 Jack Delano/Farm Security Administration - Office of War Information Photograph
234 Allen Porter/Bauhaus Chicago Foundation
235 Gordon Coster/Peter Coster
236 Gordon Coster/Peter Coster
237 Raymond Trowbridge/Chicago History Museum/ICHi-81166
238 Robert Murphy
239 Gordon Coster/Peter Coster

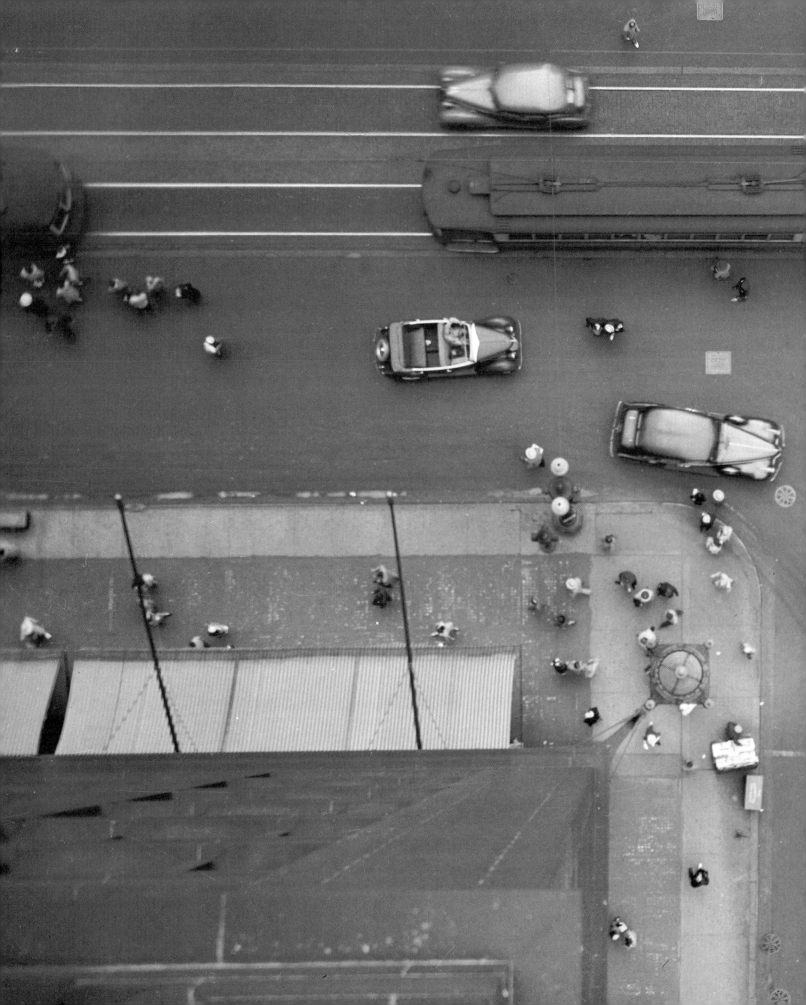